Prints and Printmakers of New York State, 1825–1940

A New York State Study

Prints and Printmakers
of New York State, 1825-1940

Edited by
DAVID TATHAM

Syracuse University Press 1986

This book is published with the assistance of a grant from the John
Ben Snow Foundation.

The paper used in this publication meets the minimum requirements of
American National Standard for Information Sciences—Permanence of
Paper for Printed Library Materials, ANSI Z39.48-1984.∞

Library of Congress Cataloging-in-Publication Data

Prints and printmakers of New York State, 1825–1940.

(A New York State study)
Bibliography: p.
Includes index.
1. Prints, American—New York (State) 2. Prints—
19th century—New York (State) 3. Prints—20th century—
New York (State) 4. Printmakers—New York (State)
I. Tatham, David. II. Series.
NE535.N49P75 1986 769.9747 86-3773
ISBN 0-8156-0204-9 (alk. paper)

Manufactured in the United States of America

CONTENTS

CONTRIBUTORS

CLINTON ADAMS is director emeritus of the Tamarind Institute in Albuquerque, New Mexico, and the author of many studies of the graphic arts, including *American Lithographers 1900–1960* (1983).

GRANT ARNOLD, who has drawn and printed lithographs since the 1920s, is the author of *Creative Lithography* (1941) and honorary professor of art emeritus at the State University of New York College at Oswego.

GEORGIA BRADY BUMGARDNER is the Andrew W. Mellon Curator of Graphic Arts at the American Antiquarian Society. She is the author of *American Broadsides* (1971) and several articles about book illustration. She compiled and annotated the section on the graphic arts of the seventeenth through nineteenth centuries in *Arts in America: A Bibliography* (1979).

JOHN CARBONELL is a book dealer who lives in Alexandria, Virginia.

EDWARD COMSTOCK, JR., a former curator at the Adirondack Museum, Blue Mountain Lake, New York, is the proprietor of Wildwood Books, Old Forge, New York.

NANCY R. DAVISON is an artist-printmaker whose etchings and linocuts are in private and public collections. She is the author of several scholarly papers on American historical prints.

AMY S. DOHERTY is University Archivist at Syracuse University. She is actively researching and writing about nineteenth-century American women photographers.

ELTON W. HALL, formerly curator of the Old Dartmouth Historical Society and Whaling Museum at New Bedford, Massachusetts, is the author of numerous papers relating to American prints and the editor of the book *American Maritime Prints* (1985).

BETTINA A. NORTON is director of the Cambridge Historical Society, Cambridge, Massachusetts. She is the author of numerous articles on American graphic art and social history, and the book *Edwin Whitefield: Nineteenth-century North American Scenery* (1977).

BERNARD REILLY is the Library of Congress's curator for historical prints and drawings, and has published extensively in the areas of political art and American documentary prints and drawings.

JOHN W. REPS is Professor of City and Regional Planning at Cornell University, where he has taught since 1952. He is the author of several books on the history of American planning and urban iconography, of which the most recent is *Views and Viewmakers of Urban America* (1984).

WENDY SHADWELL has been Curator of Prints at the New-York Historical Society since 1974. She is author of *American Printmaking: The First 150 Years* (1969) and of numerous articles on American historical prints.

DAVID TATHAM is Professor of Fine Arts at Syracuse University and the author of many articles, reviews, and exhibition catalogues concerning American art. His book, *The Lure of the Striped Pig* (1973), is a study of the illustration of printed music.

PREFACE

This collection of essays is drawn from the program of original papers presented at a conference on the history of prints pertaining to New York State between 1825 and 1940. The conference was held in Syracuse, New York, on May 14–16, 1981, sponsored jointly by the Department of Fine Arts of Syracuse University's College of Arts and Sciences, Everson Museum of Art, and the Erie Canal Museum, and funded in part by a grant from the New York Council for the Humanities.

More than a hundred scholars, curators, collectors, local historians, printmakers, print dealers, and others interested in the history of the pictorial graphic arts in America attended the conference. The sessions of scholarly papers were enhanced by three historical exhibitions mounted especially for the occasion. These were "Bolton Brown, Lithographer" at Syracuse University's Lowe Art Gallery, for which a catalogue was published; "Bird's Eye Views of New York Canal Towns" at the Canal Museum; and "American Prints from the Permanent Collection" at the Everson Museum. To demonstrate that the art of printmaking remained alive and well in upstate New York, the Onondaga County Public Library exhibited recent work by local graphic artists in its nineteen branch libraries.

The history of prints has been, until the 1970s, the least studied and understood aspect of the history of art in North America. It is a history more deeply rooted in popular culture and more closely tied, for a long time, to the world of commerce, than the other arts. The usually small scale, sometimes ephemeral, and often highly subtle (or highly unsubtle) nature of prints makes it easy to overlook them.

The purpose of the conference was to add to the rapidly growing body of documentary and interpretive information about American prints of many kinds. The papers presented at the conference made a powerful impact. They brought to life and fleshed out figures who had previously been little more than names, established facts that corrected long-held erroneous assumptions, introduced many prints of exceptional interest that had remained out of public view for generations, and provided a rich, new context for many familiar images. All of the papers included here have been revised for publication.

Thanks are due to the authors for their cooperation in preparing manuscripts. The staff of the New York Council for the Humanities contributed much helpful advice for promoting the conference and Dean (now Vice-Chancellor) Gershon Vincow of Syracuse University supported the program in word and deed. Thanks are also due to many of the persons who helped in planning the conference and overseeing its successful unfolding. Among these were Lynette Jentoff-Nilsen, Director, and Todd Weseloh, Librarian, of the Erie Canal Museum; Ronald Kuchta, Director, and Ross Anderson, Curator, of Everson Museum of Art; Joseph Scala, Director of the Lowe Art Gallery, Syracuse University; Domenic Iacono, Curator of the Syracuse University Art Collection; Alice Hemenway, Director of the Regional Conference for Historical Agencies; and many of my associates at Syracuse University including Professors Stanton Catlin, Alfred T. Colette, Donald Cortese, and Bruce Manwaring, and graduate students Rebecca Lawton, Rosemary Romano, and Cynthia Snodgrass. Shirley McInerney, Ann Wagner and Claudia Weiss provided resourceful secretarial help, and Donald Pulfer expertly managed many of the conference arrangements. Marcia Lawrence ably assisted in the final preparation of the manuscript. Cleota Reed took time from her own scholarly work to supply indispensable assistance at every stage from the inception of the project to the reading of proofs.

The conference was the twelfth in a series concerning the history of prints in North America that began at the Winterthur Museum in 1970 and has met annually ever since in various locations in the United States and Canada. A comprehensive list of the conferences and their publications will be found at the back of this book.

David Tatham

Syracuse University
Fall 1985

Prints and Printmakers of New York State, 1825–1940

INTRODUCTION

DAVID TATHAM

The year 1825 was one of singular importance in the development of nineteenth-century American culture. Such momentous events of that year as the opening of the Erie Canal and the conclusion of the Marquis de Lafayette's tour of the United States as "The Nation's Guest" are well known, and their influences on many aspects of Jacksonian society have been closely examined. But other events, largely unheralded in 1825 and often inadequately comprehended since, also had far-reaching consequences for American life and thought. Among these was the introduction to the United States of lithography as a means of pictorial printing.[1]

Printmaking in America up to 1825 had been almost entirely an artisan's craft. With the arrival of lithography, thought began to stir that printmaking in America might also be a fine art. Though lithography developed throughout the rest of the nineteenth century largely through its commercial applications, its reputation as a medium especially well suited for artistic expression persisted. In the twentieth century its development has been phenomenal. The photo-offset process that has produced the illustrations for this book, and that has been in near-universal use for pictorial reproduction since the 1960s, is a direct descendant of the means of printing from flat-surfaced blocks of limestone that was discovered in Europe at the end of the eighteenth century, named lithography, and brought to America little more than a quarter of a century later.

The history of American prints from 1825 to the present is enormously rich. It embraces much more than lithography, of course, since one of the results of the introduction of that process was the revitalization of the older processes of

copperplate engraving and woodblock cutting. Wave after wave of advances in the technology of printing and papermaking, changes in graphic styles, shifts in thinking about how prints are used, and the lack of clear distinctions between "fine" art and "popular" or "applied" art, have made the history of prints in all media quite different from the history of painting in America.

In the early decades of the twentieth century, the first attempts to study the history of American prints arose from the need of collectors, curators, and antiquarians to make sense of the vast body of printed pictures that seemed to document, directly and indirectly, so much of the American past. The serious study of these prints has grown rapidly since the 1960s.[2] The authors of the essays published in this collection have contributed to this substantial body of scholarship by identifying important but hitherto insufficiently studied aspects of the graphic arts and treating them authoritatively. Their subjects concern prints in New York State, whose great metropolitan city was, after 1825, the acknowledged center of nearly everything important in the graphic arts in the United States. There were other vital centers of commercial and artistic printmaking, but they all remained in New York City's shadow until well into the twentieth-century.

The introduction of lithography into America in 1825 occurred nearly simultaneously in Boston and New York. Because the history of early lithography in Boston has been extensively documented through the work of several scholars and collectors, that city has come to seem the more important of the two early centers.[3] John Carbonell redresses this misconception in his study of New York's first lithographer, Anthony Imbert, and demonstrates that early lithography in New York was even more closely allied with the fine arts than the early efforts in Boston.

The production of art or "framing" prints was rarely sufficient to keep a lithographic printing house in business for long. The notable exception to this rule was the firm of Currier and Ives, the most widely known of American lithographic houses in the nineteenth century, and the least typical.[4] Virtually all other lithographers survived on commercial work of great variety, some of it as interesting as illustrations for books and printed music, and some as routine as billheads and labels. The lithographic draftsmen associated with the shops that by the 1840s had sprung up in more than a dozen cities, were first and foremost

copyists. They adapted designs from many sources including, after 1840, photographs. But some of them were also capable of interesting original work. Their level of draftsmanship was not as high as in the lithographic shops of France, but it was enlivened by some distinctively American subjects and a sometimes quasi-primitive Jacksonian democratic style.

The lithographic shops of the period were modest in size, usually managed by an owner who perhaps had a silent partner or two. The owner employed a few pressmen, some draftsmen, a bookkeeper, apprentices, and a few lads for pickup and delivery. Since many printers were also publishers in these years, the shop's street-front windows often displayed the products of its presses. The dual function of printing and publishing, uncommon in the twentieth century, was an eminently practical arrangement in the small scale enterprises of the first half of the nineteenth century. Shops "put on stone" (i.e., copied and often improved) sketches, drawings, and other pictorial matter brought to them from many sources; they originated their own prints, thus keeping busy presses and draftsmen who might otherwise be idle; and they printed stones with drawings already on them brought to them by independent lithographic artists. The shop might or might not be the actual or nominal publisher of the prints in any of these cases, but when the shop's name appears in a lithograph's imprint, it is nearly always certain that the shop printed it. The term "lithographer" loosely embraced original artists, copyists on stone, printers, and shop owners alike.

Georgia Bumgardner's study of New York City's Endicott shop provides a glimpse of the life of one of the most successful shops of the era. The Endicott shop was characteristic of its time in taking on a great variety of jobs for many commercial customers, in addition to publishing its own line of framing prints. A few shops took a more narrow course. Nancy Davison's discussion of one of the major satiric artists of the era, E. W. Clay, also brings to the fore a publisher who specialized in political caricatures, Henry R. Robinson. The speed with which a lithograph could be created from start to finish made it a superior medium for fast-breaking and short-lived political subjects—superior, that is, to the older printmaking processes of copperplate engraving and woodblock cutting.

In the 1830s and 1840s, technological advances enhanced the usefulness of these older processes. Improvements in the steel facing of copperplate engravings and etchings made them capable of large-volume work. The invention of the electrotype made it possible to print type-metal replicas of finely engraved woodblocks on cylinder presses in many thousands of impressions. Each process dominated a certain range of uses. Intaglio (copperplate) work remained the

preferred, though costly, medium for the reproduction of works of fine art until well after the Civil War. Relief (wood cut and wood engraving) work, because it could be easily set with moveable type, was widely used for book and magazine illustration. Lithography lent itself to the widest number of applications and was the only process capable, beginning in the mid-1840s, of effective color printing. It was, excepting the aquatint and mezzotint forms of intaglio, neither of which was practically feasible for commercial work, the only tonal medium, and alone was capable of directly reproducing a draftsman's work. In intaglio and relief work, tonal drawings were normally translated into lines.

American printmaking in the ante-bellum years developed in complex relationship to a multitude of economic, geographic, and other cultural factors. The prodigious growth of the built environment—the conversion of wild nature into a pastoral landscape, villages into towns, and towns into cities, all within a long generation—cried out for documentation. A sense of pride in place supporting the flourishing business in town and city views is examined by John Reps in his survey of the makers, sellers, and buyers of this popular nineteenth-century genre. A more personal sense of pride in accomplishment lay behind the set of eight lithographs designed by Salathiel Ellis to document the appearances of an important mining enterprise and its impact on St. Lawrence County in the 1830s. Wendy Shadwell's detective work in tracing the history of this exceedingly rare set of prints demonstrates how effectively the information preserved in printed images, imprints, and captions can illuminate biographical, geographical, technological, and artistic aspects of cultural history.

Pride of accomplishment in scientific, engineering, and technological matters, coupled with an interest in self promotion, spawned a great many views of buildings, shops, and other man-made objects in the middle decades of the century. The view of the Lewiston and Queenston suspension bridge over the Niagara River is one such example. As Bettina Norton shows, a single impression of a print can have a life entirely of its own. In this instance an inscription made in 1851, recording the remarks of an American Indian whose ancestral home had been in the environs of the bridge, introduces issues not apparent in the print's image.

The lithographed views examined by Reps, Shadwell, and Norton have more historical than artistic interest, and it is easy to fall prey to the notion that popular printmaking of the era allowed little outlet for original talent. This was not quite the case. Before turning to some of the more important outlets for

graphic expression, however, it will be best to consider the remarkable—but, oddly enough, little-remarked-on—improvement in the general level of drafts-manship that occured very rapidly in America in the late 1840s and early 1850s. There were two causes for this. The first was an influx of young, well-trained graphic artists from the failed revolutions of the late 1840s in Europe. Especially from Germany and France came first-rate lithographic draftsmen. Their pres-ence elevated the general standard of drawing and obliged native graphic artists to match it. The second reason for the marked improvement in the quality of drawing in American prints around 1850 was the introduction on a grand scale of illustrated weekly magazines intended for a large, nationwide readership. The "pictorial press," as this species of publication came to be known, depended on the availability of a fresh lot of skillful, interesting illustrations every seven days. *Gleason's, Frank Leslie's,* and, beginning in 1855, *Harper's Weekly* were among the best known of their kind. Their illustrations, which were engraved in wood and printed from electrotypes, closely followed the styles of the English pictorial press, styles that required a high level of competence in drawing. The demand for artists brought about by the weeklies' insatiable appetites for new and news-worthy drawings lured able young draftsmen such as Winslow Homer away from lithography and into the realm of wood-engraved illustration.

Because the illustrators of the weeklies almost never engraved the blocks they drew on—artisan engravers attended to that—it has been common to view wood engravings published in the pictorial press as something other than origi-nal prints. Without question, a lithograph drawn on stone by an artist is more completely his or her work than a wood engraving in which the drawing on the surface of the block is transformed into a series of lines by a team of wood engravers. Still, the illustrations published in the pictorial press constitute a very large and very rich body of graphic art, and one that has received less serious attention than it deserves.

Bernard Reilly examines one of the hallmarks of the early pictorial press—graphic humor—as it developed in New York in the 1850s in both lithography and wood engraving. Satire and low comedy have long been a dis-tinguished part of the history of prints. The work of Hogarth, Gillray, and Cruikshank in England, and Daumier in France, among others, was well known to most graphic artists in America. The distinctive quality of American graphic humor arose from many things, including the democratic outlook of the culture, the experience of immigrants in a new land, such traditions of American oral

humor as the "tall tale," and regional and racial dialects. Graphic humor was encouraged by guarantees of freedom of expression that made censorship, especially of political subjects, nearly impossible.

Much of the humor was regional in subject, though meant for national consumption. In his essay, Edward Comstock considers a little-known body of humorous wood engravings relating to the Adirondack region of New York State, a region which by the 1870s had gained a national reputation as a splendid locale for hunting, fishing, and communing with nature.

In the 1870s, the first of a series of consciously "fine art" movements in American printmaking gathered genteel force. This was the etching revival. There had, in fact, never been a significant earlier practice of etching as a fine art in America to revive, but the American movement saw itself as part of the European-centered revival of interest in the art of etching as it had been practiced by Rembrandt and other masters of the past. The contemporary work of James A. McNeil Whistler, a key figure in the revival in England, set a standard never attained in America, but it inspired many American painters to turn to etching as a second medium of expression, as he had done. For the first time since the 1820s, American fine artists approached printmaking with eagerness and a sense of adventure, not only in the United States but in Canada as well.

For the most part, American etchers of the period sought a delicacy and subtlety of expression that had never previously been seen in American printmaking. They avoided popular subjects. Humor was virtually absent. The revival was part of the international aesthetic movement that had arisen in Europe in the second half of the nineteenth-century in reaction to the mass-produced, machine-made products of the new industrial society. Elton Hall illuminates the thinking of some of the central figures of the revival in America through his study of the New York Etching Club, and introduces us to some of the unpublished correspondence of R. Swain Gifford, a leading light of the movement.

The popularity of the etching revival in America lasted long enough, from the late 1870s into the 1890s, to establish a firm distinction between fine prints and popular or commercial prints. The division was strengthened in the 1880s and 1890s by the elevation of wood engraving to a fine print medium by Timothy Cole and others, who sought a painter-etcher sensitivity in their treatment of the block. They printed directly from the block rather than from electrotypes, and like the etchers, printed on a variety of art papers. By the 1880s, American art dealers had begun to sell fine etchings and wood engravings.

The revival of lithography as a fine-print medium took longer, perhaps because the ever-more-ubiquitous lithograph had, by the end of the century, become associated almost entirely with commercial pictorialism. A medium so closely tied to the mass-production of theater posters, sheet music covers, and cigar bands seemed beyond redemption. Yet by returning to the hand-press circumstances in which Imbert had worked in 1825, a few artists redeemed the art. As Clinton Adams shows, Bolton Brown became one of the great figures of the revival of interest in lithography as a medium for original fine prints.

In all of these revivals, the printmaker controlled the work from inception to completion. The term printmaker now came almost exclusively to be applied to persons who were able artists, capable of putting their own drawings on the plate, block, or stone, and often capable also of printing them. The interest in fine printmaking proved durable. Beginning in the late 1920s, Woodstock, New York, one of the most important American summer art colonies, became a busy center for lithographic printmaking. Grant Arnold went to the village in 1930 to print the drawings of others and began a decade's association with many notable figures of the era. He drew and printed his own work as well.

During the years of the development of fine print traditions in America, photomechanical processes began to shoulder the increasingly heavy load of pictorial reproduction for mass publication. The illustration of books and weeklies that once depended largely on wood engravings now became the task of photographers. Their images were converted into ink-printing matrices by photo engraving or other processes that preserved the appearances of the original photographic prints. Amy Doherty discusses one important instance in her examination of the use of Grace Woodworth's portrait photograph of Susan B. Anthony as a book illustration.

By the 1930s, the three major printmaking processes had reached maturity in America. The prints that came off the presses were no longer revivals of anything in the past nor echoes of European tastes. Printmaking had, with its sister art, painting, gained a broad following as it undertook American scene and regionalist subjects, and as the federal government through its W.P.A. program encouraged artists to work as printmakers and facilitated the placement of their work in museums, libraries, and schools.[5]

In all of this, New York State remained the center. Only after the 1940s, when university printmaking studios of great distinction began to be formed across the continent and the center of gravity in the pictorial arts began to move westward, did New York's hegemony weaken. At the same time, new ways of

manipulating printing surfaces, of mixing media, and of obtaining images, not to mention new ways of thinking about how and why prints communicate visual information, made the second half of the twentieth century very different from the first. The history of printmaking in America, exemplified above all in what happened in the Empire State, can be seen as a complex but consistent development of ideas, processes, and styles over a long era, from the Jacksonian period to World War II, when a new era began. The papers that follow, each using a different angle of vision, allow us to see the development of that first era of richly varied achievements more clearly.

NOTES

1. Attempts to introduce lithographic printing to the United States occurred as early as 1807. These earliest known attempts, from which no prints seem to have survived, are described in Philip J. Weimerskirch, "Naturalists and the Beginnings of Lithography in America," in *From Linnaeus to Darwin: Commentaries on the History of Biology and Geology* (London: Society for the History of Natural Science, 1985), pp. 167–77. The first lithograph published in America is generally conceded to be one by Bass Otis in the *Analectic Magazine* for July 1819. William Barnet and Isaac Doolittle working as partners opened the first American lithographic printing shop in New York in 1821, but it survived for only a year or so. Henry Stone in Washington, D.C., was briefly active as a lithographer around 1823. These amounted to false starts, however, and had no appreciable influence on the graphic arts of their time. Only with the establishment of the Imbert shop in New York and the Pendleton shop in Boston, both in 1825, did the continuing, successful practice of the process begin.

2. The series of North American print conferences listed in the appendix, and their publications, have contributed much to this growth. So also have *Imprint,* the journal of the American Historical Print Collector's Society, the attention paid to American prints in the *American Art Journal* and the *Print Collector's Newsletter,* and many exhibition catalogues.

3. The pioneering research of Charles Henry Taylor on Boston lithographers is summarized in "Some Notes on Early American Lithography," *Proceedings of the American Antiquarian Society* 32 (April 1922): 68–80. It is supplemented by Harry T. Peters, *America on Stone* (New York: Doubleday, 1931), though both accounts include errors and inaccuracies that more recent research has corrected.

4. For a summary of the differences between the operating philosophies of Currier & Ives and other printers and publishers of lithographs, see my brief discussion of Nathaniel Currier's shop in "John Henry Bufford, American Lithographer," *Proceedings of the American Antiquarian Society* 86 (April 1976): 66–67.

5. The essential introduction to the acceptance of lithography as a medium for serious art and its development thereafter is Clinton Adams, *American Lithographers, 1900–1960* (Albuquerque: University of New Mexico Press, 1983). Among other recent studies of twentieth-century prints, one of the most thoughtful, encompassing work in all media is Richard S. Field, et al., *American Prints 1900–1950*, exhibition catalogue (New Haven: Yale University Art Gallery, 1983).

1

Anthony Imbert
New York's Pioneer Lithographer

JOHN CARBONELL

In 1824, more than twenty years after the death of his friend George Washington, the Marquis de Lafayette returned to America for a tour of remembrance and tribute. The pageantry of his landing in New York on August 16th was reported throughout the nation, and in due course several prints of the scene were issued. One of these, engraved by Samuel Maverick in New York, was based on a design by Lafayette's fellow-countryman, Anthony Imbert, presumably an eyewitness to the event.[1] There is no record of Imbert's presence in the United States prior to this, so it is possible that he arrived with Lafayette and had some official connection with the entourage. Lafayette returned to France early in 1825, but Imbert did not; he spent the remaining ten years of his life in New York, becoming in that time the outstanding American commercial lithographer of his generation. His accomplishments, hitherto largely unrecorded in the literature of the graphic arts, are important in the general history of American printmaking.

Little is known of Imbert's pre-American career. He was born in 1794 or 1795.[2] It is reported that he was from Calais, served as a first lieutenant in the French navy during the Napoleonic wars, was captured by the British off Dover on February 23, 1810, and was a prisoner at Chatham until released on May 20, 1814, when, if his presumed date of birth is accurate, he would still have been less than twenty years old.[3] It is also said that during this confinement he studied drawing and painting, although no pre-American works have been located. Nothing is known of his life or whereabouts between 1814 and 1824, and he may

well have returned to service at sea; in fact, he might have been an officer on the Cadmus, the ship that brought Lafayette.

The first definite record of Imbert's presence in New York is provided by Longworth's 1825 directory (published in the summer of that year) which identifies him as a "painter" at 146 Fulton Street. Even if Imbert had not arrived with Lafayette's party, he might, as a freelance artist, have sought to profit from the exhibition or sale of topical pictures limelighted by his countryman's presence. *The New-York American* for October 9, 1824, contains the following advertisement: "*A Painting*, representing a View of the Landing of General Lafayette at the Battery, is now exhibiting in Broadway, opposite the City Hotel." This is the same subject as the Imbert/Maverick print. The identity of the artist, unfortunately, is not disclosed, but if this painting was by Imbert, it could well have been the source of the Imbert/Maverick engraving. A work such as this was only one of the many artifacts and events, spawned by Lafayette's popularity, which bombarded the viewing, listening, and purchasing public of the time.[4]

There is reliable evidence that Imbert had established his lithographic press in New York by mid-October 1825. The editorial in *The New-York Evening Post* on October 15, after reviewing the advent and nature of lithography and remarking that "a number of beautiful specimens . . . are to be seen at Doyle's book store" (without saying of what or by whom), took a unexpected turn. Instead of providing the usual positive promotion of the new medium, the editor worried gloomily about its potential for misuse by forgers and other subversives, so that when, referring to Imbert's new enterprise, he then announced "there is now a lithographic press in operation in this city," it sounded like a warning to all law-abiding citizens. Imbert must have been relieved when, after he placed his first advertisements in the New York papers on or about November 8, 1825, he received another, less alarmed mention. On November 9, the editor of *The New-York American* observed: "The Lithographic Press recently established in this city, (of which the advertisement will be seen in the proper place) has produced a very spirited piece representing the tomb of Napoleon on the rock of St. Helena, around which the departed spirits of French soldiers are seen to mourn. This engraving may be seen and purchased at 116 Beekman-street." This was Imbert's address.

Apart from a few isolated notices such as these, however, there is no account of the establishment of Imbert's press. It is at times like this that one especially regrets the premature death of the lithographer Moses Swett. The early historian of American art, William Dunlap, in his diary for November 1833

reports that Swett showed him some notes for a history of American lithography, but, unfortunately, nothing of the project seems to have survived. Swett was particularly well qualified to write on the subject, having worked in early lithographic companies in Boston, Baltimore, and New York, and there is every reason to suppose that he was well acquainted with Imbert and his associates. (Dunlap's diary for the decade 1822–32, the crucial years for the development of lithography in the United States, is lost.) In the absence of answers which Swett and Dunlap could have provided, the questions multiply. What, if any, was Imbert's lithographic experience prior to 1825? Who else was involved in his press? Where and when did he obtain his lithographic equipment? An elaboration of this list would reveal how much is still to be discovered.

We do know that Imbert was not the first commercial lithographer in New York. There was at least one functioning if shortlived press there as early as 1821, Barnet and Doolittle's,[5] and before the end of 1824 the engraver Peter Maverick had also produced a few lithographs. It has been suggested that Prosper Desobry and the firm of Chanou and Desobry were also established as early as 1824, but this is questionable.[6]

Imbert's first advertisements identified his press as "Imbert & Co.," and this imprint was not dropped until sometime in 1826. If being a "company" was not just an inflated title but meant that Imbert had formal associates when he set up the press, two men who might have been involved were the artists C. Des Essarts (fl. 1825) and E. Rousseau (fl. 1825–43). Almost nothing is known about Des Essarts. He may have been an itinerant French artist, perhaps the D. D. Des Essarts Groce and Wallace located in New Orleans in 1808.[7] Des Essarts' lithograph *Simon Bolivar Libertator* (figure 1.1) has the imprint "New York. Published by Imbert & Co. Lithographic Printers. Fulton St.," and is the only located Imbert print which mentions the Fulton Street address. It is not known whether this lithograph was produced before or after the scene at Napoleon's tomb said to have been available at 116 Beekman Street in November 1825. In fact, no Imbert prints which mention Beekman Street have been discovered, even though he was still advertising from there as late as February 1826. By the time Longworth's directory appeared in the summer of 1826, Imbert's "lithographic office" was at 79 Murray Street, and other evidence suggests he was there before June. The only other recorded work by Des Essarts is *Piercing the Ears,* a domestic scene, drawn and hand colored in a French style, imprinted "A. Imbert litho New York 1825."

More is known about Rousseau, whose name is given variously as Edme or

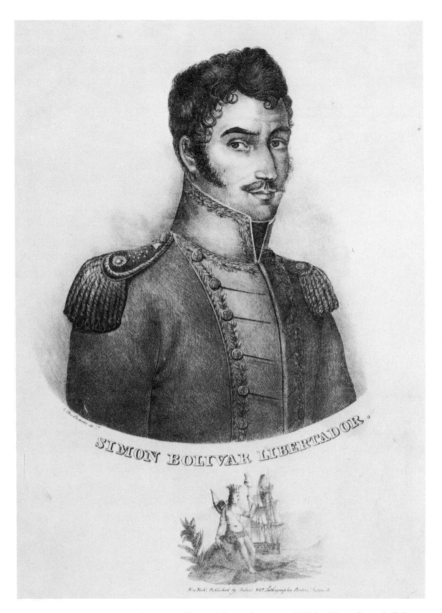

1.1. C. Des Essarts, *Simon Bolivar Libertador*, ca. 1825. Uncolored lithograph, 13 × 8⅝ in. "Published by Imbert & Co. Lithographic Printers, Fulton St." Private collection.

Edmund, and who first appears in Longworth's 1825 directory as a "merchant." Very shortly before Imbert placed his initial advertisements, Rousseau submitted this announcement, which was published in the biweekly issue of *The New-York American* for November 8, 1825: "*Academy of Drawing and Painting in Miniature.* M. Rousseau, Pupil of Augustin, the celebrated Miniature Painter in Paris, informs the amateurs of the fine arts that he has opened at his house, 18 Reed-st, a *School of Drawing and Painting in Miniature. . . .*" It went on to specify subjects and classes, noting that "Madame R" was also available as a French teacher to young ladies. It is evident from the surviving prints that Rousseau was associated with Imbert by 1825, if not earlier. There is an untitled lithograph of Castle Garden imprinted "Litho of Imbert & Co. New York. Rousseau delt [delineavit, "he drew it"] 1825," which seems to be one of a set of at least seven scenes by Rousseau-Imbert in a similar format (perhaps all of the environs of New York) which may have been bound or collected together as a book or portfolio.

At about the same time that Rousseau's first advertisement appeared, he was arranging the exhibition in New York of Jacques Louis David's painting of the Coronation of Napoleon, *Le Sacre.* In its editorial dated December 1, 1825, *The New-York American* noted: "This great work has only just arrived; but is, we understand, in preparation, and it will be exhibited as soon as it can be got ready, and a favorable position be found for it." A little later the same paper ran the following announcement: "Exhibition, at the Gallery of the Academy of Fine Arts, of the splendid Picture representing the great CORONATION OF THE EMPEROR NAPOLEON, . . . by the celebrated painter, DAVID. . . . The first exhibition to begin Monday night, January 2d, 1826. . . ." The paper went on to give the exhibition a favorable review in its editorial for January 10, 1826, adding: "M. Rousseau, whose taste and skill as an instructor in drawing and painting, we have before had occasion to notice, and in whose charge this picture is, has issued proposals, which will be found at the gallery, for making a lithographic engraving of this fine picture. We cannot doubt that he will be abundantly encouraged."

Unfortunately the abundance of the encouragement is questionable, since no copy of such a print has been located. What did appear was a pamphlet guide "Notice, On the Picture of the Coronation of Napoleon" (most probably issued by Rousseau in New York late in 1825 or early in 1826) containing a plate ("lithography of Imbert & Co. New York") which was an outline sketch of the painting with a key to fifty-eight of its principal features. (Perhaps *this* was the "lithographic engraving" Rousseau announced, but it seems unlikely.) The *Notice* also included this prospectus:

"Lithographic Principles of Landscape Drawing, By E. Rousseau, Professor of Drawing & Painting in New York. This work will consist of fifty sheets, divided into ten numbers. The numbers, as they successively appear, will be sent to subscribers. Each will contain five drawings, and the price will be ONE dollar, payable on delivery. The price of the whole work will be—

> For subscribers, and Mr. Rousseau's pupils, $10.00
> For subscribers out of the city of New-York, $12.00
> For non-subscribers, $15.00

Subscription book is open at the door of the exhibition room of Napoleon's Coronation; OR, Subscriptions can be forwarded (post paid,) to Mr. ROUSSEAU, 310½ Broadway, in New-York."

Apparently this project was also less than abundantly encouraged as its progress was slow. In an advertisement placed a year later, on January 9, 1827, Rousseau reported: "The work is begun, and will be continued as soon as the number of subscribers shall be great enough to cover the expenses." In October an Imbert announcement stated that three numbers of Rousseau's work had been delivered and the subscription book was almost full, but it seems unlikely that the series was completed. All that seem to have survived are a few separate plates; the highest number noted on these is twenty-one, which implies that at least five of the proposed ten parts were eventually published.

Imbert's early connection with Des Essarts and his more enduring relationship with Rousseau (whether or not either of them was formally a part of Imbert and Company) bring out an obvious but important fact that tends to be obscured by Imbert's later career: his Frenchness. Rousseau and probably Des Essarts were also French. It is certainly appropriate, given Imbert's service in the Napoleonic wars, that the first Imbert lithograph of which there is a contemporary account is the mourning scene at St. Helena, and that other Imbert prints depict Napoleon, including an early Imbert and Company portrait by Rousseau. And, as has been mentioned, Rousseau was also the custodian of David's *Le Sacre* in New York, with which Imbert was involved as the printer of the key to it. Other artists, probably French, who worked with Imbert in the early years included Felix Duponchel and one "Victor." More generally, the interest and good will surrounding Lafayette's tour, which was both a reminder and creator of bonds between France and the United States, was a boost to all things French in

America, and was particularly helpful to French art and artists. Lithography was definitely included in this.

Because Imbert so quickly became an American businessman, it is necessary to stress his nationality and his early links with other French artists. He was, after all, setting up as a commercial lithographic printer, and it was important for his success that he secure good standing in the native artistic establishment and attract a general clientele. What Imbert's fledgling business most needed was a quick breakthrough, consisting ideally of a well-connected patron, a substantial and profitable commission, and some attendant publicity. And for once it seemed that a beginning lithographer's prayers were answered.

The patron was Archibald Robertson (1765–1835) a successful artist of Scottish origin who was at the time secretary of the American Academy of the Fine Arts. Robertson had been invited by the Committee of Arrangements for the celebration in New York City of the opening of the Erie Canal, to head the "Department of the Fine Arts" that would, among other tasks, prepare the illustrations for the commemorative book that was to record the proceedings. The work which resulted, the *Memoir,* included more than thirty-five Imbert lithographs, plus a "Report" by Robertson on the work of his "Department". The report, unfortunately, is as frustrating for what it does not contain as it is useful for what it does.[8]

One of the particular disappointments of Robertson's "Report" is that, although he worked closely with Imbert on the production of the lithographs for the *Memoir,* he tells us very little about the man or his firm. He identifies Imbert only as a "Marine Artist" who was "originally . . . a French Naval Officer," and discloses that he employed as an assistant one "Signore Cuppa, pronounced *Anglice* Coopa," about whom nothing more is known. On the positive side, Robertson did note and give specific credit to the artists and artisans involved in the various plates, as well as provide a great deal of information (and some misinformation) of other kinds. (Regarding Imbert, he claims on page 353 that the plate of *The Plan of the Fleet* "was the first test of Mr. Imbert's talents as a Lithographer, and Lithographic Printer," meaning that this was Imbert's first trial under Robertson's supervision. Robertson's statement, however, has also given rise to the mistaken belief that Imbert's work on the *Memoir* plates were his first lithographic efforts.) Robertson declared that Imbert's "first test" proved "satisfactory" and proceeded to assign him "a much more difficult task," the lithographic title page to the Appendix of the *Memoir,* which he graded as "not quite equal to copperplate" but "to be admired" nonetheless. In general, his

review of the prints in the *Memoir* reveals that while Imbert was involved in designing and drawing some of the plates, his main responsibility was to oversee the printing of all the lithographs, and these (despite Robertson's faint praise) stand as conclusive evidence of Imbert's considerable competence at this early stage in his career.

The most conspicuous lithograph in the *Memoir* is a sizeable folding plate, approximately one hundred centimeters long, showing the scene in New York harbor during the celebration. It was designed by Robertson and drawn on stone by Imbert (who drew and lithographed the shipping) with help from Robertson and Felix Duponchel. Despite its dark tones, it deserves commendation as the first large-view lithograph produced in the United States.[9]

The other lithographs in the *Memoir* are a strange assortment. Perhaps the best known are six views, "drawn from nature and lithographed" by George Catlin early in his career, which show the construction of the Erie Canal and the city at its western terminus, Buffalo. Interestingly, his two views of Buffalo exist in two states, in the second of which each scene is enlarged and more lightly sketched and printed. Catlin may have redrawn these himself but since the second states, unlike the first, do not credit him on the print, it seems more likely that they were reworked by someone else, perhaps Imbert.[10]

Another well-known group of plates in the *Memoir* show the men and equipment of the fire companies that went on parade for the celebration. Robertson notes that the lithograph of Engine No. 15 by W. P. Morgan, a wood engraver who was a pupil of Alexander Anderson, "is lithographed in the ink style, and in lines, in imitation of Woodcut," and as such it is a precursor of the various ways in which later commercial lithographers simulated the more expensive or prestigious engraving processes. Of the several portraits in the *Memoir*, only the likeness of Richard Riker by Dominic Canova is a lithograph. (There are two states of this because the stone broke.) The portrait of DeWitt Clinton is an engraving by J. B. Longacre printed by Samuel Maverick after a painting by George Catlin, and it is interesting to compare this with Catlin's own portrait print of Clinton "drawn on stone from life" and separately published by Imbert. Unfortunately this has the characteristic fault of overdrawing or overinking of many of the Catlin-Imbert prints, affording Clinton a very swarthy complexion. Another engraved portrait in the *Memoir* is of Samuel L. Mitchell, by Asher B. Durand after a painting by J. W. Jarvis. This can be compared with another separately published Imbert lithograph of Mitchell, drawn on stone by Vistus

Balch after a painting by Benjamin Trott. Balch was an engraver, and this is believed to be his only lithograph.

The diversity of the Imbert lithographs in the *Memoir* reflects not only the many different artists who were involved, but also Robertson and Imbert's intention to use the plates to display the variety of lithographic techniques, especially the potential of transfer lithographs. The illustrations were designed explicitly to demonstrate and promote lithography as a manifold aesthetic and practical art. Imbert's own interest in the different technical possibilities is evident not only in his involvement with the *Memoir* plates (and in some of his subsequent prints), but also from Robertson's disclosure that he was deliberately restricting his own discussion because Imbert was "preparing a publication on the essential parts and uses of the Art of Lithography, which he is about to lay before the public with all convenient dispatch."

Regrettably, there is no record of such a work, so that Imbert's manual of American lithography, like Swett's history of American lithography, is a book we can only dream of. If it had appeared it would probably have closely resembled textbooks such as those of Senefelder, Englemann, or Hullmandel, all published in Europe, and perhaps it was the availability in New York of these as imports which altered Imbert's plans.

The publication of the *Memoir* was obviously a vital boost for Imbert's business. In the course of his "Report" Robertson went out of his way to proclaim that Imbert was the leading lithographer in New York, and the fact that some of his statements about lithography were false or exaggerated, and his unqualified endorsement of Imbert somewhat unfair to Imbert's competitors and predecessors, probably upset few besides Peter Maverick. An important part of this commercial pitch was directed to artists; they were encouraged to believe that this potent new medium was worth investigating. In Robertson's words, since the requisite "materials are always to be procured in every lithographic establishment, and as Mr. Imbert's is the only efficient one we know of in this city, we refer those who wish it to him, 79, Murray Street."[11] The fact that many professional and amateur artists did just this, whether as a response to Robertson or not, is significant to the subsequent history of Imbert as a lithographer.

Certainly the publicity that Imbert received from the publication of the *Memoir* occurred at a propitious time in the art life of New York. In the early 1820s the leading institution of culture was the American Academy of the Fine Arts, which was dominated by its longtime president, Colonel John Trumbull. It

was a loose organization of elected artists, other friends and patrons of the arts, and the socially prominent. But by mid-1825 a number of artists, both members and nonmembers, had reached the conclusion that the Academy did not serve them well, and sought instead an association, for professional artists only, that would provide adequate facilities for exhibitions, classes, and other activities. Trumbull opposed this nascent rival and in December 1825, accompanied by Archibald Robertson, he attended a meeting of the group to try to kill or absorb the project. He failed, and so early in 1826, when Robertson and Imbert were at work on the *Memoir*, the National Academy of Design came into being. This stirring and consequential event was both an effect and a contributing cause of more general changes that were taking place, including the growing interest of local artists in depicting American scenery, changes which were part of the basis for the emergence of New York as the artistic capital of the country.

Without doubt the exhilaration and ambitions of the group of artists who set up the National Academy, and those who were attracted to it, created a climate that benefited Imbert. Several of the initial members of the organization were early experimenters in the new-found art of lithography. Perhaps the most prominent of these was Thomas Cole, whose known Imbert lithographs reflect his interest in American landscape.[12] *Distant View of the Slides that Destroyed the Whilley* [sic] *Family. White Mountains* is imprinted "Cole delt. Imbert's Lithography." A second print titled *Falls at Catskill* does not have an imprint but is also most probably from Imbert's press and on stone by Cole, since impressions of both descended through Cole's family. Another artist who worked with Imbert was Gherlando Marsiglia, a professional portrait painter of Italian origin who was both a member of the American Academy and one of the founders of the National Academy. Marsiglia, like Cole, produced a striking Imbert lithograph of Catskill Falls after his own painting of the subject (figure 1.2), as well as two studies of Niagara and several portraits, all of a high standard. The fact that Cole, Marsiglia, and other Imbert artists produced prints of the Catskills is not surprising. The so-called "Hudson River School" of American painters, of whom Cole is usually considered the leader, could just as appropriately have been named the "Catskill Mountains School," and the growing interest of New York area artists in depicting their accessible "wilderness" is well represented in the surviving Imbert lithographs of the period.

A third Imbert lithograph of Catskill Falls, a larger hand-colored print, is by John Robert Murray (1775–1851), a competent amateur artist who was involved with Imbert in several projects. Murray was a New York businessman

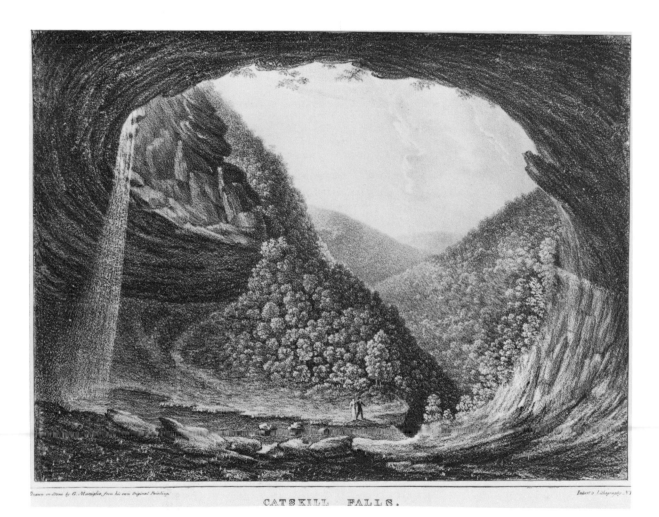

CATSKILL FALLS.

1.2. G. Marsiglia, *Catskill Falls,* ca. 1828. Uncolored lithograph, 10⅜ × 11 in. "Imbert's Lithography N.Y." Private collection.

from a prominent family, and was both a founder of the American Academy and an active participant in the proceedings which established the National Academy. (As an amateur he was ineligible for elected membership but was appointed an honorary member in 1839.) Murray apparently drew and lithographed a view of "Woodlawn, Seat of Lawrence Lewis near Mount Vernon," which shows the house with Lewis and Lafayette conversing in the grounds.[13] The printer is not identified, but it was probably Imbert, since Murray is not known to have worked with any other lithographer. In some respects the most interesting Murray-Imbert lithograph is a study of cattle and sheep drinking from a stream with the explicit imprint "Transferred to the Stone from an original drawing on paper by J. R. Murray, Esqr. Imbert's lithography 79 Murray St." (figure 1.3). This is one of several located transfer lithographs by Imbert (in addition to the demonstration plates in the *Memoir*); two others are views of Niagara and Trenton Falls, both marked "Imbert's litho transfer" with no indication of artist. Murray's transfer lithograph is pleasing proof that the technique was not just a textbook exercise and was put to use at the time. The print is successful, and although Murray's other lithographs do not so state, some of them (including the view of Catskill Falls) have a soft, unfocused tone which suggests that they too might be transfers. It is understandable why the transfer process—which, because of the double reversal involved, does not require the artist to draw a mirror-image of what will appear—might be particularly appealing to amateurs, or indeed any artist who wanted passable results without having to learn the skills of drawing on stone.

Murray and Imbert were also responsible for the plates in the first edition of C. S. Stewart's *Private Journal of a Voyage to the Pacific Ocean, and Residence at the Sandwich Islands,* which was published in New York early in 1828. On page 7 the author states: "the principal drawings—taken from sketches of my own, made at the Islands—are the production of an amateur of this city, with whose friendship I have the happiness to be honored." All the plates are from Imbert's press; one of them identifies Murray as the lithographic artist, while another is "Drawn by A. Imbert," but there are different states so that the collation of the book is problematic.

John R. Murray was not the only member of his family to work with Imbert. In 1827 Imbert produced *The American Toilet,* a small volume consisting of twenty lithographed leaves. Each page has the image of a boudoir or homely object incorporating a moveable flap which, when lifted, reveals the name of an associated virtue; for example, a picture of a clock covers the word "Regularity."

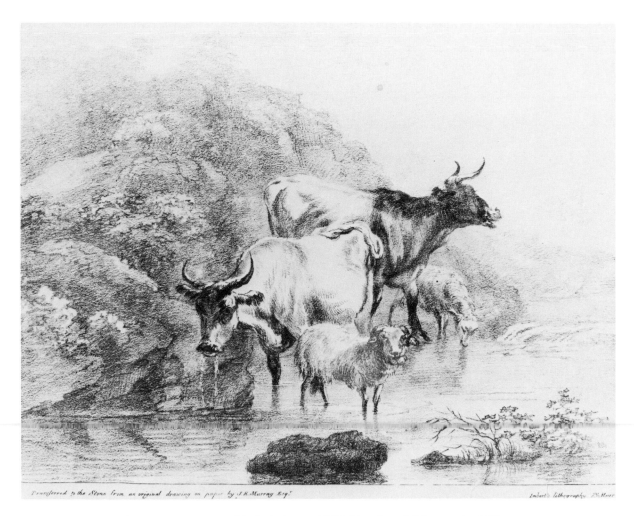

1.3. J. R. Murray, untitled study, ca. 1827. Uncolored lithograph, 10⅜ × 13⅝ in. "Imbert's lithography 79 Murray St." Private collection.

Although derivative from Stacey Grimaldi's *The Toilet,* first published in London in 1821, the American book was the work of his sisters Hannah Lindley Murray and Mary Murray. Neither of them is credited in the book itself, which was copyrighted by George Tracy, and the nature and extent of their involvement in its production is unclear. A second, "improved" edition was also issued in 1827 for seventy-five cents a copy (the first cost fifty cents), and copies of each were available colored or uncolored. The publication of a second edition indicates some success, and the work was undoubtedly bought as a novelty, since it is probably the first American book to contain transformation plates. It began something of a tradition; its only direct descendant is an 1867 edition published in Washington, D.C.,[14] but more distant relatives abound, including the splendid *My Lady's Casket of Jewels and Flowers for her Adorning,* published in Boston in 1885.

If the *Memoir,* which was issued sometime after July 3, 1826, was the first major project undertaken by Imbert's press, the second was the attempt in 1827 to publish a series of views of American architecture lithographed by Alexander Jackson Davis (1803–92). Davis must have been one of Imbert's first artist associates. The earliest Imbert advertisements (as noted) appeared about November 8, 1825; Davis recorded in his memorandum book that on November 15, he quit his job at a printer's "and took up the profession of Lithographer," and goes on to report that he "Painted a view of Castle Garden from Greenwich Street and copied it on stone for a Lithographer Nov. 24, 1825." Almost certainly this print is *Castle Garden, New York* with the clumsy imprint "Alex J. Davis, desigt. and Engt. Lithograph Lithographic Press of Imbert & Co. New York."[15] This lithograph is probably Davis's first, and is also one of the earliest (but not the first) from Imbert's press. The only other Imbert prints so far known to have been produced in 1825, apart from some of the *Memoir* plates, are the unlocated St. Helena scene, and those already mentioned by Des Essarts and Rousseau.

Davis's records do not reveal any work with Imbert in 1826, but in 1827 he began an ambitious series of lithographs titled *Views of Public Buildings, Edifices and Monuments, in the Principal Cities of the United States.*[16] Imbert was the proprietor of the project and his plan was to sell the Davis views either individually, or to subscribers in parts containing four prints each, with a separate title page for each city depicted and a general title page for the whole work. Davis drew the first four lithographs in August 1827.[17] In *The New-York American* for August 10, 1827, the following advertisement appeared: "Public Buildings of New-York, embracing, at present very correct views of the Exchange, Branch Bank, Bowery Theatre, and Masonic Hall. The above were drawn on stone by A. J. Davis, and

executed at the Lithographic Office of A. Innbert [sic]. The attention of a patriotic and liberal public is invited to the above productions, which may be purchased at BOURNE'S, 359 Broadway."

In retrospect it is ironic that George Melksham Bourne should have advertised Imbert's production. Although he had been in business in New York for only a few months, Bourne, who was listed as one of the agents for the work on the general title page, quickly developed into an aggressive and threatening competitor to the local lithographers.

Davis completed the second four lithographs in October 1827. Unfortunately, after these first two sets of New York views were issued, the project was given up, presumably for lack of support. This failure must have been particularly discouraging to Imbert. The poor showing of Rousseau's subscription publications, which were begun early in Imbert's career, could be discounted in a number of ways, but the Davis-Imbert *Public Buildings* series, undertaken after he was well established, consisted of prints of a very high quality. They were of a kind that should have appealed to mainstream civic and national pride. Imbert never again attempted a subscription publication.

The reluctance of many potential customers to patronize projects such as the *Public Buildings* lithographs was probably due in some measure to that ubiquitous bias against local talent which has plagued American artists and artisans: the assumption that truly fine art is foreign art. During the 1820s entrepreneurs such as Bourne were active importers of prints, advertising them in a manner and at prices which bespoke their presumed superiority. In March 1828, for example, in one of a barrage of announcements, Bourne noted that he had recently received from France an aquatint of David's *Le Sacre*. If, earlier, Rousseau had succeeded in publishing his subscription lithograph of this painting, it would probably have sold for a dollar or two; Bourne's engraving, on the other hand, was available for forty-five dollars, a very substantial sum at that time. (It was probably bought by some "connoisseur," glad to exhibit discriminating taste in the "fine" arts, who might not have considered spending the mere four dollars required to purchase the entire set of Davis-Imbert New York views. In general, this preference for European prints effectively hampered local printmakers and publishers. While in all fairness few of their works in the 1820s, especially the lithographs, could stand comparison with the best of the imports, it is surprising that the Davis-Imbert architectural views, which were genuinely exceptional in subject matter and quality, received so little support.

The lesson in all of this for Imbert was clear enough; if the public would

not buy his better "framing" prints, he would have to go "down market." This meant publishing less expensive goods which undercut or bypassed "fine prints" and other imports—in the main, items of a more ephemeral nature, including sheet music, caricature and comic prints of local concern, and scrapbook images and novelties. Whereas in 1827 Imbert advertisements highlighted his more ambitious publications (the better prints, view series, books, and other works), their substance and tone were quite different after 1830. For example, *The New-York American* on January 4, 1831, contained the following: "*New Caricatures. Cheap Engravings* are constantly published and for sale cheap by the subscriber, who has also an extensive collection of small colored engravings of Birds, Flowers, Insects, Figures, Animals, suitable for Scrap Books and Tables. As a great number of those have been published by himself, he can afford them cheap. A. Imbert, 104 Broadway, Lithographic Print and Music Publisher." It is revealing that in this brief announcement the word "cheap," which does not appear once in the lengthier 1827 notices, is used three times.

Sheet music was one of the more promising areas open to the new medium of lithography. Music scores had been lithographed in the United States earlier in the 1820s, but it was not until late 1826 or early 1827 that anyone made a regular business of it. Probably the first to do so was Anthony Fleetwood (fl. ca. 1826–60),[18] an Englishman who, by his own report, had established the first lithographic press in Liverpool before coming to New York. In a later advertisement (in *The New-York American* for August 31, 1827), he claimed that he was "the first to offer music at a fair and reasonable rate"; he was "sorry, however, to inform his patrons that so far he has been a considerable loser by the experiment." Fleetwood was certainly operating as a publisher of lithographed music before Feburary 17, 1827, when he placed an advertisement in *The New-York American* complaining about his competitors.

Music soon became a staple of Imbert's business. He both printed and published it. Accurate dating of sheet music is often difficult; many pieces issued in the 1820s by the lithographers and others were pirated European compositions for which American publishers did not normally seek copyright. Apparently the first piece of music which Imbert himself deposited for copyright, on September 4, 1827, was *The White Lady*, and by 1828 sheet music dominated the advertisements he placed. For instance, the one in *The New-York American* for June 20, 1828, listed fifteen pieces "Just Published." It is important to distinguish between a lithographed musical score, which lithographers such as Fleetwood and Imbert published, and a lithographed title page or cover. The latter,

whether illustrated or not, could be combined with engraved music as readily as with a lithographed score. For example, Edward Knight's version of the song *Buy a Broom* has an engraved score but a title page (with a vignette illustration) entirely lithographed by Imbert himself. A later piece which was entirely lithographed and published by Imbert is *The Seperate Battallion President's Guard's Grand March*, (figure 1.4), remarkable for its fine, primitive cover illustration by the youthful C. B. Graham and its similarly primitive spelling. It is notable that, during the early 1830s, as lithographed music scores lost their competitive advantage, lithography came into its own as the dominant medium of sheet-music title page illustration. By 1840 little or no lithographed music was issued, but almost every sheet-music illustration was a lithograph.

A second field which opened up for commercial lithographers in the 1820s was the publication of political and social caricatures. Prints of this nature, even more than sheet music, were bought by the general public as topical amusements and could not command high prices. The fact that they needed to be quickly and cheaply produced gave the advantage to the relative quickness of lithography as a printmaking process so that by the mid-1830s most of the separately issued political caricatures published in the United States were lithographs. In Frank Weitenkampf's chronological checklist of these, five prints are noted for 1828, two of them lithographs; but of the more than fifty prints listed for 1836, all but one is a lithograph, indicative of the interdependent development of caricature printmaking and commercial lithography in the intervening years.[19] The two lithographs listed for 1828 are both New York publications; Imbert's *A New Map of the United States* and Prosper Desobry's *Opposition Blown "Sky High Sir, Sky High"* (see note 5).

Between 1828 and his death in 1834, Imbert established himself as the most prolific publisher of lithographed caricatures in the United States; Weitemkampf records nineteen issued in that period, more than twice the number released by any other publisher. Only five of these were copyrighted, four of them in 1834, including Imbert's last copyright entry of any kind, on March 5, 1834, for *Set to between Old Hickory and Bully Nick*. It is clear from this that in the last phase of Imbert's career, caricatures were an important and expanding part of his business. And, in addition to the caricatures listed by Weitemkampf, Imbert produced a selection of other satiric or comic lithographs.

These included a group titled *Life in New York*, which was indebted to E. W. Clay's highly successful *Life in Philadelphia* series.[20] Unlike Clay's series, however, Imbert's *Life in New York* lithographs did not concentrate to such an extent on

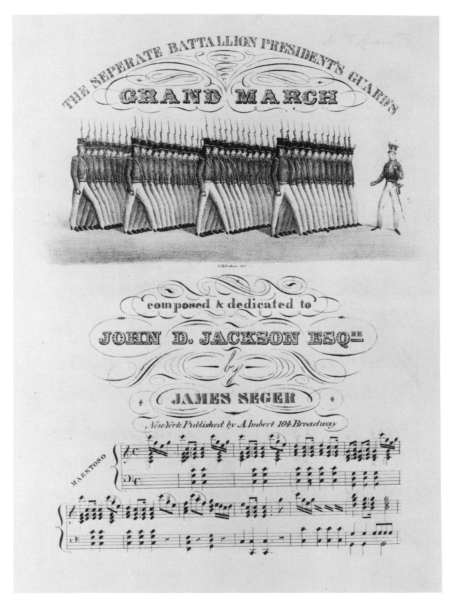

1.4. C. B. Graham, *The Seperate Battallion President's Guard's Grand March*, ca. 1830. Uncolored lithograph, sheet music title page, 5 × 8⅜ in. Private collection.

ridiculing black culture, but took a wider aim at a variety of New York types and situations. Figure 1.5 reproduces one in which both blacks and Irish immigrants are the butt of crude and insensitive humor of a kind common in the 1820s and '30s. Examples of Imbert lithographs which are more purely humorous are two which have been attributed to Henry Inman, *This is the time to try men's Soles!* and *Travelling in-Cog*, (although only the first credits Imbert as the lithographer), as well as Marsiglia's *Disturbed by the Night Mare.*

Though it is impractical to list a large number of Imbert's other prints, a few deserve notice. In addition to the books containing Imbert plates referred to previously, he contributed lithographs to a number of others, as well as to pamphlets and periodicals. He provided plates for Thomas L. McKenny's *Sketches of a Tour to the Lakes*, which described Indian life at Lake Superior and in the adjacent territories. This book was published in Baltimore in 1827 by Fielding Lucas, Jr., and it is interesting that its lithographic illustrations are divided between Imbert's press in New York and the Pendleton firm in Boston, the Pendleton plates being the work of Moses Swett. On the whole, these prints do little credit to either Imbert's or the Pendletons' reputation. The periodicals to which Imbert occasionally contributed plates included *The New York Mirror* and *The Rural Repository.*

A relatively large number of Imbert portrait prints survive. Some were issued as book illustrations; of those separately published, two of the most noteworthy not already cited are Bass Otis's *Rev. Joseph Eastburn*, produced in 1826, and George Catlin's portrait of M. M. Noah, described and illustrated in Stephanie Munsing's *Made in America.*[21] Also in 1826, the same year that he did his lithographic portrait of DeWitt Clinton, Catlin produced a "from life" Imbert print of *John A. Graham L.L.D.* A larger and particularly impressive Imbert portrait print, artist/lithographer unknown, is *Mr. John Roulstone of the New York Riding School* shown at work in his indoor ring (figure 1.6). The copy of this in the Harry T. Peters collection at the Smithsonian is inscribed on the back "Mr. Joel Capen from your brother[?] J. Roulstone, Jan 21 [?] 1829." Imbert also published an interesting assortment of portraits of theatrical figures, including E. W. Clay's depiction of T. B. Crane titled *Sketch at the Forest Garden Passaic Falls*, Victor's *Madame Francisque Hutin, From the Opera House Paris*, and the hand-colored *Mr. Kean as Richard the Third Act V. Scene last* lithographed for "Imbert and Co." by W. H. Tuthill. Somewhat differently, there is also a well-known "group portrait" of the Shakers of New Lebanon, New York, a print which may have been the source for the many other depictions of this scene.

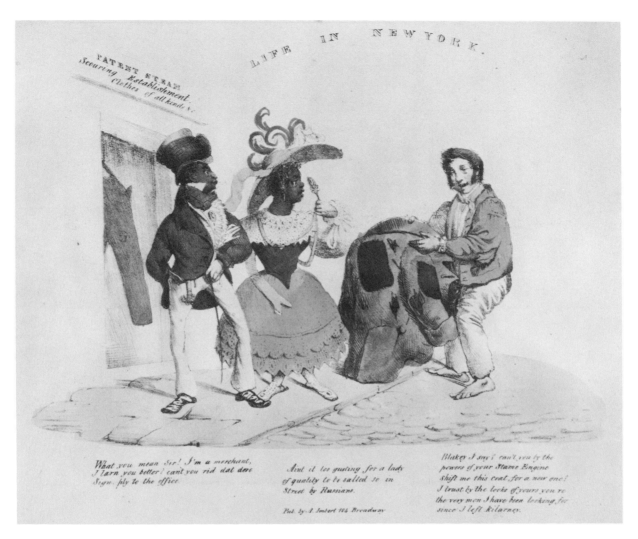

1.5. Unknown artist, *Life in New York*, ca. 1830. Colored lithograph, 6½ ×
22⅕ in. "Pub. by A. Imbert 104 Broadway." Private collection.

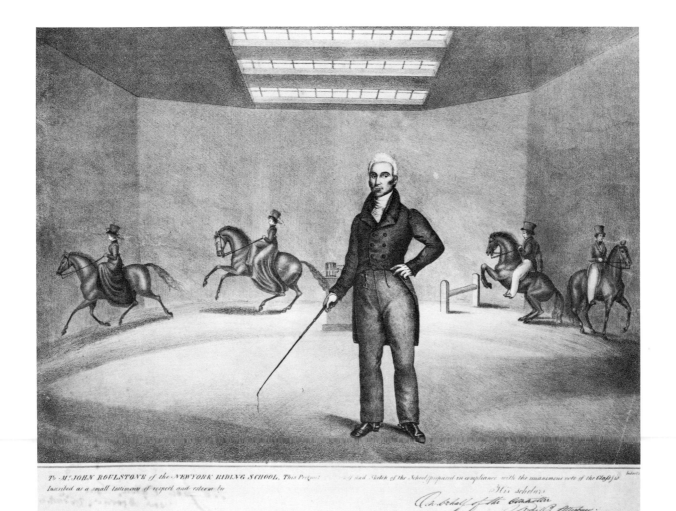

To Mʳ. JOHN ROULSTONE of the NEWYORK RIDING SCHOOL, This Present and said Sketch of the School prepared in compliance with the unanimous vote of the Class is Inscribed as a small testimony of respect and esteem by

1.6. Unknown artist, *Mr. John Roulstone of the New York Riding School*, ca. 1829. Uncolored lithograph, 13½ × 18⅝ in. "Imbert's litho." Courtesy of the Harry T. Peters Collection, Smithsonian Institution.

Some of the Imbert prints by his fellow Frenchmen, or which reflect his French heritage, have already been identified; others represent his naval background. In addition to the early *Memoir* plate noted earlier, in which he lithographed the shipping, he published two views, one folio sized, of the USS Brandywine, the ship in which Lafayette returned to France. Perhaps the most important of the other Imbert maritime lithographs is a set of six scenes of the naval actions during 1827 between Brazil and Argentina, in which the American Commodore G. C. DeKay participated.[22] At least three of these were drawn on stone by J. M. Roberts.

This set of views, like so much in Imbert's career, is puzzling; there is no indication of their source, their date, or the circumstances of their publication, and the lithographer J. M. Roberts, whose name appears on a number of other Imbert lithographs, is himself a mystery. He is not listed in the city directories of the time, or mentioned in any of the other standard sources of information about artists; indeed, his manifest nonidentity suggests that the name may be a pseudonym. My own view is that "Roberts" is in fact John R. Murray, and that he used this assumed name on those Imbert lithographs which were for public distribution, reserving his own name for prints of a more private or experimental nature, such as his transfer lithograph (figure 1.3). A need for anonymity accords with Murray's status as a prominent figure in the commercial and social life of New York, and the pseudonym fits the symmetry of the equation John Robert Murray = J.[ohn] M.[urray] Roberts. Also, as mentioned, Roberts produced a version of the caricature *A Dead cut*, suggesting that he may have been responsible for the *Life in New York* prints as well. If Murray was "Roberts" and did these, he would probably not have wanted this to be public knowledge, given his standing in the community and the low humor and doubtful taste of these prints; in fact, even his pseudonym may have been too well known at the time for him to use it in this case. More generally, the hypothesis that Murray was "Roberts" prompts further questions about his overall role in Imbert's career. Perhaps it was Murray, rather than the other candidates already entered, who was from the outset an anonymous partner in "Imbert & Co.," and also he rather than Robertson who was instrumental in setting up the commission for the *Memoir* plates as well as subsequent benefactions. Imbert's association with other members of Murray's family has already been noted. It may be that he and Imbert became involved initially when Murray returned to New York with his drawing of Lafayette at Woodlawn and sought a printer. Speculations such as these await evidence pro or con, but it may turn out to be highly appropriate that

for almost all his time as an American lithographer Imbert lived at 79 Murray Street.

The other Imbert lithographs by J. M. Roberts, whoever he was, are a miscellaneous group, including a portrait of Joseph S. Christmas, pastor of the Bowery Presbyterian Church (the frontispiece to a funeral sermon for him by Gardiner Spring titled *Moses on Nebo,* New York, 1830), and a view of the *Brooklyn Collegiate Institute for Young Ladies* published in the periodical, the *New York Mirror* in 1830. Perhaps the most charming is *Reverie* (figure 1.7), a larger hand-colored lithograph credited jointly to Roberts and Dominic Canova. Canova, who lithographed several of the *Memoir* plates, produced a number of other prints for Imbert over the years, and became an independent lithographer and publisher of caricatures in the early 1830s.

The actual output of Imbert's press will never be known unless his business records or their equivalent are found. The prints which do survive are a basis for extrapolating his career, but they also indicate the limitations of what is available. Most of Imbert's lithographs are genuinely rare; for example, five of the seven prints used as illustrations here are reproduced from unique located impressions. The prints most at risk are those of an ephemeral nature to begin with, including artists' experiments which were not created for sale or general distribution, and which, even if they do survive, may not be identified. The only Imbert lithographs which are relatively common are some of those made as book illustrations, such as the *Memoir* plates.

It has become something of a cliché in histories of American prints to call Imbert "New York's pioneer lithographer." To do so suggests that he is of only regional significance, and that his work is only interesting as an anticipation of later and greater things. Such an estimate is, in any event, based on quite limited knowledge, for until now very little has been known about the history and output of his press. Even the prints which survive, in many instances so rare as to be virtually unknown, have rarely been reproduced. Perhaps the most important factor which has limited Imbert's reputation, however, is the comparative aggrandizement of the Pendleton firm of Boston. This began with the Pendletons themselves and such contemporaries as Rembrandt Peale, and has continued through the twentieth century. Two typical comments reveal this bias: "It appears that the firm of W. S. & John Pendleton, in Boston, was, if not indeed the first of its kind, the earliest to attain any distinction for quality of work or volume of output"[23]; and "To this firm belongs the credit of being America's pioneer commercial lithographers."[24] A comparison of institutions as complex as

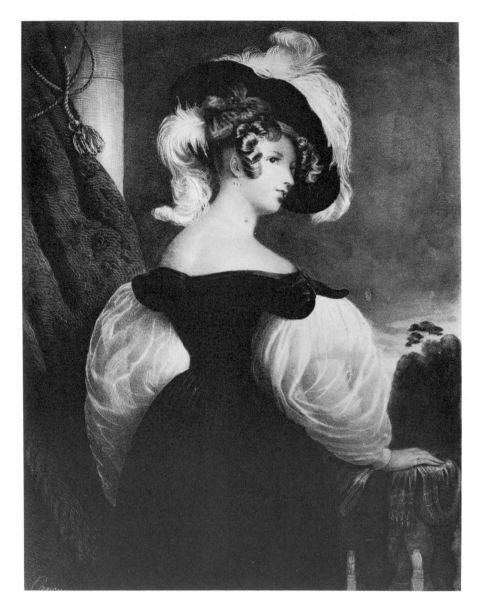

1.7. J. M. Roberts & D. Canova, *Reverie*, ca. 1827. Handcolored lithograph, 10¾ × 8 in. "A. Imbert's Lithography N. York." Courtesy of the Harry T. Peters Collection, Smithsonian Institution.

lithographic firms would seem an ill-conceived undertaking, but it has been done so frequently to Imbert's disadvantage that, in all fairness, some response on his behalf is overdue.

The Pendleton firm, unlike Imbert's, was commercially successful, lasted a longer time under its own name, and set up a dynasty of succeeding businesses, including the Moore, Thayer, Bufford, and other companies that lasted through the entire period of commercial stone lithography in Boston. One reason for the degree of this success was that the Pendletons had little or no competition from other local lithographers throughout the years from 1825 to 1834, whereas Imbert's situation was decidedly different. New York was in general a more competitive environment during the 1820s, and soon after Imbert's press was established new rivals, such as Fleetwood, appeared. Before the end of the decade there was a veritable explosion of competition in all the areas of Imbert's activity, not the least of which was the arrival in New York of experienced lithographers and lithographic businessmen such as Endicott and Swett from Baltimore, and (in 1828 or 1829) John Pendleton himself. By the time of Imbert's death in 1834, New York had clearly become the most active, contested, and probably overcrowded market for commercial lithographers in the United States. As suggested earlier, however, the relative prosperity and longevity of the Pendleton firm, while certainly important aspects of its general reputation, are also largely irrelevant to other questions about its performance.

A second feature of the Pendleton company which has lengthened its shadow is that it employed or attracted a number of apprentices or associates who were or became important figures in the American art world, including Fitz Hugh Lane, William Rimmer, David Claypoole Johnston, and, as mentioned, Rembrandt Peale. The glow from these luminaries, however, should not blind us to what is really relevant here: the quality of the work they did for or with the Pendleton firm. It is also worth noting that Imbert had his own stars, including Bass Otis, Henry Inman, George Catlin, and Thomas Cole, who are not obviously eclipsed by the Pendleton galaxy. Furthermore, because the Pendleton firm outlasted Imbert's, a significant number of its better (and better-known) prints were produced after Imbert's death, and so, in fairness, should not be part of a comparison. In fact, unlike the Pendletons, most of Imbert's best work was done early in his career; he is preeminently a lithographer of the 1820s and, with a few exceptions, his production after 1830 is anticlimactic. In contrast, many of the Pendleton artists on whom a large part of the company's reputation rests,

including Lane, Rimmer, Benjamin Champney, and George Loring Brown, did not begin work until after 1832.

With these preliminaries aside, it is possible to state some facts and make some more focused observations. First, it seems that Imbert's press was established slightly before the Pendletons', and that it managed to produce a body of successful prints before they did. It is revealing that whereas Imbert, by the end of 1825, was effectively at work on his first major project, involving the printing in quantity of the more than thirty-five *Memoir* lithographs, John Pendleton was struggling and failing with his first important commission, the printing of the five Gilbert Stuart-Maurin portraits of the presidents. These had been drawn on stone by Maurin in France, and brought back, together with a French printer, to be issued in Boston. But Pendleton proved incapable of doing this. A contemporary reported his "astonishment to find that on the first of January, 1826, . . . said P. [Pendleton] could not perform the workmanship as had been represented, and after making divers frivolous excuses & delays was obliged to confess that he could not himself but offered to go or send to France at my expense & procure the prints to be executed, but I losing all confidence in him concluded it would be most prudent in me not to have anything more to do with him—in pursuance of this resolution I caused the contract to be annulled."[25] If this is true it suggests that in early 1826 Imbert's press was considerably more advanced than Pendleton's; in fact, it was not until late in 1828 that work on this Pendleton presidential series was resumed. In sum, the Pendletons were *not* "the earliest to attain any distinction for . . . volume of output": Imbert's press was.

Second, just as Imbert's press probably preceded the Pendletons' and got off to a sounder start, Imbert was also ahead of them in exploring the technical and commercial possibilities of lithography. His very first advertisement listed a full range of lithographic services for "Merchants" as well as "Artists and Amateurs," including "Drawings, Writings, Heads of Bills, Vignettes, Bills of Exchange, Maps, Cards, &c. &c." He also stressed that "Merchants will find it an expeditious method of forwarding circulars and commercial advices, as by means of transfer a number of copies, of any hand-writing or fac-simile can be obtained in 24 hours." (By February 1826 the time for this service had been reduced to only a few hours.) Imbert, as noted earlier, also stood ready to supply artists with advice and materials for producing lithographs, and undertook their printing, and set about producing a wide variety of lithographic goods, many of which were published at his own risk. The Pendletons, in due course, offered a similar range of services and products, but their activity was not as various; for

example, they did not themselves publish lithographed music scores or caricatures in the way that Imbert did. In sum, Imbert and not the Pendletons has to be fairly considered America's pioneer lithographer.

The purpose of this comparison is not to discredit the Pendleton firm, but to try to balance the record, deflating the part of its reputation that has unfairly obliterated Imbert's achievements, and thereby establishing some measured conclusions about these. One aspect of the comparison which remains is that of quality of work. Judgments of quality, which bring in subjective factors, are notoriously difficult. Were the Pendletons the first to produce *any* lithographs of quality? Was their output in general of a higher quality than that of any of their predecessors and contemporaries? In my view the answer is no on both counts. If Imbert's known prints, produced in the first five years of his operation, are matched against those of the Pendleton firm produced in the same period, the comparison favors Imbert. Even if the later Pendleton prints, including those produced after Imbert's death, are added in, the outcome is not obviously different. Certain individual Pendleton prints, such as Lane's view of Gloucester, are remarkable, but also exceptional. And who is to say that even an exemplary Pendleton lithograph such as this is objectively superior to, say, Marsiglia's view of Catskill Falls, or the best of the Davis-Imbert architectural scenes?

The Anthony Imbert who steps from behind the glare of the Pendleton reputation is a substantial figure. Unlike either of the Pendletons he was himself a productive lithographic artist and delineator, as well as a competent printer, with a documented interest in the technical possibilities of lithography that is refelcted in his prints. His press was the first lithographic company in the United States to issue a significant amount of quality work, and the first to develop the full spectrum of goods and services which later became characteristic of lithographic businesses. This unheralded Frenchman was indeed not only New York's but also America's pioneer lithographer.

NOTES

I wish to thank especially Professor David Tatham of Syracuse University, who introduced me to the fascinations of early American lithography, and the outstanding staff and collections of the American Antiquarian Society in Worcester, Massachusetts, where research is made so pleasant.

1. According to Phelps Stokes this print, titled *Landing of Gen. Lafayette, At Castle Garden, New York, 16th. August 1824* and credited "Imbert Del [*delineavit*, "he drew it"] Sam Maverick Sct," [*Sculpsit*, "he engraved it"] appears opposite "p 333 of *A Complete History of the Marquis de Lafayette. . . . By an officer in the late army. . . . New York, 1826*." See I. N. Phelps Stokes, *The Iconography of Manhattan Island*, 6 vols. (New York: Robert H. Dodd, 1915–1928, vol. 3, p. 581). Stokes reproduces the engraving as Plate 94-b. The copyright records at the Library of Congress state that the book in which it was issued was entered for copyright by P. M. Davis on September 22, 1825. This Imbert-Maverick print should not be confused with another Maverick engraving with the same title; this view, which is circular, was entered for copyright by Samuel Maverick on October 27, 1824, and is reproduced in *Iconography* as Plate 94-a. It is not known whether Imbert had anything to do with this print, or other similar views produced by other engravers.

2. Imbert's obituary as it appeared in *The New-York American* for August 25, 1834, reads: "DIED: . . . On Thursday morning, of consumption, Mr. Anthony Imbert, in the 40th year of his age." If this is correct, he died on August 21, 1834, and must have been born after August 21, 1794, and before August 21, 1795.

3. *Dictionary of American Biography* (New York: Scribners, 1931) s. v. *Imbert*.

4. Within a few days of his landing, New York printsellers such as Megary and Colman advertised likenesses, but it is not clear whether these were local products or imports. The papercutter Master Huband exhibited a life-sized profile. *The New-York Evening Post* for October 16, 1824 reports: "The transparent painting, representing *La Grange*, the Home of La Fayette, as exhibited at the Castle Garden fete, will be sold at auction by John T. Boyd, on Monday evening at the Assembly Room, at 8 o'clock." A little later, in 1826, four views of La Grange by the American artist Alvin Fisher were lithographed in France and published as a portfolio by the artist in Boston. The sculptor John Frazee made a plaster cast of Lafayette's face from life and sold reproductions of it. But even before these were available his cast had been put to a more extended use; in *The New-York American* for October 9, 1824, Mr. Campfield of the Boys' Clothing Emporium reported that he had employed Charles Cushing Wright, of Durand and Wright, to make engravings after Frazee's cast, which were then crafted by a Connecticut firm into several sizes of "extra rich gilt" "La Fayette Buttons".

5. See Note 4 in David Tatham, "The Pendleton-Moore Shop: Lithographic Artists in Boston, 1825–1840," *Old-Time New England*, 62 (Fall 1971): 45. See also, Philip J. Weimerskirch, "Naturalist's and the Beginnings of Lithography in America," in *From Linnaeus to Darwin* (London: Society for the History of Natural Science 1985): 167–77.

6. According to Harry T. Peters, the firm of Chanou and Desobry was located at 56 Exchange Place in 1824 and he cites an unnamed "music sheet" as evidence for this. See Harry T. Peters, *America on Stone* (New York: Doubleday, 1931. p. 157). Perhaps he had in mind the "Frontispiece" used by E. Riley, Music Publisher, of 29 Chatham Street. On this sheet the lithograph is credited to "Chanou & Desobry Litht. 56 Exche Place N.Y.," but since no date is given and, according to reliable sources, Riley used this address until well after 1824, this particular piece is not sufficient to prove the point. Peter's claim is repeated in numerous other publications with no better substantiation.

7. George C. Groce and David H. Wallace, *New-York Historical Society's Dictionary of Artists in America* (New Haven: Yale University Press, 1957), p. 176. Des Essarts' virtual anonymity is not

helped by Peters, *America on Stone,* p. 158, where the print mentioned is mis-dated by ten years and the artist's name is mis-spelled Dessarts, mistakes which are repeated in Groce and Wallace.

8. Colden, Cadwallader C. *Memoir, prepared at the request of a committee of the Common Council of the City of New York, and presented to the mayor of the city, at the celebration of the completion of the New York Canals:* (New York, 1825). The *Memoir* itself occupies only 102 pages of the book, the bulk of which is an appendix with a separate letterpress title page dated 1826. The complete work contains a fac-simile of a letter dated July 3, 1826, so that it cannot have been available until sometime after that date, but most of the lithographs in the appendix were probably done by the time Robertson dated his "Report" on May 28, 1826. Evidently some of them were produced late in 1825, although the only plate so dated is *Ropemakers Arms,* marked "Lithographic Press of Imbert & Co. New York 1825." This was drawn on stone by Dominic Canova and, according to Robertson, Imbert did the lettering. There are at least seven lithographs with the imprint "Imbert & Co." in the *Memoir,* two of them dated 1826. It would be a difficult task, involving an extensive census of copies, to produce a definitive plate collation of the *Memoir;* not only do different copies have different combinations of plates, but several of the lithographs exist in variant states.

9. Reproduced in Stokes, *Iconography,* vol. 3, plate 95-a. An oil painting by Imbert of the same subject was recently acquired by the Museum of the city of New York.

10. These larger second-state Buffalo views have been mistakenly supposed to be separately issued prints; see, for example, the entry C.1824 - F-38d in Stokes, *Iconography,* p. 111. The error is a natural consequence of comparing a separated, disbound impression of the second-state lithograph with a copy of the book containing a first-state plate.

11. The insistency of Robertson's endorsement of Imbert creates the suspicion that perhaps he was more than a patron; that he might in fact have been a partner in "Imbert & Co." His "Report" claims that it was the Committee of Arrangements which decided "to employ the art of lithography in furnishing plates" for the Memoir (page 351), and implies that Robertson subsequently and independently determined that Imbert was the only local lithographer capable of the task. Robertson also stresses that this was not a foregone conclusion, that Imbert was put to the test to see if he could produce adequate work. All this may have been the case, but the feeling lingers that the man protests too much.

12. Janet Flint, formerly Curator of Prints at the National Museum of American Art, identi-fied these Cole-Imbert lithographs; they are discussed and illustrated in her paper "The American Painter-Lithographer," published in *Art and Commerce,* (Charlottesville: University Press of Virginia, 1978).

13. Murray also produced a lithograph of Druid Hill, the residence of the Rogers family in Baltimore, to whom he was related by marriage. See: Bevan, Edith Rossiter 'Druid Hill, Country Seat of the Rogers and Buchanan Families', *Maryland Historical Magazine,* 44 (1949), facing p. 192. Appar-ently both the Woodlawn and Druid Hill lithographs were for private distribution and were never marketed.

14. A printed note in this edition confirms that the Murray sisters were responsible for the 1827 work, and states that their efforts raised $1000 for the Foreign Missionary Society. Even if Imbert donated his printing costs, this figure represents a considerable number sold at fifty or seventy-five cents each.

15. I am greatly indebted to Jane B. Davies for kindly supplying information from Davis's records and for help on related matters. She is the author of the entry on Davis in the *Macmillan Encyclopedia of Architects* (New York: Free Press, 1982), and is currently researching and writing a full-scale study of his life and work. The records consist of a memorandum book titled "Scraps . . ." in the A. J. Davis Collection at the Metropolitan Museum of Art, No. 46.114.82, and a day book, called a diary (volume 1), in the A. J. Davis Papers in the Manuscript Division of the New York Public Library. The *Castle* Garden print is reproduced in Stokes, *Iconography*, vol. 3, plate 106-b.

16. Judging from Davis's records and the surviving prints the complete series consisted of *"Views of Public Buildings, Edifices and Monuments, In the Principal cities of the United States, correctly drawn on Stone, by A. J. Davis* [the general title page]. Printed and Published by A. Imbert, Lithographer, 79 Murray-Street, New York," and *"Views of the Public Buildings in the City of New-York Correctly drawn on stone by A. J. Davis* [the title page for the New York views], Printed & Published by A. Imbert Lithographer No. 79 Murray St. New-York." This has the words "P. Desobry Scripsit" ["lettered it"] after the initial word "Views," and there is a lithographed vignette of the New York Rotunda before "Correctly drawn." Davis charged Imbert $10 for lithographing this "Title." In his Day Book, Davis papers, New York Public Library, Davis lists his two sets of views as follows, the prices being what Davis charged Imbert for lithographing each.

No. 1 Exchange ($18)

> Branch Bank ($15)
> Bowery Theatre ($20)
> Masonic Hall ($20)

No. 2 2d Unitarian Ch. ($20)

> Phoenix Bank ($20)
> Lafayette Theatre ($20)
> St. Thomas's Ch. ($25)

Davis's total bill to Imbert for this work was $168, implying that he was not a joint proprietor in the venture, and the Day Book reveals that in 1828 Imbert paid him off—only $55 in cash, the balance in credits for printing four lithographs for Davis, as well as "Books, & prints," "picture frames, and other value received." The Davis-Imbert series views sold for $.50 each, or $2.00 for each set of four, so that Davis's bill to Imbert, which was only part of his cost, represents a sale of 84 numbers or 336 separate prints. If it is assumed that Imbert's other costs, including the printing, were as much as Davis's bill, the figures would required an overall sale of at least 700 prints for the project to have been successful.

That the published 1827 Davis-Imbert series of New York views consisted of only eight lithographs, plus the title page containing the vignette of the Rotunda, was not known to Peters, *America on Stone*, (pp. 232–33) or Stokes, *Iconography* (vol 3, pp. 603–604) who supposed that there were more. Stokes includes the right eight, but also other Davis/Imbert prints.

17. Davis papers, Diary, p. 41. Manuscript Division, New York Public Library.

18. Apparently Fleetwood's first New York advertisements appeared in October, 1826, a year after Imbert's. The *New York Evening Post* for October 19 contained a long notice, detailing products and prices, for a "Lithographic Printing Office" whose proprietor was not, however, identified. On November 16 a second advertisement appeared: "To be disposed of, an excellent lithographic printing press, made by Ruthven & Co. of Edinburgh. . . . The purchaser can, if required, be furnished with ink, a few pieces of German stone and instructions in the art. Apply at A. Fleetwood's

Lithographic Printing Office, 235 Pearl Street. The address given in the advertisement of October 9 (corrected after its first appearance), was Fleetwood's. Both advertisements were reprinted frequently through December 22, 1826.

19. Frank Weitenkampf, *Political Caricature in the United States* (New York: New York Public Library, 1953).

20. See Nancy R. Davison's *E. W. Clay: American Political Caricaturist of the Jacksonian Era*, (Ann Arbor, Michigan: University Microfilms, International, 1980). This exemplary study contains a catalog of all Clay's known prints, including the *Life in Philadelphia* series.

21. Stephanie Munsing, *Made in America: Printmaking 1760–1860* (Philadelphia: Library Company of Philadelphia, 1973).

22. All six are reproduced in *Old Print Gallery Showcase* 6 (January–February 1976).

23. *Notes on an Exhibition of Early American Lithographs* (Boston: Club of Odd Volumes, 1924).

24. Carl Dreppard, *Early American Prints* (New York: The Century Co., 1930), p. 125.

25. Jonathan Cobb, quoted in Mabel M. Swan, "The 'American Kings,'" *Antiques* (April 1931):278–81.

2

George and William Endicott
Commercial Lithography in New York, 1831–51

GEORGIA BRADY BUMGARDNER

One of the frustrating aspects of nineteenth-century commercial lithography is its anonymity. Because of the general lack of sales catalogues and business records for American lithographic firms, the prints themselves typically provide what documentation there is for most shops and artists. Many of the prints were produced anonymously—the name of the draftsman who drew on the lithographic stone is unknown. Signed prints often offer the only proof that a draftsman or original artist was active, or that he even existed. When the name of a draftsman appears on a print, the date of the print and the appearance of the name of the artist in a city directory sometimes leads to more information, but even so, this minimal biographical framework frequently proves difficult or impossible to flesh out. The rare exceptions to this pervasive anonymity among nineteenth-century American lithographic artists have been those few who later achieved some degree of renown, artistic or otherwise, as in the cases of Fitz Hugh Lane and Winslow Homer. Some twentieth-century scholars have been able to piece fragments of information together to create coherent histories of firms and individuals.[1] But the survival of any contemporary assessments of lithographic artists, such as those few in William Dunlap's *A History of the Rise and Progress of the Arts of Design in the United States* (1834), has been a rare occurrence.

Fortunately, Charles Hart's unpublished "Lithography, Its Theory and Practice, Including a Series of Short Sketches of the Earliest Lithographic Artists, Engravers, and Printers of New York" dissipates some of the anonymity of the practice of lithography in nineteenth-century New York City. Hart's manu-

script, housed in the manuscripts division of the New York Public Library, contains the first-hand observations of a lithographic printer who worked for the firm of George Endicott and his successors from 1839 through 1859. It sheds light on many aspects of this important establishment, a firm that flourished through the 1880s. These include the duties of apprentices, details of working conditions, and the problems of proving and printing lithographs. He also recalled the names, personalities, and activities (artistic and otherwise) of many of his former colleagues. From Hart's memoirs, written around 1900, it is possible to flesh out to an extent previously impossible the biographies of the persons whose names appear on the products of the Endicott presses: lithographed sheet music covers, book and periodical illustrations, and separately published prints. Though Hart's association with George Endicott began only in 1839, he included in his account lore from the previous decade.

George Endicott was born in Canton, Massachusetts, on June 14, 1802. According to his grandson, F. Munroe Endicott, George worked as an ornamental painter in Baltimore beginning in 1820.[2] His name does not appear in the Baltimore city directories for 1822 or 1824, but he did insert an advertisement in the directory for 1827 (published late in 1826) that he "continues" the business of ornamental painter at the corner of Market and Charles Streets. He advertised his services in painting military standards, masonic aprons, and signs. His notice implies that he had been active in Baltimore for a while, but whether he arrived in 1820 at the age of eighteen remains conjectural. And, unfortunately, no examples of his work as a decorative painter are known to survive in Baltimore.[3]

The April 7, 1830, issue of the *Baltimore Patriot and Mercantile Advertiser* announced a change in plans for George Endicott. On April 1, 1830, he and Moses Swett, formerly of Boston, formed a partnership located at Graphic Hall. Swett brought to this partnership an expertise in lithography which he had gained while working as an artist and draftsman for the Pendleton lithography firm beginning in January 1826. He later became the superintendent of the Senefelder Company in the summer of 1828.[4] Endicott expected to continue his work as a decorative painter. There would also be an engraving department which would turn out "portraits, landscapes, vignettes, certificates, maps and charts, business and visiting cards and seals on steel, copper, or wood." And the partners anticipated selling prints issued by themselves and others in their "picture room." Their plans were ambitious, perhaps too much so.

The activities of Endicott and Swett in Baltimore did not last long. Late in

December 1831, the firm moved to New York. In their brief period of activity in Baltimore, the partnership had issued a number of lithographs of varying quality and subject matter. They include illustrations for a variety of publications: *The Amethyst*, a literary annual; the *Fifth Annual Report . . . of the Baltimore and Ohio Rail Road Company;* the *National Magazine;* Nathan R. Smith's *Surgical Anatomy of the Arteries;* the *American Turf Register;* John Smith Hanna's *Lecture on Mechanics;* John Rubens Smith's *Key to the Art of Drawing the Human Figure;* the *Methodist Protestant;* and *The Cabinet, A Selection of Popular Melodies.* They also published music with lithographed covers (title pages,) such as "Oh Mount thy Bright and Gallant Steed" drawn by Swett. Among their separately published lithographs was a folio print of the Battle of North Point after a painting by Thomas Ruckle. They also sold prints such as the beautiful view of *Baltimore from Federal Hill* painted and engraved by W. J. Bennett in 1831. Lois McCauley speculates in *Maryland Historical Prints* that Baltimore's first lithographic firm was not commercially successful, inasmuch as the partners left for New York City after less than two years' activity in Baltimore.[5]

A document owned by the late Gordon Colkett establishes the date of the move as occurring in December 1831. Although undated, the advertising circular bears a handwritten letter from Endicott to his parents in Canton, Massachusetts. Dated February 19, 1832, the letter indicates that Endicott had been in New York for nearly two months. After communicating some family news, he continues "Our prospects of business in N.Y. are good, much better, I am certain, than they were in Balti.° We have all hands employed profitably, three presses going, and orders constantly coming in." He closes by stating "I shall take the first opportunity to send you some of the recent prints . . . the natives are quite astonished that the Baltimoreans were so much before them in Lithography." The circular lists their readiness to execute "portraits, landscapes, views of public buildings and country seats, portraits of animals, anatomy, vignettes, title pages for books, diplomas, maps, plans, circulars, checks, notes of hands, bills of lading, bills of exchanges, etc., etc."

The firm was also ready to furnish professional and amateur artists with prepared stones and later to print them with care. Their business in New York was to be more narrowly focused than previously. No longer would Endicott take on commissions for ornamental paintings, nor did they plan to execute engravings on steel, copper, or wood, as they had in Baltimore. The circular states that "an assortment of Prints" would be on hand along with blank legal forms and bills of exchange and lading. From the beginning Endicott and Swett probably

planned to publish some of their own prints. The advertisement, however, emphasizes their capabilities as job printers. This aspect of their business accounts for the variety of prints which bear the Endicott and Swett imprint. Furthermore, George Endicott and his successors continued to solicit business of this type.[6]

By July 1834, Endicott and Swett had dissolved their partnership and Swett went his own way as a lithographer. He produced some sheet music covers on his own, including "The Texian Grand March" published by Firth and Hall in 1836. He was listed variously in the New York City directories at 359 Broadway or 150 Nassau Street from 1834 through 1837, while George Endicott was at 359 Broadway from 1834 through most of 1839. Swett seems to have left New York for Washington, D.C., in 1837, for there are two political cartoons copyrighted by him there in 1837 and 1838. He must then have returned to Boston, for an obituary appears in the *Columbian Centinel* for a Moses Swett who died on December 20, 1838, in Boston. The obituary mentions that he was "late of New York" but provides no other information.

Although Hart never knew Swett, and incorrectly thought that his death was the cause for the dissolution of the partnership, he thought highly of his work. He noted that Swett was an excellent artist and that the firm of Endicott and Swett "were the legitimate successors to John Pendleton, the pioneer of Lithography."[7] Hart recalls that Swett, who was also a painter, made several copies of Trumbull's portrait of Washington standing by his horse. The "last of these life-size pictures was sold to P. T. Barnum."[8] Hart was particularly charmed by Swett's lithographs executed for two books, *The Amethyst* and *The Cabinet*, both published in Baltimore.[9]

George Endicott ran the firm successfully after the partnership dissolved and provided a solid footing for the future. Hart remarked that the establishment "reached the zenith of its glory, attracting to its office all the best artists, engravers, and printers" during the tenure of George Endicott.[10] William Endicott, George's younger brother by sixteen years, joined the firm as bookkeeper by 1840 and became a partner in 1845. During the period of their partnership, the firm's imprint was G. & W. Endicott. George Endicott died in 1848 at the age of forty-six. William, although an invalid, carried on the business until his own untimely death in 1851 at the age of thirty-five. His wife had previously died of consumption; the disease ran in his family as well. George's widow, Sara Munroe Endicott, whom he had married in Baltimore on December 18, 1828,[11] reformed the company with Charles Mills and later with her son Francis Endicott.

As Endicott and Company, the firm continued on until 1886. But the most interesting years of the firm, at least in terms of the lithographs printed and published by the company, are those issued prior to the death of William Endicott in 1851. This period is well documented both by surviving prints and by Charles Hart's recollections. Although some of his impressions may be clouded by time, many of his details can be verified, and this lends credibility to his memoirs in general.

Charles Hart's memories of the Endicott firm date back to 1837, when he was an apprentice at the china and glass store run by Francis Stirling on Canal Street. Hart, while on errands for Stirling, would often stop by the Endicott shop at 359 Broadway and watch the printers at work. The cover for "The Gingerbread Man, A New Comic Song" (figure 2.1) shows the front of the building with steps leading up to the front door. Prints filled the shop windows, obscuring any view into the premises. Hart formed part of the crowd that watched the move of the presses and stones from this site to 152 Fulton Street in 1839. Finally, Hart saw a sign hanging in their new quarters saying that a boy was wanted, and he got the job.[12] He went to work on December 31, 1839, remaining there until a fire destroyed the premises in December 1859.

The first day of work included stacking cordwood. The duties were various and "required me to rise early in the morning, proceed to the office, make two fires, sweep out the office and printing room &c. then wait until released to return to my breakfast, consisting of a hard-boiled egg and a cup of cold coffee, for as the cook often said, 'Anything was good enough for the apprentice-boys.'"[13] Hart also learned to grind, grain and polish stones and make tracing paper, lithographic crayons, and varnish. To earn extra money, he also hand-colored stock prints—female heads, music titles, steam boats, and depictions of camp meetings—in the evenings.[14]

On his arrival, the firm was small. Charles Parsons was also an indentured apprentice, but had already been promoted to the lithographic department and was drawing on stone. Presumably, many of the unsigned lithographs which were printed during the late 1830s were drawn by Parsons. Alexander Robertson was the printer and George Endicott, owner and manager, would have solicited orders and decided which prints and songs (for they also published sheet music) to issue on their own account. William Endicott, George's younger brother, served as the bookkeeper. Hart noted only two presses, a small one and a larger one with a twenty-six by thirty-six inch bed.[15] There were probably additional presses, however, for when Endicott and Swett moved to New York, they had

2.1. "Spoodlyks," (perhaps George T. Sanford), *The Gingerbread Man, A New Comic Song*, 1836. Lithograph, sheet music title page, 12½ × 7¼ in. New York: Endicott. Courtesy of the American Antiquarian Society, Worcester, Mass.

three presses. It is possible that when the partnership dissolved, Swett took one of them. Another printer, George T. Sanford, like Parsons, was capable of drawing on stone. So was George Endicott himself, who drew the illustrations for Frances Osgood's *Puss in Boots* published in New York in 1844.

Good printers could turn out three hundred impressions a day at best. There was, in fact, a shortage of skilled printers. In the 1840s they received from six to twelve dollars a week; artists received fifteen to eighteen dollars a week.[16] In an establishment like Endicott's, the printers frequently remained for several years, whereas artists were engaged only to do specific projects or pieces of work. This arrangement was appropriate for a commercial firm whose business consisted of job work.

Even in Hart's memoirs, the precise working relationships between the artists and their employer are difficult to define. Those who worked only sporadically for the Endicotts were John H. Bufford, Anthony Fleetwood, William Ball, Edward Williams Clay, E. H. Brown, Eugene Sintzenich, and Edward Dalton Marchant. Those who enjoyed a longer association were John Crawley, Jr., Daniel T. Glasgow, James Irvine Glasgow, John Penniman, George T. Sanford, Francis D'Avignon, Charles Parsons, and Frederick Swinton. A fleeting glance at representative prints of each of these artists will provide a broad outline of the firm and its prints.

John H. Bufford (1810–70) is far better known for his work in Boston than in New York.[17] After serving his apprenticeship in the Pendleton shop in Boston from 1829 to 1831, he remained there until 1835, when he left for New York. He worked independently for five years while accepting commissions from George Endicott and Nathaniel Currier. Interestingly, Currier had worked for Pendleton at the same time as Bufford, and Moses Swett was also working at the Pendleton firm when Bufford began his work with them.

To avoid risking his own funds, Bufford seldom published his own lithographs during his stay in New York. *From the Statues of Walter Scott, Old Mortality and his Poney by J. Thom* drawn by Bufford, printed by George Endicott, and probably published by James Thom, the sculptor, demonstrates Bufford's skill as a draftsman. His ability was recognized in 1835, when he was awarded a diploma at the American Institute Fair for the "second best specimen of lithographic engraving." The first prize went to George Endicott.[18] His less successful efforts are probably due, as David Tatham has suggested, to the poor quality of the originals he copied. For example, his portraits of Mrs. Watson and her daughter Charlotte are not as skillfully drawn. Mrs. Watson appears on the

cover of a piece of sheet music, "Oh Do Not Forget Love." For the portrait of Charlotte, *Miss Watson as Aurelio in the Opera of Native Land,* Bufford based his lithograph on a sketch by Stewart Watson, the young actress's father. Both prints were published in 1835 and are rather coarse in comparison to the lithograph after Thom's sculpture. Another portrait by Bufford depicts "M. Berryer, Membre de la Chambre des Députés." It was apparently commissioned as a book illustration.

Edward Williams Clay drew at least two items, both sheet music covers, for George Endicott in the late 1830s—"When a Man's a Little Bit Poorly" and "Jim Crow." Clay drew on stone for several different lithographers in New York in the late 1830s and early 1840s, including Henry R. Robinson, John Childs, Nathaniel Currier, and James Baillie.[19]

A vignette for the song "My Darling Boy" was drawn on stone about 1840 by Anthony Fleetwood, who later operated a lithographic firm in Cincinnati from 1847 until after 1860. This sheet music cover, printed by George Endicott, shows competent draftsmanship and is undoubtedly copied from a piece published in England. Hart noted that Fleetwood "had a little shop in England, also in New York, and did very nice work."[20] His specialty in New York was sheet music and he was active as early as 1828 or 1829.

Another artist who infrequently crossed the threshold at 359 Broadway was William Ball. In 1835 he drew on stone a portrait of Martin Van Buren, then vice-president of the United States. In 1837, Ball returned to draw a series of eight presidential portraits—Washington, John Adams, Jefferson, Madison, Monroe, John Quincy Adams, Andrew Jackson, and again, Van Buren. These were published under the title, *Portraits of the Presidents of the United States.*[21] Though Peters called this "one of the finest sets of Presidents,"[22] he knew nothing about Ball, not even his first name, which is, however, found on his earlier portrait of Van Buren, an impression of which is owned by the Library of Congress.

The previously-mentioned advertisement issued by Endicott and Swett in 1832 notes that "Artists and amateurs will be furnished with prepared stones and the most scrupulous care taken in printing their drawings." Eugene Sintzenich, a landscape and portrait painter who lived and worked in various places in New York State, was so furnished. For his print *View of the Ruins of the Great Fire in New York, 1845* (figure 2.2), he made the original sketch, drew it on stone, and published it. Similarly, Edward Dalton Marchant, a miniature and portrait painter, drew a portrait of the Reverend Artemas Bullard on stone after his own oil

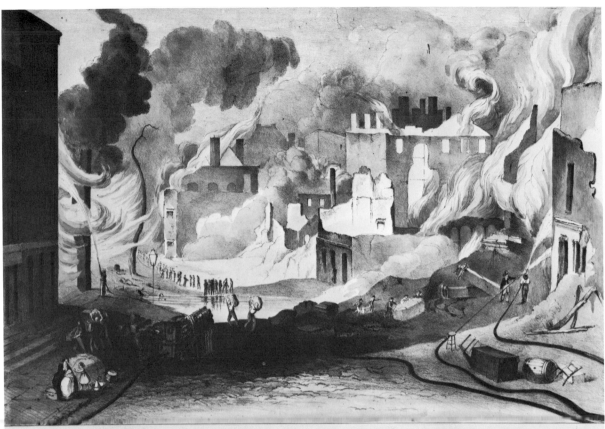

VIEW OF THE RUINS OF THE GREAT FIRE IN NEW YORK,
as they appeared on the Morning of 19ᵗʰ July 1845.
FROM THE CUSTOM HOUSE STEPS.
New York Published by Eugene Sintzenich 304 Broadway (Room Nº 33.)

2.2. Eugene Sintzenich, *View of the Ruins of the Great Fire in New York*, 1845.
Lithograph, 11 × 15¾ in. Lithographed by G. & W. Endicott. Courtesy of
the American Antiquarian Society, Worcester, Mass.

portrait. Perhaps he had been commissioned by Bullard's parish to produce the print. Artists such as these accounted for only a small proportion of the firm's business.

Another artist active for a short while at Endicott's was Eliphalet H. Brown, Jr., who was born in 1816 and died at the age of 69 in 1886. From Hart's comments, it is difficult to determine whether or not Brown was steadily employed by the firm. There are several sheet music covers signed by Brown and printed by George Endicott dating from 1840 to 1842. Typical of these are "Hewitt's Quick Step," "Ship on Fire," and "The Young Cracovienne Maid," which features a portrait of Emelina Sutton. In addition he copied Charlon's portrait of Madame Taglioni, produced a portrait of Ellen Tree, and a self-portrait as the *Gypsey King*. Hart also records that he drew a certificate of membership for the Light Guards, a militia group of which he was a member.[23] In the year following, he published his own prints and was in a partnership with J. Brown for two years. Nathaniel Currier published one of his prints in 1852. Hart noted that Brown was "a good copyist, but not an original draughtsman." He further commented that "Brown was an athlete, excellent company, and very fond of my Master [George Endicott], and was, sometimes, called the Master's Shadow."[24] In 1852 Brown accompanied Commodore Perry on his expedition to Japan as a daguerreotypist and artist. He went on to work for the United States Navy in various capacities from 1855 to 1875, severing his connections with lithography.

In contrast to those lithographic draftsmen who were probably employed by the Endicott firm on a free-lance basis, and artists who used the Endicott equipment for their occasional forays into lithography, several men served apprenticeships with the firm and remained as artists for periods of time ranging from only a year or two to twenty. These were the men that Hart knew and his comments amplify the meager information usually available about nineteenth-century lithographers. Penniman, D'Avignon, Sanford, Swinton, and Parsons were among the most prolific. Others were employed by the firm, but information on them is scant, nor do there seem to be many prints signed by them. For example, Hart mentions John Crawley, Jr., and calls him "one of Endicott's young artists." Hart describes a lithograph by Crawley entitled "The Romance," depicting a girl reading a book in bed. Supposedly this lithograph won a gold medal at the annual fair of the American Institute in New York in the 1830s,[25] but my attempts to verify this have not proved successful. Since one of the competing prints was issued by Risso and Browne, this fair must have been held between 1832 and 1836, Risso and Browne's years of activity. It would be in-

teresting to know more about it, for William Dunlap commented on Crawley's skill as a lithographic draftsman and located him at Endicott and Swett's establishment.[26]

Francis D'Avignon worked for George Endicott on his arrival in the United States. Born in Paris in 1813, he was trained as a military engineer but switched to a career as an artist. He spent twelve months in England around 1840, then opened a studio in Hamburg, which was destroyed by fire in 1842. Shortly thereafter, he came to New York.

D'Avignon's forte was portraiture. Typical of his early work is a sheet music cover, "The Gipsey in the North," published in 1846. For this portrait of Julia Newhall, D'Avignon copied a daguerreotype by L. L. Bishop. A more complex print by D'Avignon is the portrait of Ralph Izard copied from a miniature which serves as the frontispiece to the 1844 edition of his *Correspondence*. Examples of his best work are the portraits of Henry Clay (1844), Reverend Mancius S. Hutton (1846 or 1847) (figure 2.3), and Theodore Frelinghuysen. These folio lithographs exhibit D'Avignon's talents, which came to fruition in the plates for the *Gallery of Illustrious Americans*, published in 1850. D'Avignon published his own prints in New York from about 1847 until 1859, when he moved to Boston.

Hart discusses D'Avignon's work at some length. He says "The work of this artist was highly finished, and classical in style possessing all the beauty of the very best schools of lithographic art."[27] But there was another side to this perfection—the difficulties presented to the printer by D'Avignon's drawing, "owing to his peculiar method of picking and scraping" the stone.[28] Why D'Avignon's technique on stone should be a problem for printers is unclear.

John Penniman (not to be confused with another artist, John Ritto Penniman) served as an apprentice to Endicott and Swett in Baltimore and accompanied them to New York. He was born in 1817 and died in 1850, at the age of thirty-three, possibly, according to Hart, from alcohol-related problems. He lived during his apprenticeship with George Endicott and his family at 119 White Street. He left New York as soon as he was able, apparently in 1834, and returned to Baltimore. This year is verified by a vignette signed by Penniman for a piece of sheet music, "Sit by the Summer Sea," published by John Cole and Son in 1834 in Baltimore. Hart describes his exit from the Endicott shop as follows: "Being dramatically inclined, he selected the Fourth of July for the Declaration of his Independence. Having purchased an American flag attached to a Staff, he ascended to the roof, tied his flag staff to the chimney and went off with flying colors."[29] He seems to have returned to New York and the Endicott firm shortly

REV. MANCIUS S. HUTTON, D.D.

Pastor of the Dutch Church, Washington Square.

New York.

Published by William Archer, N.º 239, Wooster St.

2.3. Francis D'Avignon, *Rev. Mancius S. Hutton, D.D.*, ca. 1846–47. Lithograph, 14¾ × 10 in. Lithographed by G. & W. Endicott. Courtesy of the American Antiquarian Society, Worcester, Mass.

after 1840. Hart characterized him as a "universal artist and erratic individual" and a "clever and versatile designer" and, alluding to his drinking habits, noted his "love of the flowing bowl."[30] Hart lists a few prints designed by Penniman including a portrait of the poet Macdonald Clark of 1842 and, ironically, the certificate for the Washington Temperance Society. According to Hart, this was "by far the most elaborate and 'thoughtful' piece of work done by Penniman during his stay at the Endicott's." He also drew a portrait of William Denman, editor of the *Truth Teller* of 1842 (figure 2.4), and several sheet music covers including "The Odd Fellows Greeting" and "La Cachuca." All of these prints date from the early 1840s, the period of his second New York sojourn. At this time he was, as Hart called him, the "headman" among the artists.[31]

Among other artists active at Endicott's for a number of years was George Theodore Sanford. He was born in Litchfield, Connecticut in 1815 and died there on April 7, 1848. Small, dark complexioned, and cheerful, his talents went beyond drawing and designing to playing the flute and violin. Hart noted that he designed many music titles, sketched in pencil, painted in watercolors and oils, wrote doggerel verse, and helped Joseph Britton and Hart to create and publish humorous valentines.[32] Britton later went to San Francisco.

Sanford signed a number of lithographs issued by George Endicott, including several sheet music titles ("The Striped Pig," "Time! Thou Cheat of Human Bliss," "Yes Me thinks I See Her Smiling"), some illustrations for *The Farmer's Library and Monthly Journal*, and circus posters (*The Great Chinese Museum* and *Madam Louisa Howard*). He also drew on stone *A View from the St. Charles River at Quebec City, Showing the Great Fire of 28 June 1845* and the *Burning of the Splendid Steamer Erie off Silver Creek, Lake Erie*, impressions of which are in the Public Archives of Canada. At the Library of Congress is the *Steamship Southerner* printed by G. & W. Endicott.

Hart noted in his memoir that Sanford became very ill and was then nursed back to health by a woman whom he later married against his own better judgment. According to Hart, his wife placed so many financial demands on Sanford that he again became ill from overwork and returned to his family's farm in Litchfield, Connecticut, where he died in 1848. This is a pattern repeated many times in Hart's memoir, where he reports the deaths of a number of draftsmen and printers from consumption or alcoholism at tragically early ages.

During the years of Sanford's activity at Endicott's, there also issued forth a number of prints signed "Spoodlyks." David Tatham has suggested that this word might possibly be related to a Dutch-derived phrase, "spondulicks" mean-

WILLIAM DENMAN ESQ.

Editor of the Truth Teller.

Published by John G. Farley Nº 232 Mulberry St New York 1842.

Lithog. of G. Endicott Nº 22 John St NYork.

2.4. John Penniman, *William Denman Esq. Editor of the Truth Teller*, 1842. Lithograph, 13 × 9¾ in. Lithographed by G. Endicott. New York: John G. Farley. Courtesy of the American Antiquarian Society, Worcester, Mass.

ing "small change," or the Dutch "spoed" meaning "with dispatch." Perhaps these prints were done for small amounts of money as a sideline. In any event, Sanford may be Spoodlyks. The Spoodlyks-signed prints in the collections of the American Antiquarian Society are comic in nature, including the music covers "The Gingerbread Man" of 1836, which shows Endicott's music store on Broadway, "Dandy Jim from Carolina" of 1844, and the "Santa Claus Quadrilles" of 1846 (figure 2.5). Common to "The Striped Pig" signed by Sanford and several of the titles signed by Spoodlyks is the unusual use of an inky black tusche in areas of deep shadow. In addition to this stylistic detail is the humorous character of all the Spoodlyks prints, consistent with Hart's assessment of Sanford's personality. The years of Spoodlyk's activity also coincide with those of Sanford. On the other hand, Lester Levy has suggested that Spoodlyks might be George or William Endicott. George Endicott died in the same year as Sanford. The illustrations signed by George Endicott for *Puss in Boots* prove that he could draw on stone, yet stylistically those illustrations are very different from those signed by Spoodlyks.[33]

Another lithographer who was active for several years with the Endicotts was Frederick Swinton. Born about 1819, he was involved in several important projects and deserves more recognition than he has received. His skill was recognized by the judges of the American Institute at the fairs in 1836 and 1838, where he won diplomas for his watercolors. Peters in *America on Stone* states simply that he "drew views and animals for Endicott, and views and technical prints for R. H. Pease."[34]

Hart states that he knew Swinton between 1842 and 1844. Actually, Swinton was active at Endicott's off and on at least through 1851. Among his work were illustrations for books and periodicals, including Benjamin W. Norman's *Rambles by Land and Water* (New York, 1845), Alfred Robinson's *Life in California* (New York, 1846) and *The Farmer's Library* (1845–46). The style of these lithographs demonstrates great calmness, and it is not surprising that Hart noted Swinton's very quiet demeanor while at work.[35]

Swinton was also involved in the production of two of the plates for the *Army Portfolio* by Captain Daniel P. Whiting published in 1847. This portfolio is quite scarce; family tradition insists that only twenty-four sets were made. Whiting was an officer in General Zachary Taylor's army in the campaign in Mexico in 1846, and he made a set of drawings, only five of which were lithographed. Other drawings were lost in a steamboat on the Mississippi. Swinton drew two of the plates, the *Heights of Monterey* (figure 2.6) and *View of Monterey from Indepen-*

2.5. "Spoodlyks" (perhaps George T. Sanford), *Santa Claus' Quadrilles*, 1846. Lithograph, 12¼ × 8½ in. Lithographed by G. & W. Endicott. New York: Firth, Hall & Pond. Courtesy of the American Antiquarian Society, Worcester, Mass.

2.6. Frederick Swinton, *Heights of Monterey*, 1847. Lithograph, 14¼ × 19¾ in. Lithographed by G. & W. Endicott; Plate from Daniel P. Whiting, *Army Portfolio* (New York: D. P. Whiting). Courtesy of the American Antiquarian Society, Worcester, Mass.

dence Hill. Two of the other plates were copied by Charles Parsons, and one was by Charles Fenderich.[36]

The project that involved Swinton over several years was the publication of the geological survey of the state of New York. This survey was published in twenty-seven quarto volumes between 1842 and 1888. Those published through 1851, including volumes on zoology, botany, mineralogy, paleontology, geology, and agriculture, contain plates lithographed by the Endicott firm. Printing the plates for the New York geological survey was a great boon to the firm, for it came at a time when there was not enough work for all the lithographic firms in New York. Lithography was chosen as the medium of reproduction because the legislative committee had decided that the cost of steel plate engraving would be too high.[37] The plates are beautifully produced. After 1851, the responsibility for the lithographs shifted to R. H. Pease in Albany, and Swinton left New York to work with that firm. Swinton drew the plates for the paleontology volumes published in 1847 and for the agriculture section published in 1851.

Hart has an interesting comment on Swinton's work. "Though good as a general lithographic artist, still Mr. Swinton was truly great in the delineation of fossils. . . . In the course of time it was discovered by his alert and critical associates, that while Mr. Swinton was attaining such perfection in the delineation of fossils, he was becoming fossilized himself." In reference to a landscape by Swinton, Hart continued, "his critics called attention to what they asserted to be a fact—that fossilized trees bore fossilized leaves, and the fossilized clouds were floating through a fossilized sky and a fossilized river was flowing through a fossilized landscape."[38]

Of all the artists and draftsmen associated with the Endicott firm, Charles Parsons is the best known. Born in England in 1821, he came to the United States in 1830. At the age of twelve, he was apprenticed to George Endicott and boarded at Endicott's home. Within two years he was drawing on stone.[39] Parsons stayed with the firm until shortly after the fire on December 29, 1859, which destroyed the shop, Charles Hart's own collection of lithographs, and the firm's records and specimen books. After leaving the firm, Parsons worked briefly for Frank Leslie's publishing firm before becoming head of the art department at Harper and Brothers in 1861.[40] In addition to his work as a lithographer, he was also a watercolorist and an associate of the National Academy. The prejudice against commercial lithography was so strong at the time of his death in 1910 that his obituary in *Harper's Weekly* failed to mention his association with the medium.

Indicating Parsons's versatility, Hart noted that "he had superiors in por-

traiture and landscape, but no lithographic superior in the delineation of steamships, steamboats and sailing craft of all kinds. . . . His marine pictures have in my opinion always been his best, in lithography, as well as in watercolor."[41] It was not until the 1850s that he began to produce the large folio lithographs of steamboats for which he is best remembered. In the 1840s, Parsons signed a number of lithographs. Portraits by him are found in Jacob B. Moore's *Lives of the Governors* (New York, 1848), and scenes of ruins are in Benjamin W. Norman's *Rambles in the Yucatan* (New York, 1843). Sheet music covers by Parsons include "The Mahopac Lake Waltz" (1846), "The Ocean Wave Quickstep" (1843), and "Slaying the Deer" (1847) (Figure 2.7). The last of these shows Parsons at his best creating a visual pun on the title of Samuel Lover's song. He shared the responsibility for *The Great Chinese Museum* (1847) with George Sanford, but alone drew *The Great Egyptian Dragon Chariot* (1849). At the Library of Congress are impressions of *Calvary Church* (1847) and membership certificates for the Society of the Cincinnati and the United Americans of the State of New York. Parsons also put on stone the view of *Sacramento City, California* published by Stringer and Townsend in 1850, an impression of which is located at the New York Public Library. William Endicott and Company printed this city view, as they did several of Edwin Whitefield's.[42]

The importance of the Endicott firm has been alluded to, but their contributions to the practice and history of lithography should be enumerated. First of all, George Endicott, during his tenure as head of the firm and particularly in the 1840s, insisted on employing first-rate printers. He hired, for example, two printers at Lemercier's in Paris in 1846. Also among his printers was Francis Michelin, who had been trained at Hullmandel's firm in London. Three printers imported from Europe by the Pendleton firm in Boston also worked for Endicott at various times.[43] The printers came and went with some rapidity, and many of them later set up their own firms. The quality of their work was noted in 1835, 1836, and 1846, when the firm received awards at the annual American Institute fairs in New York.

Like the Pendleton firm in Boston, Endicott's served as a source of employment and camaraderie for emerging artists. George Endicott hired many men who considered themselves to be fine artists, and who from time to time exhibited their watercolors or oil paintings. Parsons did so at the American Art Union Sale in 1852. One artist active at the firm in 1849 was James I. Glasgow, originally from Dublin. He idolized Turner, had read Ruskin's *Modern Painters*, and undoubtedly shared his enthusiasms with his colleagues.[44] In writing about his brother Daniel T. Glasgow (1834–58), Hart noted "there was about the

2.7. Charles Parsons, *Slaying the Deer,* 1847. Lithograph, sheet music title page, 10⅞ × 7¾ in. Lithographed by G. & W. Endicott; New York: Firth, Hall & Pond. Courtesy of the American Antiquarian Society, Worcester, Mass.

Endicott's establishment an artistic atmosphere, which strongly appealed to Glasgow. There he could associate with those who, like himself, had aspirations far above commercial lithography." Napoleon Sarony tried to persuade Glasgow to join his establishment, but the offer was declined. Glasgow feared he would "relinquish all his high artistic aspirations, and settle down into the position of a lithographer, pure and simple, for the rest of his life, and grind out commercial lithography."[45]

No artists of the stature of Fitz Hugh Lane or Winslow Homer emerged from the Endicott firm. Yet the talent that went into even sheet music covers and book illustrations was generally good, and many of the draftsmen were versatile. Hart noted that at Endicott's "a lithographic artist was expected to draw anything and everything. . . . The modern system of dividing work up into many branches, and each man doing one branch is a great advantage, I think, for the establishment, but a positive injury to the operative."[46] In some firms, one man would do landscapes, one would do figures, one would do lettering or scroll work, yet another would draw portraits and so on. George Endicott seems to have permitted each man's talents to develop. Sanford, for example, was a printer who also designed and drew on stone, a versatility that most other establishments apparently did not encourage. The combination of well-trained and experienced printers and talented artists effectively maintained quality.

Hart's memoir has its pitfalls. Some of his facts are incorrect, and Hart's reverence for George Endicott is excessive and even annoying. Yet his memoir provides a wealth of information which has barely been tapped for this overview. Hart asserts at the beginning of his manuscript that "the Endicott's establishment was at the head of the lithographic business in the United States. Under the leadership of Mr. George Endicott, it reached the zenith of its glory, attracting to its office all the best artists, engravers, and printers."[47] Even allowing for Hart's exaggeration, this drawing together of many talented people was a very substantial contribution of the Endicott firm to the development of lithography in New York.

NOTES

1. Examples are David Tatham's articles, "The Pendleton-Moore Shop—Lithographic Arts in Boston, 1825–1840," *Old-Time New England* 62 (Fall 1971): 29–46; and "John Henry Bufford, American Lithographer," *Proceedings of the American Antiquarian Society* 86 (April 1976): 47–73.

2. "The Editor's Attic," *Antiques* 22, no. 5 (Nov. 1932): 167.

3. I would like to thank Laurie A. Baty, assistant librarian for prints and photographs, Maryland Historical Society, for checking that collection as well as those of the Peale Museum and the Baltimore Museum of Art.

4. See advertisement for Senefelder Lithographic Company in the bi-weekly *Columbian Centinel*, September 17, 1828. According to Everett S. Stackpole, *Swett Genealogy* (Lewiston, Me.: Journal Print Shop, 1913?), Moses Swett was born in Poland, Maine, on July 7, 1804, the son of Moses Adams Swett. The family had moved to Boston by 1807, for Moses Swett's younger sister was born there in 1807.

5. Lois B. McCauley, *Maryland Historical Prints, 1752 to 1889* (Baltimore: Maryland Historical Society, 1975), p. 229.

6. I am very grateful to the late Gordon Colkett for generously sharing this document with me. A photocopy of it is available at the American Antiquarian Society. Typical of Endicott and Swett's New York City prints are portraits of public figures (Henry Clay, Napoleon, Major Jack Downing), "pin-ups" such as the "Belle of Boston" and the "Pride of New York," and covers for pieces of sheet music ("We have met to remember the day" and "Huntsmen rouse thee! Hark the Horn!" by Joseph DePinna).

7. Introduction, Charles Hart, "Lithography, Its Theory and Practice, Including a Series of Short Sketches of the Earliest Lithographic Artists, Engravers, and Printers of New York," Manuscripts Division, New York Public Library.

8. Hart, p. 89. According to the *Journal of the American Institute* 1, no. 9 (November 1835), one of these paintings won a silver medal for the "best specimen of oil painting" at the Eighth Annual Fair of the American Institute in 1835.

9. Hart, p. 91.

10. Ibid., Introduction.

11. Maryland Historical Society, Hayward File, clipping from *Baltimore American,* courtesy of Laurie A. Baty.

12. Hart, p. 53.

13. Ibid., p. 67.

14. Ibid., p. 77.

15. Ibid., p. 75.

16. Ibid., p. 81.

17. Tatham, "John Henry Bufford," pp. 47–73.

18. *Journal of the American Institute* 1, no. 2 (November 1835): 80.

19. For information on Clay, see Nancy R. Davison's "E. W. Clay: American Political Caricaturist of the Jacksonian Era," Ph.D. Dissertation, University of Michigan, 1980.

20. Hart, p. 40.

21. American Art Association Catalogue no. 4301, February 11, 1937, pp. 35–36.

22. Harry T. Peters, *America on Stone* (Garden City, N.Y.: Doubleday, Doran and Co., 1931), p. 87.

23. Hart, p. 125.

24. Ibid., p. 127.

25. Ibid., pp. 91–93.

26. William Dunlap, *A History of the Rise and Progress of the Arts of Design in the United States,* vol. 3 (Boston: C. E. Goodspeed, 1918), pp. 266–67.

27. Hart, p. 175.

28. Ibid., p. 177.

29. Ibid., p. 139.

30. Ibid., p. 149.

31. Ibid., p. 138.

32. Carleton E. Sanford, *Thomas Sanford, The Emigrant to New England,* vol. 1 (Rutland, Vt.: Tuttle Company, 1911), p. 174; and Hart, pp. 40, 119, 121–123.

33. Lester S. Levy, *Picture the Songs: Lithographs from the Sheet Music of Nineteenth-Century America* (Baltimore: Johns Hopkins University Press, 1976), p. 74.

34. Peters, *America on Stone,* p. 379.

35. Hart, p. 208 1/2.

36. *The Month at Goodspeed's Book Shop* 21, nos. 2–3 (November–December 1959): 43–46.

37. Hart, p. 239.

38. Ibid., pp. 209 1/2–210.

39. Peters, *America on Stone,* p. 308.

40. Henry Mills Acton, "Charles Parsons," *Harper's Weekly,* November 19, 1910.

41. Hart, p. 151.

42. Bettina A. Norton in *Edwin Whitefield* (Barre, Mass.: Barre Publishers, 1977) lists several views printed by William Endicott and Endicott and Company.

43. Hart, p. 241.

44. James Glasgow died on January 21, 1853, from consumption.

45. Hart, p. 195.

46. Ibid., p. 209.

47. Ibid., Introduction.

3

St. Lawrence County, 1838,
As Seen through the Eyes of Salathiel Ellis

WENDY SHADWELL

A set of eight lithographs depicting scenes in St. Lawrence County, New York, provided the initial impetus for this chapter. It would perhaps be more accurate to say two sets of four lithographs each, for two different lithographers were involved. Four scenes were produced by the Speckter lithographic firm of Hamburg, Germany, which was run by Johann Michael Speckter, assisted by his son, Otto, between 1834 and 1845. The dimensions of these are virtually identical: about 11 × 14¼ inches. The other four were lithographed by Eugène Cicéri, a painter and lithographer of landscapes who lived and worked in Paris from 1813 to 1890. One of the Cicéri prints measures 11¼ × 14½ inches, but the other three are progressively larger, the largest measuring 17½ × 25⅝ inches. All eight are after designs by Salathiel Ellis and they appear to date about 1838. Seven of these scenes are in the collection of the New-York Historical Society.[1]

It was a family named Parish that commissioned the artist and arranged for the lithography of these views of its properties and industrial ventures in St. Lawrence County. Originally English landed gentry, the Parishes moved to Scotland as a result of the English Civil War and became successful merchants. One enterprising Parish took advantage of business connections in Hamburg to establish a concern there. His son John was born in Hamburg. This John sired five sons between 1774 and 1781. The eldest, a keen astronomer, became such an important landowner in eastern Bohemia (now Czechoslovakia) that he was created Baron Senftenberg. Two carried on the family business in Hamburg.

And two, after conducting business in Antwerp and London, spent their most fruitful years developing upstate New York.[2]

David Parish (1778–1826) was the first to arrive, landing in New York City in January 1806. His main goal was to complete delicate negotiations and to implement plans for transferring gold bullion from Spanish colonies in the Western Hemisphere to Spain, despite the ongoing Napoleonic Wars. He was spectacularly successful, and his share of the profits from the syndicate brought him about a million dollars. Gouverneur Morris, an old Parish family friend, entertained David at his New York City residence and persuaded him to invest in real estate in the North Country. Parish had the area carefully surveyed, hired an agent, and on December 2, 1808, purchased 200,000 acres in St. Lawrence and Jefferson counties. Early in 1809 he bought the town of Ogdensburg on the St. Lawrence River, which became the principal settlement in the district. By June 1809 Daniel W. Church, a local builder, had started to work upon a house for David Parish (figure 3.1) with the assistance of forty skilled laborers brought from Montreal.[3]

By 1815 Parish was yearning to return to Europe, so he invited his younger brother, George (1780–1839), to oversee his American properties in his absence. George (called George I to distinguish him from others in his family) arrived late in 1815 and found the climate suited him ideally. He described the house in his journal early in 1816:

> David's House is a fine Brick Building of two Stories, with Wings, and commands a noble view of the River. A Stable for Six Horses with Coach House Annexed are in the Rear, and the whole is enclosed by a neat fence. In a situation so remote (being 500 Miles from the Capitol) it would scarcely be expected to find all the luxuries of the Old World, but I can assure you, that in David's House, nothing is wanting to render it as pleasant a residence, as if the establishment was situated on the Banks of the Thames. A well stocked Larder, and the finest Venison, an overflowing Cellar, with the best Wines, are now to be found on the St. Lawrence.[4]

David departed in July 1816 and never returned. George I acquired all of David's property and lived in the Parish mansion until 1838, shortly before his death, which occurred in Paris. He was succeeded by another bachelor, his nephew George II (1807–81), who arrived in the United States in 1838. George II lived here until February 2, 1861, when he left New York to take possession of

3.1. Salathiel Ellis, *View of the Residence of George Parish, Esqr.,* ca. 1838.
Lithograph, 11¼ × 14½ in. Lithographed by Cicéri, Paris. Courtesy of the
New-York Historical Society, New York City.

the Senftenberg barony, which had been vacant since the death of his uncle, John, in 1858. During most of his residency in Ogdensburg George II's companion was Maria Ameriga Vespucci, a descendant of the navigator, whom he won from John Van Buren, son of the president, in a poker match![5]

The house still stands and serves as the Frederic Remington Art Museum. The Ellis lithograph shows what was then the front of the house; nowadays the front of the Museum faces the river. The original lot of Parish property was subdivided and sold years ago, part becoming a business area. An addition to the museum was built in 1976, so the façade shown in the lithograph is no longer visible.

David Parish was concerned about the development and improvement of his land; unlike other holders of vast tracts, he did not intend to resell to the highest bidder at the earliest opportunity. To this end he encouraged settlement by hardworking farmers, he experimented with sheep-raising, and he established the St. Lawrence *Gazette* in Ogdensburg in 1816. To provide the necessary commercial facilities he had Daniel W. Church erect a large stone structure (figure 3.2) on Water Street. It went up between May 7, 1809, and late summer of 1810. This then served as the permanent home of a store that had opened in November 1808 with $40,000 worth of merchandise. Whiskey was not the only, nor even the main commodity, as it appears from the illustration. Parish's senior agent, Joseph Rosseel, was one of the original partners in the store, which floundered after five years and had to be saved from bankruptcy by Parish. A new partner was found for the mercantile business, and thereafter Rosseel confined his activities to land agency.[6] This building still stands and has been used as headquarters of the Ogdensburg Custom District since September 16, 1928. There is a glimpse of the St. Lawrence River in the background of this Ellis view as well. David Parish was anxious to develop Ogdensburg into a port for shipping on Lake Ontario and also to Montreal via the St. Lawrence. A shipyard he founded in Ogdensburg was put out of business by the War of 1812. In that year he sold the two schooners the yard had constructed to the United States Navy.[7]

Parishville, a village named for David Parish, is located about thirty-five miles east of Ogdensburg. A view of Parishville (figure 3.3) shows the clearing of the land that Parish started in 1810 under the direction of his agent, Daniel Hoard. Turnpikes were cut and roads extended. In 1811 Parish had Daniel W. Church erect a grist mill and a sawmill, and Hoard had a distillery built on his own account, which was successfully operated for years. During the War of 1812 the dangers posed by naval activity on the St. Lawrence and the proximity of the

3.2. Salathiel Ellis, *Ogdensburg Whiskey Store*, ca. 1838. Lithograph, 11¼ ×
14½ in. Lithographed by Speckter & Co., Hamburg. Courtesy of the New-
York Historical Society, New York City.

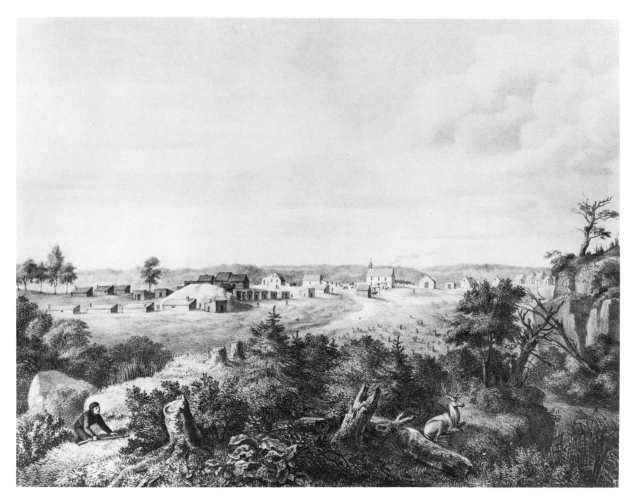

3.3. Salathiel Ellis, *Parishville*, ca. 1838. Lithograph, 11 × 14¼ in. Lithographed by Speckter & Co., Hamburg. Courtesy of the New-York Historical Society, New York City.

Canadian border to Ogdensburg resulted in a notable population increase around Parishville. A forge was built and operated, an elementary school was established in 1813, and David Parish erected a wooden building for public purposes such as religious gatherings and town meetings, and a tavern, the latter at a cost of $12,000. In the foreground of this view a wary hunter stalks a resting stag. It wasn't only in Parishville that venison could be obtained. In a letter to his father David Parish wrote: "I receive from Rossie more fat deer than we can consume."[8]

The town of Rossie is located twenty-five miles southwest of Ogdensburg on the Indian River. The name Rossie derives from Rossie Castle near Montrose in Scotland, which was owned by the husband of David Parish's sister. The surrounding area in the western part of the county was the scene of David and George I's most intense industrial enterprises. Settlement of Rossie began in 1807, just a year before David Parish acquired the land. Farms were established and a lumber mill was started on the river. Although a blockhouse was built to which the inhabitants could retire in case of need, the community was not touched by the War of 1812. Upon learning of the presence of iron ore on his lands, David Parish sent samples for analysis and he visited iron works in Pennsylvania and New Jersey. As a result of positive reports, Rossie Furnace (figure 3.4), the first blast furnace in northern New York State, was constructed in 1813 and went into operation in 1815. Ample fine-quality ore was available, but there was difficulty locating experienced men to superintend and to work the furnace. It lay idle for various periods until George I got it into operation again in 1837 when a new stack, shown here, was built. This was replaced in 1844 by an even taller one.[9]

An area near Rossie that was later to boast an iron works was first developed late in the summer of 1810, when David Parish dispatched Daniel W. Church and a group of workers to erect lumber mills and to encourage settlement of the land. This business prospered, nearby new roads were cut through and bridges built. Success of the blasting operation at Rossie Furnace made feasible establishment of an ironworks to smelt the metal and make heavy iron products. The Rossie Ironworks (figure 3.5) included mills, a foundry, and a machine shop which produced castings and machinery. The community and the industry flourished and in the words of the county historian, "from this period the settlement exhibited much life and spirit under the enterprising direction of Mr. Parish, its proprietor."[10]

Lead deposits were present in the Rossie vicinity and had been known to local Indians, who could work the metal in a simple way. Discovery of the rich

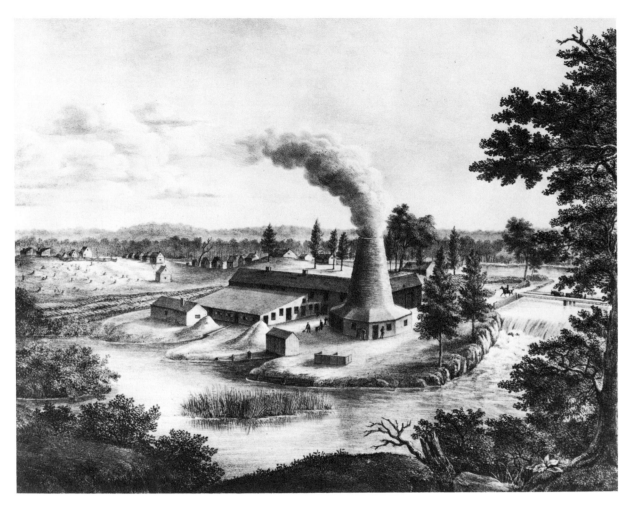

3.4. Salathiel Ellis, *Rossie Furnace*, ca. 1838. Lithograph, 11½ × 14¾. Lithographed by Speckter & Co., Hamburg. Courtesy of the New-York Historical Society, New York City.

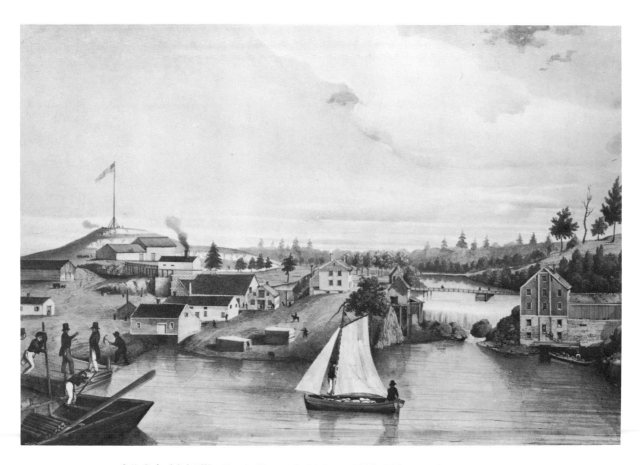

3.5. Salathiel Ellis, *Rossie Honworks* [sic], ca. 1838. Lithograph, 15 × 21½ in. Lithographed by Cicéri, Paris. Courtesy of the Sigmund Samuel Canadiana Collection, Royal Ontario Museum, Toronto.

Victoria vein on the Indian River about two miles southeast of the iron works was reported to George Parish I upon his return from a trip to Europe in September 1835. Rossie Lead Mines (figure 3.6) and Victoria Lead Mines (figure 3.7) therefore represent the last of all the Parish family ventures in this series and, as it happens, the least successful. Serious operations began in January 1837, and the mines were spectacularly lucrative at first, producing many tons of unusually pure lead. Both managers and miners were inexperienced, however, expenses were high, machinery turned out to be inefficient, and the final blow came when the market for lead dropped off, lowering the price. Working of the lead mines ceased about 1840. In each view several horsepowered whins are shown. These hoisting devices wound a rope around a drum to raise a basket or bucket from the mine.[11]

The final scene in the series is entitled simply *A Winter Scene* (figure 3.8). The North Country's frozen vistas are enlivened by a group of Indians, one pulling a sled at the lower right, a trio of ice skaters in the left background, and in the center a person on foot watching a low box sleigh drawn by four horses crossing a bridge. It would be pure speculation to surmise that the proprietorial figure seated at the rear of the sleigh represents George Parish I or II. It seems, however, to be a personage of some standing who is being kept comfortable with warming stones in a bed of straw beneath the buffalo robes.[12]

It is not certain which George Parish was responsible for the commissioning and execution of this unusual set of views of family properties and enterprises. In 1838 George II arrived from Bohemia and George I returned to Europe. George I, who had been living in northern New York for over twenty years, would have had ample opportunity to commission Ellis to make the drawings and then to have taken them back to the Continent with him for lithography. The Speckter firm was headquartered in Hamburg, where his brothers, Charles and Richard, still owned and operated Parish & Co. It was in Paris, home of the Cicéri firm, that George I died in 1839. I think it probable that we can thank George I for the existence of these prints, although George II may well have had a hand in the project. The most likely dates for the drawings would seem to be 1837 or 1838 and for the lithographs 1838 or 1839.

And what of the artist responsible for these revealing glimpses into life and work in St. Lawrence County, around 1838? Salathiel Ellis was named for an Old Testament worthy, Shealtiel, who served as a governor or captain of Judah. Salathiel's father and a brother were both named Ziba, but the family penchant

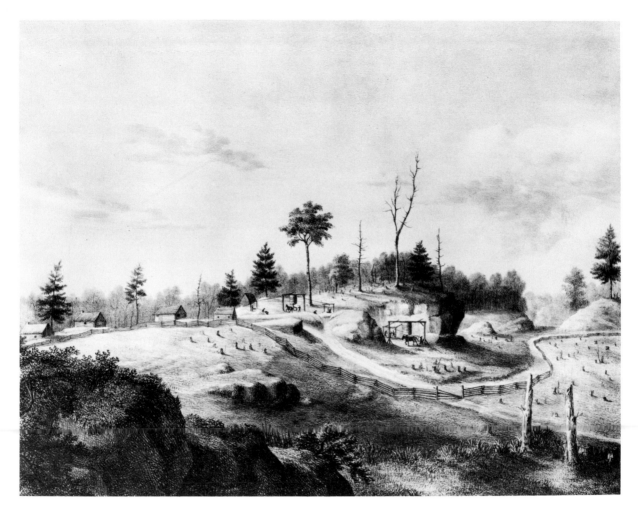

3.6. Salathiel Ellis, *Rossie,* ca. 1838. Lithograph, 11 × 14¼ in. Lithographed by Speckter & Co., Hamburg. Courtesy of the New-York Historical Society, New York City.

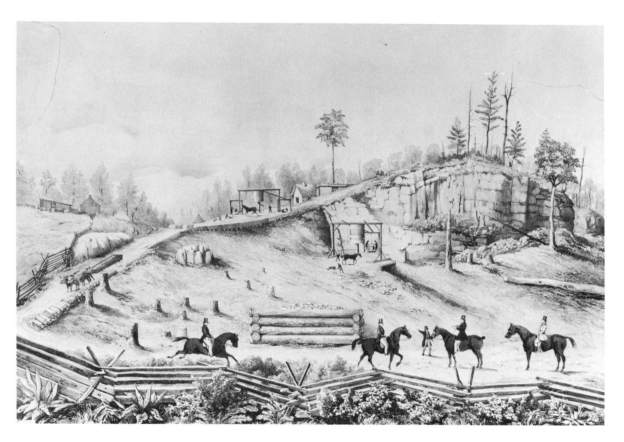

3.7. Salathiel Ellis, *Victoria Lead Mines,* ca. 1838. Lithograph, 17¾ × 25¾ in. (margins trimmed). Lithographed by Cicéri, Paris. Courtesy of the New-York Historical Society, New York City.

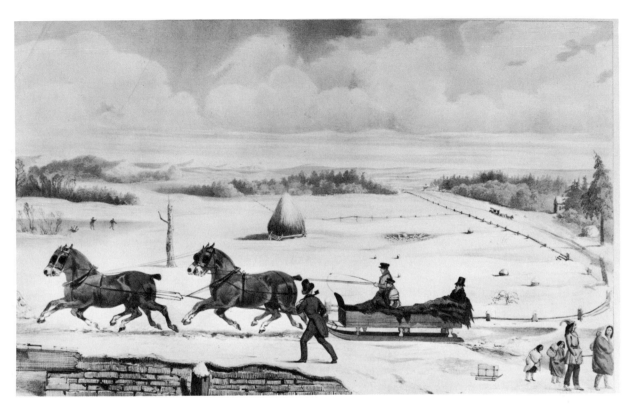

3.8. Salathiel Ellis, *A Winter Scene, County of St. Lawrence, State of Newyork* [sic], ca. 1838. Lithograph, 11 × 17¾ in. Lithographed by Cicéri, Paris. Courtesy of the New-York Historical Society, New York City.

for exotic names seems to have evaporated with that generation, for Salathiel gave his children such names as Mary, William, Frank, and Clara.

Salathiel Ellis was born in Vermont, some sources say in Windsor County, some say in Burlington, which is in Chittenden County. His date of birth is November 13, 1803 (not 1806 as is often given, nor 1860 as Groce and Wallace's *Dictionary of Artists in America* states).[13] Ziba Ellis, Sr., purchased ninety-eight acres of land in the town of Potsdam in 1809, and it is probable that he brought his family to St. Lawrence County at that time. Potsdam was settled largely by emigrants from Vermont. Nothing is known of Salathiel's formative years nor of the source of any instruction he may have received in drawing, sculpture, or the decorative arts. A local book of deeds records that one Salathiel Ellis of Potsdam purchased sixty rods (approximately three acres) of land in Canton in 1828. His partner in this venture was Benjamin Stimpson, and they operated what was described as a "chair shop" and a "picture shop" until 1835, when Stimpson sold out and his place was taken by Joseph F. Blood. The shop was near a brick meetinghouse used by both Baptist and Universalist congregations. Salathiel and his younger brother, Ziba N. Ellis, were charter members of the Universalist Society that was founded in Canton in November 1825.[14]

In 1839 the St. Lawrence *Republican,* which was published in Ogdensburg, referred to "Mr. S. Ellis of this village." It seems possible, therefore, that after his work on the Parish commission Ellis settled permanently in Ogdensburg. He was certainly there in November 1838, for he was an eyewitness of the Battle of Windmill Point.

This battle took place during the Patriot War, which pitted Canadian rebels and their American supporters from northern border counties against the British in Canada. The goal was to invade Canada, free it from the British yoke, and establish a republic. To spearhead the invasion two schooners loaded with arms, ammunition, and men were supposed to make a night landing at Prescott, Ontario, directly across the St. Lawrence from Ogdensburg, and take nearby Fort Wellington by surprise. However, they were spotted by a sentry, who sounded the alarm. One schooner ran aground on a sandbar, and the other landed at Windmill Point, a mile and a half downstream of Prescott. The Patriot commander took possession of a strong stone windmill and prepared for battle while awaiting reinforcements that never arrived. The British kept a vigilant guard on the Patriots until they had gathered sufficient men and arms for an all-out attack, which came on November 16th. The Patriots surrendered after fifteen of them

had been killed and thirty wounded. Of the one hundred and fifty-seven taken prisoner, over fifty were sent to the penal colony on Tasmania.

The *Battle of Windmill Point* illustrated here (figure 3.9) is a lithograph, but the original of this lively scene was an oil on canvas that Ellis was exhibiting by February 6, 1839. An announcement in the St. Lawrence *Republican* on February 5 reads: "The painting of the closing scene at Windmill Point will be exhibited at the town hall (in Ogdensburg) on Wednesday evening, the 6th. S. Ellis. Tickets of admission, 25 cents. . . . The same will be exhibited at Canton on Thursday evening, the 7th." The paper editorializes:

> The painting is upon canvas six feet by four, and embodies a comprehensive view of the battleground, memorable for the conflict of Tuesday, the 13th of November, and its finale on the Friday following, as it appeared in the evening, lit up by the lurid glare emitted from the buildings consumed on that occasion. There is a grandeur and sublimity in the picture that all will appreciate who witnessed the reality, which reflects much credit upon the artist for fidelity and good taste. The expense which Mr. Ellis has incurred in bringing out this interesting piece we hope to see cancelled in part or whole by our citizens, who will felicitate themselves on so fit an opportunity to extend a fostering hand to native genius. The picture will afford a rich treat to the lovers of the fine arts.[15]

The view shows the embattled windmill, stone and wooden buildings, and British warships overwhelming the outnumbered Patriots. At the lower right, the river's edge in Ogdensburg is crowded with excited spectators. It is not known how great a success Ellis had with these exhibitions, or with the sale of the lithograph, which was copyrighted by George Endicott in New York City on February 8, 1839. Why did Ellis choose an American lithographer for this work? It may be because George Parish I, who had arranged for the European lithography of his family pieces and who very likely even transported the originals to the Continent himself, had already left this country. Without an intermediary it would have been easier for Ellis to deal with an American lithographer.[16]

Ellis left St. Lawrence County and moved to New York City by 1842. From that year through 1848 he appears in the city directory with his occupation given as cameo cutter, cameo portraits, cameo likenesses, or just cameos. In 1849 Ellis's occupation in the city directory is given as "sculptor," which then alternates with

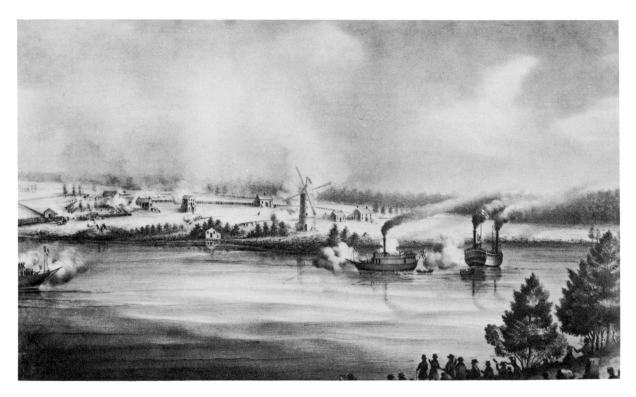

3.9. Salathiel Ellis, *Battle of Windmill Point*, ca. 1838. Lithograph, 12½ ×
20¾ in. Lithographed by Endicott, New York. Courtesy of the Sigmund
Samuel Canadiana Collection, Royal Ontario Museum, Toronto.

"artist" through his final appearance there in 1864. His most consistent business addresses were at 247 Broadway and 346–48 Broadway, the latter being the famous Appleton building, in which Ellis set up his studio in 1855. His home addresses in this period ranged from Williamsburg in Brooklyn, and Rye, New York, back to St. Lawrence County, the latter in 1853 and 1854.

Ellis exhibited at the National Academy of Design nine times between 1843 and 1867. Among the items he entered were: a frame of cameo minatures, a sculpture of Dr. Carnochan in marble, a medallion of Dr. James R. Chilton, and portraits of Cornelius Vanderbilt, Horace Greeley, Elias Howe, and Preston King.[17] At the American Art Union sale in 1852 Ellis displayed a medal of Gilbert Stuart that he had designed and that Charles Cushing Wright had sculpted.[18] Ellis was active and successful over many years as a medal designer and sculptor for the United States Government. Among others he was responsible for national medals of Generals Scott and Taylor in 1848, and for those of Presidents Lincoln, Fillmore, Pierce, and Buchanan.[19]

Ellis's brief reappearance in New York City in 1864 after a four-year gap was probably due to the Metropolitan Fair that opened in April of that year to benefit the Sanitary Commission. He presented two plaster bas-reliefs to the fair, one of Isaac Tatem Hopper, an ardent abolitionist, and one of President Lincoln.[20] The New-York Historical Society owns both of these likenesses, as well as a similar bas-relief of Joshua Brookes and the original plaster for the Gilbert Stuart medal (figure 3.10).[21] A cabinet photograph of Ellis by Charles H. Bill was probably taken during this visit to New York.[22] In 1864 Bill had his studio at 603 Broadway, more or less opposite Ellis's at 596 Broadway. Ellis would have been sixty or sixty-one at that time, which seems consistent with his appearance.

It is not known when Ellis and his wife, the former Clarinda Wilson, were married. It was probably after 1822, when his older brother, James, married her sister, Malinda. Ellis was survived by three sons and four daughters, but it has not been possible to ascertain all their names and establish their birth and death dates and places. The presumed eldest son, born about 1835–36, was named Preston King Ellis, after the Ogdensburg-born politician whose portrait the senior Ellis sculpted.

The family moved to Minnesota in 1858. When the 1860 census was taken, Ellis and his wife were living in Milton, Dodge County, with three sons and two daughters. The occupation given for Ellis and his two eldest sons was farmer.[23] When the 1870 census was taken the family was living in Mantorville, the Dodge County seat. Ellis's occupation was given as sculptor, his wife was still

3.10. Salathiel Ellis, *Gilbert Stuart,* ca. 1848. Plaster bas-relief, 7 × 6 in. oval.
Courtesy of the New-York Historical Society, New York City.

keeping house, and his youngest son, Frank Wilson Ellis, was listed as a photographer.[24] Ellis seems to have falsified or forgotten his age for the enumerators. The age that he claimed to be in each case would have made his birth date 1806 or 1807 instead of 1803. This could be the source of the oft-repeated statement that his birth date was 1806. And it may have some bearing on the statement that he enlisted in Washington, D.C., for the defense of that city upon the outbreak of the Civil War when he was in actual fact fifty-seven years old.[25]

In February 1871 William Fred Ellis, the middle son, registered as a resident of Santa Clara County, California, and was working as a clerk in the city of San Jose. Two years later his brother, Preston King, registered in the county as a farmer. Less than a year after that Salathiel Ellis registered, giving his correct age and his occupation as sculptor. Finally in less than another year Frank Wilson joined his family, registering as a bookkeeper.[26] It is not known whether Clarinda Ellis accompanied her husband and sons to the West. As Ellis was boarding with his son William, according to the 1874 San Jose directory, it is likely that she was no longer living.[27] It is thought that one daughter did move to California.

Ellis was still active as a sculptor after his move to San Jose, if the local papers can be believed. The *Mercury* wrote: "Among his last works, since he became a resident of San Jose, is his bust, in marble, of the late Mrs. Hill, which is regarded as among the most faithful and finished productions of his chisel."[28] The *Daily Morning Times* wrote: "His last work was the colossal statue in bronze of Elias Howe, the inventor of sewing machines, which is now in New York, and for which he was to receive from the Howe Sewing Machine Company $20,000. He has never received but $5000. of the amount and this he got in dribbets."[29] This statue of Howe was exhibited at the 1876 Centennial Exhibition in Philadelphia. It is listed as: "Out-Doors Works of Art. No. 52½. The Howe Monument. A bronze statue, life size, on a sandstone pedestal, erected by the Howe Sewing Machine Company to the memory of the late Elias Howe; situated near the western end of the lake."[30] A photograph of it *in situ* has not been located. The statue was presented to the town of Bridgeport, Connecticut and was installed in the fall of 1884 on a pedestal in Seaside Park, where it remains to this day.[31] On March 4, 1880, the Brooklyn *Daily Times* reported: "Salathiel Ellis has received only $8500 of the $20,000 guaranteed him by contract for his statue of Elias Howe. . . . Litigation has arisen which makes it improbable that he will ever get the rest of his money unless he chooses to lay out more than it amounts to in law suits."[32]

One wonders if Ellis had in fact received the additional $3500 as indicated

here. He certainly never sued for additional payment for, by the time this piece was published, he had been dead for over four months. Ellis died at the home of his son, Preston King Ellis, on Tuesday, October 28, 1879, at age seventy-five. His funeral was held on Thursday the 30th. A brief notice in the San Jose *Daily Morning Times* reported: "The funeral of the late Salathiel Ellis took place yesterday morning under the auspices of Phil Sheridan Post, G. A. R. It was largely attended; the members of the Post, in uniform, marching as an escort. The cortege was preceded by a band of 11 pieces, which made the march to the cemetery more impressive by playing a dirge."[33]

Thus ended the life and career of Salathiel Ellis who, in the words of one of my correspondents, was "a worthy, but forgotten, artist." I trust that after this investigation and the publication of his charming and lively views of St. Lawrence County, he will be better known but considered none the less worthy.

Appendix

Locations of All Known Impressions of Lithographs after Designs by Salathiel Ellis

View of the Residence of George Parish, Esqr.	Private Collection, Canada New-York Historical Society Remington Art Museum
Ogdensburg Whiskey Store	Private Collection, Canada New-York Historical Society
Parishville	Private Collection, Canada New-York Historical Society Canton Free Library
Rossie Furnace	Private Collection, Canada New-York Historical Society
Rossie Honworks [sic]	Private Collection, Canada Remington Art Museum Sigmund Samuel Canadiana Collection, Royal Ontario Museum
Rossie	Private Collection, Canada New-York Historical Society Canton Free Library
Victoria Lead Mines	Private Collection, Canada New-York Historical Society
A Winter Scene	Private Collection, Canada New-York Historical Society Remington Art Museum

Battle of Windmill Point

Private Collection, Ogdensburg
Remington Art Museum
Ogdensburg Public Library
Public Archives, Ottawa
Library of Congress
Sigmund Samuel Canadiana Collection,
Royal Ontario Museum
Thousand Island Museum, Clayton, N.Y.

NOTES

The author wishes to express her appreciation to the dozens of librarians, collectors, curators, professors, and historians in New York City, in the North Country, in Minnesota, and in California, who have patiently and creatively answered her questions and provided her with information. They have generously shared their findings with her and provided illustrations. Special thanks go to Varick A. Chittenden, State University of New York College at Canton.

1. In 1977 six were purchased from the Old Print Shop, New York City, which had acquired them from two sources by 1974. (See *The Old Print Shop Portfolio* 33, no. 6:132–33.) One was purchased from a private dealer in 1981.

2. Activities of the Parish brothers in the United States are discussed in: Philip G. Walters, and Raymond Walters, Jr., "The American Career of David Parish," *The Journal of Economic History* (November 1944): 149–66; and Raymond Walters, Jr., and Philip G. Walters, "David Parish: York State Land Promoter," *New York History* (April 1945): 146–61.

3. Franklin B. Hough, *A History of St. Lawrence and Franklin Counties, New York* (Albany: Little & Co., 1853) pp. 600–604. A portrait of David Parish is reproduced on page 601.

4. Herbert Lasky, "New York State in 1816: The Journal of George Parish," *New York History* (July 1975): 289. A portrait of George Parish is reproduced on page 268.

5. A historical novel, rather coy in tone but well-grounded in fact, was written about the unsuccessful attempt of Mlle. Vespucci to win citizenship and a land grant from the American government, and her subsequent life in Ogdensburg. (Walter Guest Kellogg, *Parish's Fancy* [New York: The John Day Company, 1929]). Her portrait is owned by the Remington Art Museum in Ogdensburg.

6. Rosseel proved a valued agent and consultant who worked for decades under David, George I, and George II. His house in Ogdensburg still stands and serves as the Ogdensburg Public Library. Rosseel's likeness was taken by Ellis in an oval plaster medallion that is signed and dated 1860 (collection of Ogdensburg Public Library). His wife, Louisa, was portrayed by Ellis in a cameo brooch (collection of Owen D. Young Library, St. Lawrence University, Canton).

7. Hough, pp. 402–404; Parish to John Parish, December 1, 1812, Parish Letter Books, New-York Historical Society, 4:163.

8. Hough, pp. 422–25; Parish to John Parish, December 1, 1812, Parish Letter Books, 4:163.

9. Hough, pp. 448–52. David Hounshell, Curator of Technology, the Hagley Museum, points out several inaccuracies in this view. No charging bridge, from which iron ore, charcoal, and flux are put into the furnace from the top, is visible. In addition the waterpower is incorrectly shown: there should be a waterwheel and blowing engines. Also, the stack appears to be round rather than the customary tetrahedron shape. These inaccuracies may be due to lack of comprehension on the artist's part or to artistic license. Correctly presented details are the two heaps of slag or flux near the river's edge, sheds for storing charcoal, and lengthy stacks of cordwood across the left middle ground. (Letter to the author, July 7, 1981.)

10. Hough, pp. 450, 452–55. The work "honworks" in the title of the lithograph presumably represents a French misreading of the word *ironworks*.

11. Lewis C. Beck, *Mineralogy of New-York* (Albany: W. & A. White & J. Visscher, 1842), pp. 48–50; Hough, pp. 455–64. A lithograph by John H. Bufford entitled "Rossie Lead Vein" was included as Plate I in "Report of E. Emmons, Geologist of the 2d Geological District of the State of New York." This report of observations made and explorations undertaken in 1837 was published in *Documents of the Assembly of the State of New-York*, 61st sess. (Albany, 1838) 4, no. 200:185–250. The lithograph is used to illustrate the statement: "The dip [of the vein] is nearly vertical, slightly inclining to the north, as may be seen by the diagram exhibiting a view of the eastern termination of the vein as it was when first exposed by the removal of the rubbish concealing it" (p. 210). No mining activities have commenced in this view, although some trees have been felled and several observers are standing about. The Parish lead mining and iron working industries are specifically mentioned in the text (pp. 209, 211). It might be speculated that Emmons's journey through the North Country and Adirondacks accompanied by an artist, Charles C. Ingham, impelled George Parish immediately to have his family properties and activities depicted.

12. David and George Parish I journeyed from Utica to Ogdensburg in such a sleigh (Lasky, pp. 278–88). In his journal George also remarked upon the lack of Indians even in remote areas, noting that the sight of an Indian was considered a curiosity (ibid., p. 294).

13. Salathiel Ellis's birth is recorded in the Ellis/Spears family Bible, cited in G. Atwood Manley, "S. Ellis Works," in the *St. Lawrence Plain-dealer*, Ogdensburg, September 13, 1961, p. 20.

14. Edward J. Blankman, *The First 150 Years: A Sesquicentennial History of the Unitarian Universalist Church, Canton, New York, 1826–1976* (Ogdensburg: 1976) p. 3.

15. The *St. Lawrence Republican*, Ogdensburg, February 5, 1839, quoted in Elizabeth Baxter, "Back Then," *Rural News*, Canton, N.Y., March 28, 1978. The present whereabouts of the painting are not known.

16. An illustration after Ellis's view appeared in *Mackenzie's Gazette*, Rochester, N.Y., October 12, 1839, and this version is reproduced in "The Battle of the Windmill," a brochure published by the Bureau of Indian and Northern Affairs, Parks Canada, 1976.

17. New-York Historical Society, *National Academy of Design Exhibition Record, 1826–1860* (New York, 1943) 1:151; Maria Naylor, ibid., *1861–1900* (New York: Kennedy Galleries, 1973) 1:269–70.

18. Mary Bartlett Cowdrey, *American Academy of Fine Arts and American Art-Union 1816–1852* (New York: New-York Historical Society, 1953), p. 129.

19. Georgia S. Chamberlain, "Salathiel Ellis," *The Antiques Journal* (February 1954): 36–37; Idem, "Bas-Relief Portraits by Salathiel Ellis," ibid. (October 1954): 23, 39.

20. Ellis's bas-relief of Hopper and marble bust of Dr. John Murray Carnochan (1817–87) received favorable mention in *The Crayon* (April 1857):123.

21. New-York Historical Society, *Catalogue of American Portraits in the New-York Historical Society* (New Haven, 1974) pp. 95, 366–67, 461, 774.

22. This photograph is in the collection of G. Atwood Manley, Canton, N.Y.

23. The census of 1860, Milton Township, Dodge County, Minn., p. 45.

24. The census of 1870, Mantorville, Dodge County, Minn., p. 757.

25. Age and health requirements were frequently compromised in order to fill regiments during the Civil War. (Marvin A. Kreidberg, and Merton G. Henry, *History of Military Mobilization in the United States Army, 1775–1945* ([Washington]: Department of the Army, 1955, p. 98.) It is certain that Ellis was a member of the Phil Sheridan Post, no. 7, G. A. R. in San Jose. See the *San Jose Pioneer*, November 1, 1879, cols. 1, 3; and sources in note 33.

26. *Great Register of Santa Clara County* [1876], nos. 2651, 2653, 2654, 2655.

27. *San Jose City Directory*, 1874, p. 61.

28. *San Jose Mercury*, October 29, 1879, p. 3, col. 3.

29. *San Jose Daily Morning Times*, October 29, 1879, p. 3, col. 2.

30. United States Centennial Commission, International Exhibition, *1876 Official Catalogue*, 7th rev. ed. (Philadelphia, 1876), p. 148.

31. George Curtis Waldo, *The Standard's History of Bridgeport* (Bridgeport: The Standard Association, 1897) and George C. Waldo, Jr., ed. *History of Bridgeport and Vicinity* (New York, Chicago: S. J. Clarke Co., 1917).

32. "Studio Gossip," *Brooklyn Daily Times*, March 4, 1880, p. 2.

33. *San Jose Daily Morning Times*, October 29, 1879, p. 2, col. 2., p. 3, col. 2; October 30, p. 3, col. 1; and October 31, p. 3, col. 1.

4

E. W. Clay and the
American Political Caricature Business

NANCY R. DAVISON

hen Edward Williams Clay moved from Philadelphia to New York in late 1834 or early 1835, he had already published engravings, etchings, and lithographs. These included illustrations for books, magazines, and sheet music, single-sheet lithographs of militia encampments and other events, a popular series of etchings entitled *Life in Philadelphia,* and a handful of political caricatures, about seven. One of these, *The Rats Leaving a Falling House,* "he sketched . . . [in 1834] on the dissolution of Jackson's Cabinet. This brought him into notice, and for more than twenty years he was the only American caricaturist"—or so it says in his obituary.[1] In fact Clay was not the "only American caricaturist" active during the Jacksonian era, but he was the first American artist to specialize in political caricature. For over twenty years he was the most prolific designer of political cartoons in America.

Beginning in 1836 Clay, together with lithographer and print publisher Henry R. Robinson, established and developed an informal support system for political caricature in New York City. Through the efforts of Clay, Robinson, and their associates, New York became the center of a growing trade in political caricature. The trade was not profitable at first, but Clay and Robinson were persistent. Gradually other artists and print publishers began to draw and issue political caricatures as part of their everyday work.

Clay and Robinson, jointly and separately, were most productive from 1836 to 1840. It was during this period that political caricatures by American artists on American issues became an ordinary part of life in the United States.

Political caricature in America had begun in the mid- and late-eighteenth

century as both a series of borrowings from English sources and isolated experiments. During the early nineteenth-century, when immigrants such as William Charles drew cartoons of the War of 1812, political caricatures became more common in America. James Akin made the transition from etched cartoons in the style of the English cartoonist James Gillray to lithographed single-sheet caricatures that possessed an American flavor and an American voice. Although Akin and his younger contemporary in Philadelphia, David Claypoole Johnston, both had original ideas and distinctive caricature styles, each worked alone. E. W. Clay also worked alone in Philadelphia, publishing his political caricatures under his own name or, occasionally under a pseudonym or disguised signature.

When Clay moved to New York City in the mid-1830s, he found a congenial coterie of artists, lithographers, and publishers, a prosperous and growing economy, and a structured and active political climate. All of these elements contributed to his activity as a political caricaturist over the next five years and to the establishment of an American tradition of political caricature.

Clay had produced very few prints between 1832 and 1835. The few lithographs he had designed were printed in New York by John Pendleton, whom he had known in Philadelphia, and by Anthony Imbert, John Dorival, and Henry R. Robinson. These shops were within a few blocks of each other on Broadway and just off Broadway. Numerous other lithographers, etchers, and engravers in wood and copper were active in New York as well. In 1834–35 when E. W. Clay first took up residence, New York City was the fastest-growing center for the graphic arts in America.

The city was also growing in importance as a center of trade, finance, and business. Trade in raw materials and finished goods between New York City and all of the upstate regions expanded greatly after the Erie Canal opened in 1825. New York had already replaced Philadelphia as the most important trading port and business center by the early 1830s. After President Andrew Jackson removed the federal deposits from the Second Bank of the United States in Philadelphia and redistributed them among banks in New York and other cities in 1833, New York became the financial center of the United States as well.[2]

The rise of new political parties and the organization and restructuring of political machines, such as Martin Van Buren's Albany Regency and New York City's Tammany Hall in the mid-1830s, influenced the development of American political caricature in several ways.

Political interest and activity increased on the local level, especially in New York City. Politicians and issues generally became identified with either the Dem-

ocrats or the Whigs, although specific personalities and policies occasionally defined third parties as well.

Political debate in New York City was defined by Tammany Hall's "custom of seeking local victory on national issues,"[3] a policy that the caricaturists, who produced for the nation as well as for the city, found congenial and one that accounts for the predominance of caricatures on national issues over those on local concerns.

Most caricatures were drawn by such men as Clay, who generally opposed the Democrats in his cartoons, and Clay's lithographer and publisher, Robinson, who was strictly partisan to Whig policies and candidates. Tammany Hall politicians, who had a highly organized system for registering immigrants as voters and then turning them out to vote for the Democratic ticket, do not seem to have used political caricatures in their campaigns. Whig politicians accepted the caricatures published by Clay, Robinson, and other Whig-oriented artists and lithographers as part of the general political effort, but there is no evidence that they commissioned or subsidized political caricatures on a formal basis. Individual artists and publishers, not political organizations, were responsible for American single-sheet political cartoons during the Jacksonian era.

Although E. W. Clay's sympathies were basically Whig, his point of view varied from issue to issue, and he did not always follow a party line in his caricatures. *A Grand Functionary* of 1829 is based on a personal distaste for Andrew Jackson, but *The Downfall of Mother Bank* of 1833 unequivocally approves of Jackson's veto of the rechartering of the Second Bank of the United States. In 1838–39 when H. R. Robinson vigorously attacked Van Buren's Subtreasury plan, Clay sidestepped the issue, drawing few political cartoons and concentrating instead on theatrical portraits and an ill-tempered sequel to his *Life in Philadelphia* series. Clay's work shows that he reserved the right to comment on events and personalities regardless of political affiliation, as well as the right to change his mind on issues.

Robinson, however, publicly advertised his own political bias. In a letter to a Connecticut newspaper in 1848 he proudly proclaimed that he had been a Whig for "over a quarter of a century."[4] This was an exaggeration, since there was no Whig party in 1823, but still a declaration of a longstanding commitment to the Whig cause. His trade cards and caricatures also reflect his political preference.

Robinson's Print and Caricature shop was part of the self-contained section of the American business world in which single-sheet political caricatures

were conceived, drawn, printed, published, and sold. This commercial activity was based upon the organization of the English pictorial print trade that flourished in London during the late eighteenth and early nineteenth centuries. Political caricatures and other prints were published as single sheets independent of newspapers and magazines, partly for technical reasons and, in England, partly for tax reasons. Ideas for prints and caricatures were generated by artists, publishers, and amateurs and were then drawn on the intaglio plate or the lithographic stone either by artists or by copyists who worked in the print shops. The prints were then pulled by professional printers and distributed for sale.

Little information about the marketing of political caricatures exists independent of the caricatures themselves. In the left corner of Robinson's *Loco Foco Persecution, or Custom House Versus Caricatures* of 1838 (figure 4.1), two boys with bundles of papers under their arms demand "some more of your Whig Caricatures" from the harassed proprietor of the shop, possibly Robinson himself. Both youngsters look like newspaper boys, and the inference is that political cartoons were hawked on the streets like the new penny newspapers. The cartoons were also sold in bookstores, lithographers' studios, and caricature shops. Many of the single sheet political caricatures of the Jacksonian era have an address on them, even if no artist's or publisher's name appears. These addresses often include specific directions for the potential customer, such as "Published by John Childs, New York, Lithographer, 119, Fulton Street, upstairs." A caricature shop complete with display window and an array of political caricatures and other prints behind it is shown on the trade card of "H. R. Robinson, Print and Caricature Publisher" (figure 4.2).

Robinson, who was the most specialized and productive of the lithographers who published political cartoons before 1850, issued his first political caricatures, including Clay's *A Political Game of Brag*, between 1831 and 1835. He published an average of over twenty per year during Van Buren's term as President. After William Henry Harrison's death in 1841, Robinson's production of political caricatures dropped sharply to average about six per year until 1849. Although Robinson is listed as a "caricaturist" in New York City Directories between 1836 and 1843, no caricatures bearing his signature are known to exist. His Whig viewpoint was expressed as an editor and publisher of caricatures rather than as an artist. Clay also collaborated with Robinson on an occasional non-political subject, such as a certificate or lithograph of a steamboat. The two of them issued prints of news events, theatrical portraits, and a few genre scenes,

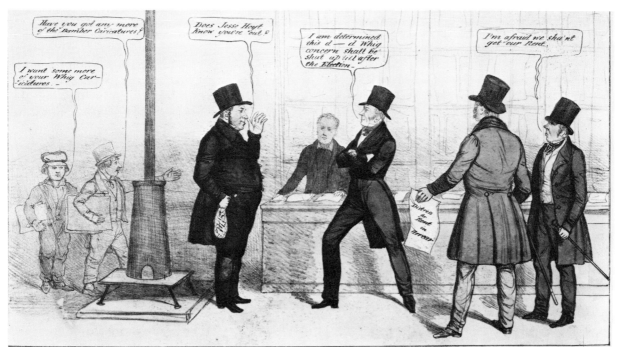

4.1. Unknown artist, *Loco Foco Persecution, or Custom House, Versus Caricatures*, 1838, Lithograph, 9½ × 17¼ in. Printed and published by H. R. Robinson, New York. Courtesy of the Library of Congress.

4.2. Unknown artist, *H. R. Robinson Trade Card*, showing store front, ca. 1836–42. Lithograph, 4¹³⁄₁₆ × 3³⁄₁₆ in. Courtesy of the American Antiquarian Society.

but the focus of their joint activity was political caricature. Between them, they made New York City the center of political caricature production in America.

In 1836, nearly fifty single-sheet political caricatures were published in the United States, the highest number for any year to that date. Thirty-seven of these were published in New York City and thirty of those were produced by Clay and Robinson, separately and together. Robinson printed thirteen of Clay's fifteen caricatures and another fifteen that are unsigned except for his imprint, or signed by an artist other than Clay. Most of the non-Robinson cartoons for 1836 are unsigned and bear no publisher's imprint. Of the nearly fifty political caricatures that were printed in the United States in 1836, a quarter relate to foreign affairs, about half concern national politics, and the rest deal with local political events.

Most of the cartoons on foreign affairs deal with the question of the French spoliation payments. Angered by French procrastination with regard to the payment of twenty-five million francs to the United States as reparations for damages to American property during the Napoleonic Wars, Jackson suggested possible reprisals against French property or even war with France in a message to Congress in December of 1834. In April of 1835 the French government appropriated the funds for payment but asked for an apology from Jackson. After discussion with Prime Minister Palmerston and William IV of England, Jackson made an apology of sorts in December 1835, and the French began payments in early 1836.[5]

Clay summarized these events in his cartoon *The Apology/Mediation/Satisfaction* (figure 4.3). In it Van Buren urges an angry Jackson to speak with William IV of England, who stands between Jackson and an anxious Louis Philippe, holding each by the hand. Jackson, a veteran duellist, objects to William's intervention but gives him a message for the French leader: "Let Louis Philippe pay the money and then if he wants to fight . . . I'll meet him with pistol, rifle, or broadsword and ask no favor." William tells Louis Philippe that Jackson "apologizes in the handsomest manner" and Louis Philippe is satisfied. He would, however, like a discount of "7 per cent for de cash payment." All four figures are skillfully drawn and characterized. Their respective positions on the issue are reinforced by their poses as well as their speeches.

Unfortunately for the caricaturists and also for the Whigs, the election of 1836 was not simply a contest between two opponents. The Democrats held their second national convention in late May and selected Martin Van Buren as their candidate in spite of some objections. The newly formed Whig party, whose

4.3. E. W. Clay, *The Apology/Meditation/Satisfaction*, 1836. Lithograph, 10⅜ × 14½ in. Courtesy of the American Antiquarian Society.

members were unified primarily by their dislike of Jackson and his policies, scorned a convention and ran a collection of favorite sons against Van Buren. Daniel Webster of Massachusetts and Hugh Lawson White of Tennessee were regional favorites, but William Henry Harrison, the elderly hero of the battle of Tippecanoe in the War of 1812, was the favorite of the West and the leading Whig contender. The election lacked any other real issues and soon became a referendum on the Jackson presidency. Van Buren was the clearcut winner but he received no mandate.[6]

Clay and Robinson supported Harrison and opposed the Democrats throughout the campaign. In *Set-to Between the Champion Old Tip and the Swell Dutchman of Kinderhook—1836* (figure 4.4), Harrison and Van Buren square off for a bare-knuckles boxing match, surrounded by their seconds and stakesholders. Old Tip is backed by the Western Lad, Old Seventy-Six, and the People. The Kinderhooker, or Van Buren, whose home in New York was called Kinderhook, is backed by a worried Andrew Jackson, the Postmaster General Amos Kendall, and the "Office holders & mail contractors" who owe their jobs to Jackson's policy for rotation in office, also known as the spoils system.

Clay and Robinson also published caricatures on local events. The cost of living had been rising rapidly since 1834 and the winter of 1835–36 was unusually severe. In response to these conditions members of the fledgling trade unions mounted several strikes for pay raises and other benefits in New York and other cities.[7] In February 1836 Philip Hone reported in his *Diary* that stevedores and other dock workers were not content with a wage increase but demanded further concessions that were refused. On February 23, "an immense body of the malcontents paraded the wharves . . . and attacked the men who refused to join them." Order was restored but Hone noted darkly that "the elements of disorder are at work."[8]

Clay shared Hone's low opinion of strikes and trade union activities. In *A Strike! A Strike!* drawn by Clay and published by Robinson in March 1836, he showed the ultimate absurdity, a parade of farm animals striking for higher prices for their eggs and meat. A fierce, skinny dog, chained to a doghouse that is for rent at Robinson's address, snarls "this is all contrary to law." In the foreground fish and shellfish vendors tend to business and offer good value at a moderate price.

In 1837 all ten of Clay's political caricatures were published by H. R. Robinson, who also published nine additional cartoons, accounting for nineteen

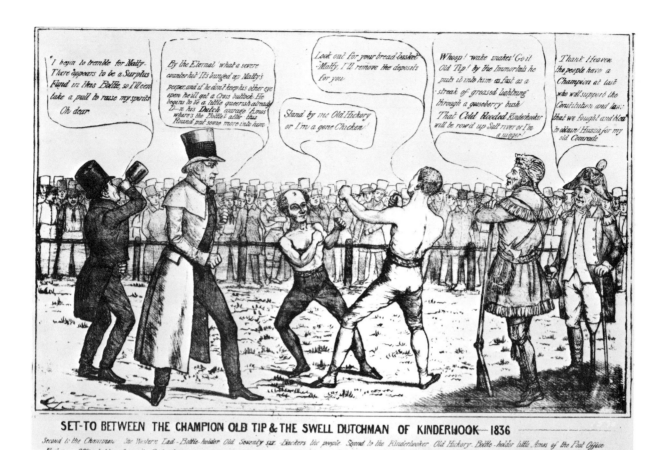

4.4. E. W. Clay, *Set-To Between the Champion Old Tip & The Swell Dutchman of Kinderhook*, 1836. Lithograph, 10¼ × 16 in. Printed and published by H. R. Robinson, New York. Courtesy of the Library of Congress.

of the thirty-one political caricatures published in the United States in that year. The primary subjects of these cartoons were the economy and New York politics.

In March 1837 Martin Van Buren succeeded Andrew Jackson as President of the United States. A month later the first of a series of business and bank failures touched off the Panic of 1837. The depression had been building for several months. Real estate speculation, rapidly rising interest rates and prices, labor unrest, and unemployment were increasingly common from 1834 to 1837. Business and bank failures increased in early 1837, and Philip Hone noted that "the distress and ruin caused by these failures will be tremendous; general bankruptcy seems inevitable."[9]

In *The Times* (figure 4.5) Clay summarizes the effects of the Panic of 1837 on ordinary people in New York. A widow and her child beg for alms. Unemployed workingmen louge listlessly against a foreground structure that is plastered with handbills offering "Money to loan at 7 Pr. Ct. pr. month" and "Specie for sale 15 pr. ct. Premium." Flour at fourteen dollars a barrel is beyond the reach of these workers, but liquor is cheap at "three cts per Glass" at the crowded liquor store at the left. The sheriff's office and the pawnshop are also crowded, and there is a run on the Mechanics Bank. In contrast the Custom House where "All Bonds must be paid in Specie" is quiet and ships are tied up at the dock. Every detail of this lithograph reinforces the illustration of general misery and the shut-down of economic activity. Andrew Jackson, blinded by the "Glory" smoke of his own pipe as he looks down on the scene, is responsible by implication.

Local politics were also disrupted in the economic and administrative upheavals of the Panic. The New York City Whigs upset Tammany Hall's ticket of Democratic regulars in the city elections of 1837 and elected a Whig mayor and Common Council for the first time in the city's history.[10] *The Death of Old Tammany and his Wife Loco Foco* (figure 4.6), drawn by Clay and published—undoubtedly with great satisfaction—by Robinson, shows the fireman James Gulick leading the Whig newspaper editors in battle against the Democratic Tammany brave and his supporters. As Tammany falls beneath the arrow of Whig editor James Watson Webb and a ballot box full of "Whig tickets," he is supported by his wife, Loco Foco, an Irish slattern who represents Tammany Hall's usually reliable immigrant vote.

Newspaper editors and print publishers were among the small businessmen and entrepreneurs who constituted much of the strength of the Whig party. Newspapers run by Whig editors, with or without financial patronage,

4.5. E. W. Clay, *The Times*, 1837. Lithograph, 13¼ × 19 in. Printed and published by H. R. Robinson, New York. Courtesy of the Library of Congress.

4.6. E. W. Clay, *The Death of Old Tammany and his Wife Loco Foco*, 1837. Lithograph, 10 × 13⅝ in. Published by H. R. Robinson. Courtesy of the Library of Congress.

were more common than Democratic papers during Clay's career, but the Democrats had more votes and political offices. In the twentieth century, the historian of American periodicals, Frank L. Mott, observed that, "there seems to be no significant correlation between the proportion of papers adhering to a given party and the proportion of votes polled by that party in national elections."[11]

The same is true of political caricatures, at least in New York City. Caricatures against Jackson, Van Buren, and the Democrats were far more numerous than those against Henry Clay, Harrison, and the Whigs. During E. W. Clay's career in New York, Tammany Hall Democrats controlled the mayor's office for fourteen years out of twenty. This contrast between the sentiments of the political caricaturists and the voters in New York was especially pronounced in the 1840 campaign for the presidency, when a flood of anti-Van Buren caricatures appeared, but New York voted for Van Buren instead of the national victor, William Henry Harrison.[12]

After New York banks suspended specie payments on May 10, 1837, the government was left with no legal depositories for its funds. Federal revenues could be kept only in banks that would redeem their banknotes in gold or silver, that is, specie. Money accumulated in custom houses, land offices, and post offices and was effectively withdrawn from circulation.

Van Buren presented his solution to the problem in a message to Congress in September 1837. He proposed the establishment of an independent treasury or subtreasury that would permit the government to collect and disperse its own funds independent of state or private banks. The alternatives, establishment of a Third Bank of the United States as proposed by the Whigs, or continued reliance on state banks, had their adherents, and opinions were sufficiently firm on these matters to give the Whigs a useful political issue and to split the Democratic party further.[13]

In *Major Joe Bunker's Last Parade, or the Fix of a Senator and his 700 Independents* (figure 4.7), E. W. Clay shows the leader of the state bank or conservative faction of the Democratic party, Senator N. P. Tallmadge of New York, as a hapless militia major whose parading troops have defected to follow another flag—Van Buren's subtreasury message. Tallmadge's consternation is echoed by an unidentified Capt. Ben and a group of civilian supporters who cluster under the banner of the Conservative newspaper, *The Madisonian*. Major Joe Bunker, a familiar and popular Yankee stage character from James Hackett's play, *Down East, or the Militia Muster*,[14] was an earnest if inept militia officer whose enthusi-

4.7. E. W. Clay, *Major Joe Bunker's Last Parade, or The Fix of a Senator and his 700 Independents*, 1837. Lithograph, 8⅞ × 15⅛ in. Published by H. R. Robinson, New York. Courtesy of the Library of Congress.

asm for drill and the manual of arms was not matched by his experience, information, or judgment. In this cartoon, Clay ridicules the conservative leader, delights in the disarray of the Democrats, and expresses some mild support for Van Buren's subtreasury plan.

In 1838 Clay drew only eight political caricatures, a relatively small proportion of the forty cartoons produced in the United States that year. Robinson continued to dominate the caricature publishing field with twenty-seven cartoons, but only five of these were designed by Clay. John Childs, who was to be Robinson's main rival in 1840, as well as E. W. Clay's exclusive publisher in 1839–40 and in 1852, issued four political caricatures, three of which were signed by Clay.

Clay abstained from the caricature debate on the subtreasury question and discussed the issue in only one of his caricatures for 1838. His *Machines for the Pay-tent Office* (figure 4.8), signed "By O'Graphic" on one side but marked with Clay's characteristic "C" on the other, shows a series of newly invented machines for government use. One is a National Cooking Range that heats Treasury Pap or hard money and bakes loaves and fishes and golden eggs. Another is an Automaton Chess Player. The Automaton is Martin Van Buren, who is controlled by the concealed Andrew Jackson. The cartoon is well drawn, but it lacks focus and bite.

Clay's work for 1838 and 1839 seems unfocused and distracted compared to his pointed caricatures of 1836 and 1837. His cartoons for Robinson in 1838 often satirize specific events instead of attacking political parties and policies. In contrast, H. R. Robinson published caricatures by other artists castigating New York City Loco Focos, New York State Democrats, and Martin Van Buren and his policies, in particular the subtreasury plan.

Clay and Robinson published forty-five political caricatures and miscellaneous prints together between 1836 and 1838. They shared the most productive periods of Clay's transfer to New York and Robinson's beginnings as a publisher of political caricature. Then, for some reason, Clay and Robinson broke their business association in 1838 and did not work together again until 1843.

Clay's new publisher in New York, John Childs, was an artist, print colorist, and newly established lithographer who issued popular prints from 1836 to 1844. Unlike Robinson, Childs did not publish significant numbers of political caricatures over an extended period. He was most active in 1840, when he

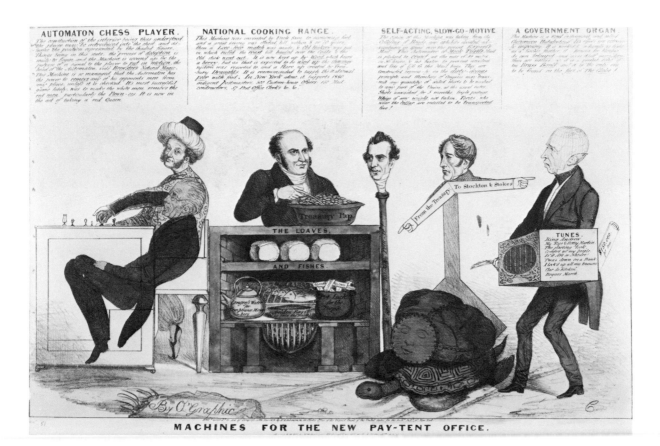

MACHINES FOR THE NEW PAY-TENT OFFICE.

4.8. E. W. Clay, *Machines for the Pay-tent Office*, 1838. Lithograph, 12¼ × 18⅞ in. Printed and published by H. R. Robinson, New York. Courtesy of the Library of Congress.

published thirty-four political cartoons, of which twenty-six were designed by Clay.

Van Buren's troubles with the subtreasury bill in 1839 and the continuing economic depression had insured that the election of 1840 was a topic of widespread and constant interest. This was the year of the log cabin campaign, of "Tippecanoe and Tyler, Too" versus "Van, Van the Used Up Man." There were substantial differences between the platforms of the two political parties, but the issues quickly disappeared in the unprecedented ballyhoo of the campaign. Whig mass meetings, parades, and processions with log cabins and uncounted barrels of hard cider were held all over the North and West. Campaign newspapers and Whig songs characterized Van Buren as an ineffectual leader whose vanity and love of luxury were an affront to the American people. The Democrats countered with attacks on Harrison's war record, his age, his drinking habits, and his silence on questions of policy and politics. But the Democrats were on the defensive as the depression continued and attacks on Van Buren, who was in office during the first days of the Panic of 1837, increased.

Political caricature played a role in the campaign as well. Seventy-six cartoons are known to have been published in the United States in 1840, surpassing the record set in the previous Presidential campaign. A few dealt with foreign affairs or other issues, but most were concerned with the election and the defeat of Martin Van Buren. Clay, whose political cartoons for late 1838 and 1839 showed a loose analysis of political events, focused tightly on the election issues in his cartoons for 1840. Of the twenty-six caricatures he designed that year (more than one-third of the national total), one concerns a dispute with Great Britain, three are anti-Harrison, and twenty-two oppose Van Buren. Sacrificing complexity for speed of production, Clay simplified his compositions and developed a set of ideas and symbols to convey his point of view. In 1840, his work was focused stylistically as well as politically.

William Henry Harrison was known as "General Mum" for his silence on the issues and ridiculed as a "Petticoat General" on the basis of his overall military record. This record was attacked by Vice President Richard M. Johnson and Senator James Allen of Harrison's home state of Ohio, among others, who stumped the West to tell the "true" story of the Battle of the Thames in 1813, a battle in which Harrison was more than a mile from the action when Col. Johnson killed Tecumseh and suffered more than seventeen wounds.[15]

In *General Mum Facing the Enemies of his Country*, Clay depicts Harrison's

steed fleeing the distant action while Harrison, mounted backwards, clings to the horse's tail and urges Johnson to "Give it to them." In the middle ground Commodore Perry exclaims, "We have met the enemy and they are ours! But where the deuce is the General?" In the background is a sketch of Johnson shooting Tecumseh taken from Clay's *Battle of the Thames. Oct. 5, 1813,* a heroic lithograph that was part of Johnson's first campaign for the presidency in 1833. Cogent and funny, the caricature scarcely needs the minimal dialogue for its effect.

In his anti-Van Buren caricatures, Clay shows the President as a man at the mercy of circumstances, headed for a fall, partly as a result of his own actions, partly as a result of the ill-conceived policies of his predecessor Andrew Jackson, and partly as a result of the efforts of the vigorous farmer, soldier, and man of the people, William Henry Harrison. Clay with Childs, Childs alone, and Robinson alone published fifty-five of the seventy-six single-sheet political cartoons printed in the United States in 1840. Their caricatures focused on the same themes, the projected defeat of Martin Van Buren and the victory of William Henry Harrison.

Very few political caricatures were published between the elections of 1840 and 1844, but over eighty were produced in 1844, the largest number ever issued in one year in the United States. Clay and Robinson contributed to this outpouring of caricature, but they no longer dominated the field as they had in the late 1830s and in 1840. Print publishers such as James S. Baillie, Andrew Donnelly, and others were beginning to print political cartoons as part of their everyday publishing efforts, particularly in election years.

After 1844 American artists gradually began to design caricatures for the new illustrated weekly magazines, published in imitation of English magazines such as *Punch.* The cartoons were engraved on boxwood and printed with type. The form of caricature changed from single-sheet lithographs, hawked on the streets and sold in shops, to wood engravings incorporated into large-circulation magazines. But the American traditions of graphic political satire which had been so strongly established by Clay and Robinson, remained.

Clay continued to produce single-sheet political caricatures with a variety of publishers until he retired in 1852. He designed more political cartoons than any other American artist before him or during his career. Before he began his work in New York, political caricatures by American artists on American subjects were rare. By the time of his death in 1857, political caricatures had become a common part of American life.

NOTES

This paper is derived from "E. W. Clay: American Political Caricaturist of the Jacksonian Era" by Nancy R. Davison, a doctoral dissertation that was accepted by the Program in American Culture at the University of Michigan in 1980.

1. "E. W. Clay—Obituary," *Philadelphia Press,* January 5, 1858.

2. Samuel Eliot Morison, *Oxford History of the American People,* Vol. 2 (New York and Scarborough, Ontario: Mentor Books, New American Library, 1972), p. 181; Ross M. Robertson, *History of the American Economy,* 3rd ed. (New York: Harcourt Brace Jovanovich, 1973), p. 57.

3. Gustavus Myers, *The History of Tammany Hall* (New York: Boni & Liveright, 1917; reprint ed. New York: Dover Publications, Inc., 1971), p. 119.

4. "Robinson the Caricaturist," *Bridgeport* (Conn.) *Republican Farmer,* October 17, 1848.

5. Glyndon G. Van Deusen, *The Jacksonian Era: 1828–1848* (New York: Harper Torchbooks, The University Library, Harper and Row, 1963), pp. 101–103.

6. Ibid., pp. 109–12.

7. Allan Nevins, introduction to Philip Hone, *Diary of Philip Hone: 1828–1851,* Vol. 1 (New York: Dodd, Mead, and Company, 1927), p. 199.

8. Hone, *Diary,* 1:200.

9. Ibid., 1:255.

10. Myers, *Tammany Hall,* p. 110.

11. Frank Luther Mott, *American Journalism: A History, 1690–1960,* 3rd ed. (New York: Macmillan, 1962), pp. 101–103).

12. Myers, *Tammany Hall,* p. 130.

13. Van Deusen, *Jacksonian Era,* p. 124.

14. Francis Hodge, *Yankee Theatre: The Image of America on the Stage 1825–1850* (Austin: University of Texas Press, 1964), p. 110.

15. Robert Gray Gunderson, *The Log Cabin Campaign* (Lexington, Ky.: University of Kentucky Press, 1957), p. 232.

5

Upstate Cities on Paper and Stone
Urban Lithographs of Nineteenth-Century New York

JOHN W. REPS

Curators, connoisseurs, and collectors of American historical prints still face challenges in finding, recording, classifying, and analyzing the prodigious output of the nation's lithographers in the nineteenth century. One phase of this effort approaches completion: cataloging the separately issued city views of the United States and Canada. This category of lithographic prints proved so popular in the last century that their publishers issued nearly 5,000 titles during the era of lithography that began in 1825.[1]

The lithographic urban view, while not unknown in England or on the continent, can properly be regarded as a uniquely American phenomenon. The sheer number of images, the reasons why they were produced, the eagerness with which they were acquired, their artistic style, their wide geographic scope, and their range of subjects—from tiny villages to metropolitan centers—all stamp them as the product of the open, optimistic, curious, unsophisticated, materialistic, and egalitarian society that characterized nineteenth century America.

Because these views came to the market tinged with commercialism, art critics of the time and through most of the present century regarded them as unworthy of scholarly examination. Yet, as Donald Karshan stated a dozen years ago, some connoisseurs (unidentified, but perhaps including himself) believe that "it was only with the advent of the full-blown city-view lithograph that American printmaking reached its first plateau of originality, making a historical contribution to the graphic arts."[2]

One need not agree with this assessment to admit city views to a more

prominent place in our studies. Quite aside from their artistic and technical characteristics, they offer still unappreciated resources for scholars of urban or architectural history, human geography, industrial archaelogy, and other disciplines.[3] It is in this capacity that I first approached these prints, and while this paper will focus mainly on other aspects of them, I still look on urban lithographs as primary materials in studying the history of city planning and urban morphology.

Upstate New York—which I will loosely define as all of the state north of the lower Hudson Valley—provided the setting for the very beginning of American urban lithography and witnessed all aspects of it as it unfolded during the ensuing years. The crudely drawn Buffalo and Lockport scenes that appeared in Colden's *Memoir* of 1825, celebrating the opening of the Erie Canal, are the first depictions of our cities to be created in America in this new medium of printmaking.[4] They reflect how little artists and printers then knew of lithography. No one looking at these examples of lithographic incunabula and unfamiliar with their source could possibly suspect they came from the hand of George Catlin.

I can find no separately issued prints of upstate New York communities until 1836. In that year John Young, then only twenty-two, produced three handsome views of Rochester, all printed in New York City at the establishment of John Bufford, who moved there a year earlier after completing his apprenticeship with Pendleton in Boston.

Young came to Rochester from the Isle of Guernsey to try his luck on the American frontier. His artistic abilities attracted the attention of the firm of Rochester booksellers that published the prints. Each measured a generous 14 × 19 inches, as put on stone by Bufford. By 1839 Young was in business as a lithographic printer himself, although the few prints bearing his name suggest that this venture did not prosper before his death in 1842 brought it to an end altogether.[5]

Two other pioneer urban viewmakers of this early period are known by single prints. William Wilson's Lockport of 1836 (figure 5.1) also came from the Bufford press. Two years later, however, Frederick Sowerby took his drawing of Rochester to Buffalo, where Oliver G. Steel's Lithographic Press had recently been established.[6]

Young and Sowerby, and probably Wilson as well, apparently regarded city views as incidental to their other work. For Henry Walton, their contemporary, townscapes constituted the bulk of his lithographic work, although Walton's

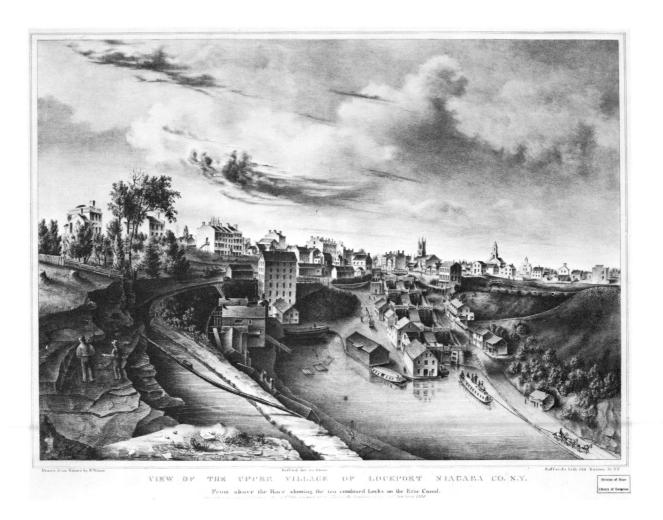

VIEW OF THE UPPER VILLAGE OF LOCKPORT NIAGARA CO. N.Y.

From above the Race showing the ten combined Locks on the Erie Canal.

5.1. W. Wilson, *View of the Upper Village of Lockport Niagara Co. N.Y.*, 1836. Lithograph, 15⅛ × 20 in. Printed by Bufford's Lith., New York City. Published in 1836, this is one of the earliest separately issued lithographic city views of New York State. It shows the series of locks on the Erie Canal leading to the upper portion of this western community. Courtesy of the Prints and Photographs Division, Library of Congress.

paintings and drawings are far more numerous than his prints. Walton's first two city views, like those by Young and Wilson, also appeared in 1836. A local firm published his view of Geneva after Eliphalet Brown, Jr., put it on stone to be printed by Bufford.[7]

All other town views by Walton, beginning with his 1836 *Ithaca from East Hill*, were drawn from nature and on stone by the artist, and Walton served as his own publisher as well. All of his city lithographs, however, went to New York for printing: first to Bufford, then Daniel Jenkins, the Endicotts, and finally, Sarony.

Probably Walton did all of his work on stone in New York City. At least this was so for his Watkins Glen view of 1847. The local paper, in announcing the artist's return from New York with copies of the lithograph for distribution, stated that it "was first drawn from nature by Mr. W., who . . . retired to the city for the purpose of drawing the same on stone."[8]

While Ithaca's rugged setting allowed Walton, in all three of the views he published of the town, to look down on it from an elevated location, his urban scenes all fall within the category of conventional townscape painting. The city appears as if sitting for a portrait before the artist at his easel. The prints reveal no more of the urban structure, its street pattern, or the relationship of major activities than a total stranger could grasp by looking at the city from the same place. The artist or antiquarian within us may be delighted; the historian or the geographer finds them tantalizing and frustrating, because the information conveyed is superficial and incomplete.

Walton, Young, and the few other pioneer viewmakers active in this dawn of upstate lithography either focused their attention on a single city or, as in Walton's case, on small towns and villages. In the ten-year period beginning in 1845 a new breed of artist-entrepreneurs entered the larger markets offered by major centers of population.

Edwin Whitefield introduced this new approach with views of Albany and Troy (figure 5.2). An Englishman, Whitefield lived for a few years after 1841 in Albany and Hudson. He pursued a career in art, teaching, canvassing for *Godey's Lady's Book* and, as his diary tells us, "practicing a little at lithography."[9]

Whitefield knew how to promote his viewmaking efforts. Like Walton he obtained advance subscriptions for his prints by exhibiting the drawings on which they were to be based. He also succeeded in attracting extensive newspaper coverage. No fewer than five Albany papers in 1845 commented favorably on his lithograph of that city. These and later accounts in other cities so closely resemble one another in both general tone and specific phraseology that it is safe

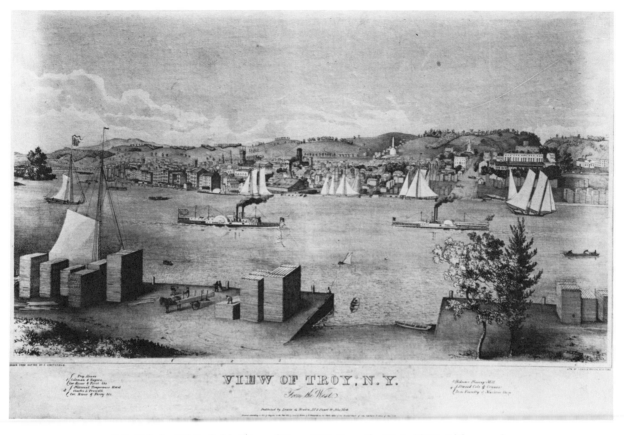

VIEW OF TROY, N.Y.
From the West

5.2. Edwin Whitefield, *View of Troy, N.Y. From the West*, 1845. Lithograph, 16³⁄₁₆ × 26¼ in. Printed and published by Lewis and Brown, New York City. Whitefield began his long career as a viewmaker with this lithograph of 1845 and one of similar character showing the appearance of Albany. Courtesy of the Mariners Museum, Newport News, Virginia.

to conclude they originated from the artist in what we would now call a news release. All other city views artists and publishers followed this practice, if similarity in wording of newspaper accounts is a reliable guide.

The Troy view also appeared in 1845. It, too, received praise from the local papers, although one remarked that it "scarcely gives a fair idea of the extent and magnitude of Troy, and especially of the business portion of it." Rochester critics could find no fault with the artist's work when his lithograph reached their city in 1847. The *Daily American* remarked that "it is an ornament peculiarly worthy of a place in the offices and houses of Rochester men, and will, we trust be liberally patronized."[10]

Whitefield's Buffalo lithograph drew mixed reviews when he published it in 1847. While the *Courier* praised it without qualification, the *Morning Express* stated that "we should have valued it higher if it had been taken from some point that would have spread the city out more before the eye, and showed some of its streets, and the extent of territory which it occupies."

Pictorially this could be done only by adopting an imaginary view-point high in the air. Starting about 1850 many American viewmakers adopted this new technique for representing the city. These prints please the modern scholar—although for different reasons—as they must have pleased the nineteenth-century town booster who wanted his community portrayed with its best face forward and all of its features on full display.

The four Smith Brothers brought this different outlook to upstate New York early in the decade. Two and probably three of the Smiths served as subscription agents for Whitefield, from whom they must have learned a great deal. One brother, Benjamin Franklin Smith, Jr., drew at least one city view as early as 1847, a small engraving for an Albany publisher, and he may have assisted Whitefield in some of his views. The Whitefield lithographs of Boston, Portland, and Providence were jointly published by the artist and the Smiths, but this relationship came to an abrupt end for reasons and under circumstances that remain unclear.[11]

Although B. F. Smith's name appears as artist on several of the firm's fifty or so large and handsome lithographs, the brothers commissioned J. W. Hill, son of the aquatint artist of an early period, and Lewis Bradley, a Utica artist, for their six upstate views.[12] Hill's elevated viewpoints for his Albany and Buffalo prints open vistas into these cities and allow one to grasp the framework and pattern of their urban form. His Buffalo warehouses appear as prominently as Whitefield's, but they no longer dominate the scene. To the flatness of White-

field's Buffalo stage-set Hill added the third dimension, accented, as in his Albany view, by the artist's choice of a single vanishing-point perspective system.

Hill used the same simple but dramatic perspective method for his portrait of Rochester. Like other high-level urban images, this invites the observer to enter the picture and roam around in search of details of city life in a busy and prospering community on the Erie Canal.

Lewis Bradley, like the younger Hill, exhibited at the National Academy of Design, and his upstate urban scenes demonstrate his abilities to handle large subjects. For the city of his residence he chose to concentrate on its central portion. This more restricted visual range resulted in a print of Utica rich in architectural detail and alive with the movement of persons and vehicles.

Bradley used the same approach in drawing Oswego (figure 5.3). The artist shows us the city as seen from above the harbor entrance looking south, framed by Fort Ontario on the left and the breakwater with its lighthouse on the right. Beyond and below the fort stand the great warehouses at water level, marking the bottom of the giant staircase of canal locks linking Lake Ontario with the Erie Canal system.

Unlike the other two views produced for the Smith Brothers series, Bradley's Syracuse print embraced all of the city as he envisaged it from an aerial easel well beyond the community's southern limits. Perhaps because the artist felt that such a distant scene would lack drama, he exaggerated the vertical dimension of the church spires. Although undeniably attractive, the view has a kind of collage quality. Individual sections are drawn with substantial accuracy, but they fit together uneasily: a railroad track leading to the city from the right side somehow jumps sideways a block to arrive at the properly sited depot.

The Panic of 1857 brought view publication in this region to an abrupt end, and Civil War conditions did not favor such artistic and commercial endeavors. During the seventeen-year period extending from 1856 through 1872, only fifteen upstate lithographs of this type can be identified. Melville deV. Martin, a Syracuse lithographer and artist, drew four of them: Syracuse, Fulton, Cooperstown, and Richfield Springs in the years 1859–65, the latter date being for his appealing but not very informative depiction of Richfield Springs in which the town is almost an incidental feature.

The small number of prints produced at this time included one of the most remarkable of the entire era when artists recorded upstate cities on stone. Leopold Laass, an architect, and Julius Caesar Laass, a civil engineer (probably father and son), brought out in 1868 a gigantic view of Syracuse, where they

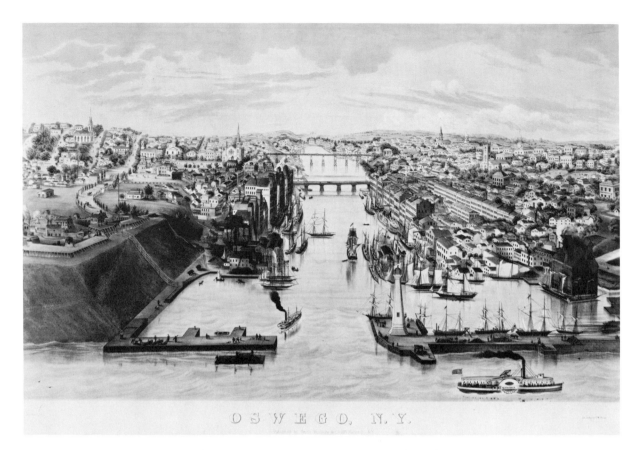

OSWEGO, N.Y.

5.3. Lewis Bradley, *Oswego, N.Y.,* 1855. Lithograph, 23¾ × 35¼ in. Lithographed by D. W. Moody. Published by Smith Brothers and Company, New York City. This large and handsome lithograph, printed from multiple stones (probably by Francis Michelin), is one of several issued by the Smith Brothers showing major cities upstate as drawn by accomplished local artists like Bradley or the itinerant J. W. Hill. Courtesy of the Division of Prints and Photographs, Library of Congress.

practiced their professions (figure 5.4). They used four large sheets to reproduce their meticulously detailed drawing. Even the smallest buildings stand out with astonishing clarity. Salt manufacturing was then the city's most important industry, and the two sheets forming the upper half are of special interest because they show the structures used in the two methods of making salt from brine: the low, glass-enclosed solar salt vats; and the taller salt blocks, so called, with their smokestacks needed for the fuel-powered boilers.

This heroic print measures almost 4½ by slightly more than 6½ feet. While surely it must have impressed all who saw it, only the Library of Congress has the complete print. Locally, the two upper sheets are in the collection of the Onondaga Historical Association, and the two lower belong to a Syracuse bank. This set in divided ownership is attractively printed in several colors, which is the work of E. Sachse and Co. of Baltimore, a firm that had produced colored lithographic city views as early as 1852.[13].

One would think that the five-year depression beginning in 1873 would have put a stop even to this leisurely pace of printmaking. Instead, a flood of prints came from the half dozen or so urban view specialists who had been engaged elsewhere in the years following the Civil War. Like the unsigned view of Ithaca in 1873 that newspaper accounts reveal to be the work of O. H. Bailey, eleven lithographs appeared the year of the panic, doubtless having been started that spring or summer when economic conditions appeared sound.

Most of the fifteen others published in 1874 and 1875, however, must have been drawn after the depression began. None bears an 1876 date, puzzling when one considers the centennial fever that gripped the nation. Two in 1877 and two more the following year bring the total produced during the depression to twenty-nine. Of the signed prints, seventeen, like that of Troy in 1877, came from the pen of Howard Heston Bailey or his brother, Oakley Hoopes Bailey. At this time the Baileys were shifting their focus from the Midwest to New England, where O. H. Bailey would produce scores of town views, many of them drawn jointly with J. C. Hazen.[14]

As in the case of his Troy view, H. H. Bailey sent the drawings for his Syracuse lithograph of 1874 to be printed in Milwaukee, then rapidly developing its reputation as a major center of skilled lithographic craftsmen. This likeness of the city is particularly valuable in showing it from almost the opposite viewpoint of the enormous 1868 view. A close study of the two would surely provide a wealth of information for anyone attempting to reconstruct exact patterns of building development, appearance, and use.

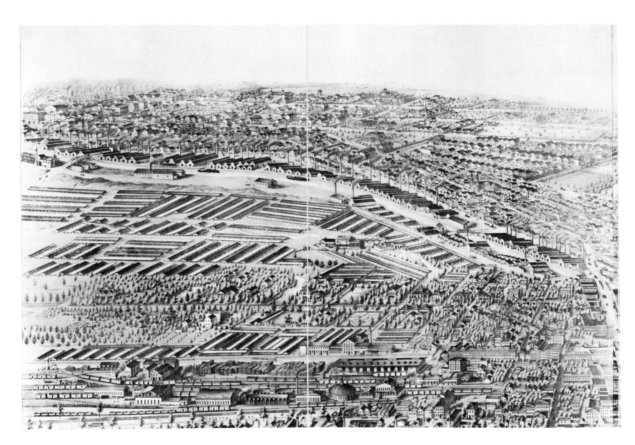

5.4. Julius Caesar and Leopold Lass, *Bird's Eye view of Syracuse, N.Y., 1868* (detail of upper left-hand sheet). Lithograph, 51½ × 78¼ in. Lithographed and printed by E. Sachse and Co., Baltimore. Published by Julius Caesar Laass and Lepopold Laass, Syracuse. This lithograph records almost every detail of the city. The portion reproduced here shows the salt industry that was so important in nineteenth-century Syracuse. Two kinds of evaporators used in making salt from brine can be seen, low, solar-powered "salt vats" and chimneyed steam-powered "salt blocks." Courtesy of the Division of Geography and Maps, Library of Congress.

Several other artists joined the Baileys in the battle for sales of city views. Four lithographs bear the signature of Augustus Koch, whose normal campaign grounds lay beyond the Mississippi. Like Waterloo, the other villages in the Koch portfolio of 1873 lay along the most direct rail route from west to east: Batavia, Canandaigua, and Geneva. Perhaps the artist, passing through to a destination elsewhere, learned that no views existed of these communities and used his skills to capitalize on this information.[15]

What brought Herman Brosius to upstate New York, also in 1873, to produce lithographs of Utica (figure 5.5) and Binghamton? The year before, he worked in such places as Shreveport, Louisiana, and the Texas towns of Dallas, Jefferson, and Victoria. Perhaps Brosius enjoyed the New York climate, for slightly less than a decade later he returned to draw views in 1882 of Olean and—with Albert F. Poole, a New England viewmaker—of nearby Jamestown.[16]

When Thaddeus M. Fowler signed the Cortland view of 1873 as co-artist with O. H. Bailey, he was in his third year as view publisher, sales agent for both of the Baileys, and occasional artist. Shortly thereafter he established his home in Pennsylvania. More than 300 views and forty-nine years later Fowler would die in his 80th year after slipping on an icy street while sketching for a view of Middletown.[17]

This does not complete the roll-call of viewmakers roaming the upstate region in the 1870s. Albert Ruger, whose midwestern views are legion and who in 1869 alone drew more than sixty of them, found Plattsburgh a suitable subject in 1877. In the next two years W. W. Denslow slipped over the border from Pennsylvania to sketch Hornell and Norwich. His name is remembered not for this work but as the illustrator of the first edition of L. Frank Baum's *Wizard of Oz*.[18]

Finally, near the end of this busy decade beginning in 1873, we find a Hartford, Connecticut, firm entering the upstate competition with a very large lithograph of Albany in 1879 (figure 5.6). The imprint tells us that it was drawn and published by the H. H. Rowley Company, giving rise to an intriguing vision of a corporate hand or a management team guiding the pencil.

Nine other upstate views by this firm—none signed by an individual artist—followed in 1879, 1880, and 1881: Fort Plain, Fulton, Ilion, Lyons, Palmyra, Rochester, Amsterdam, Little Falls, and Valatie. Although Hartford and New York offered ample facilities for lithographic printing, the Rowley Company sent its upstate views to Milwaukee or Cleveland to be printed by either Beck and Pauli or C. H. Vogt, the firm responsible for the Little Falls print. The

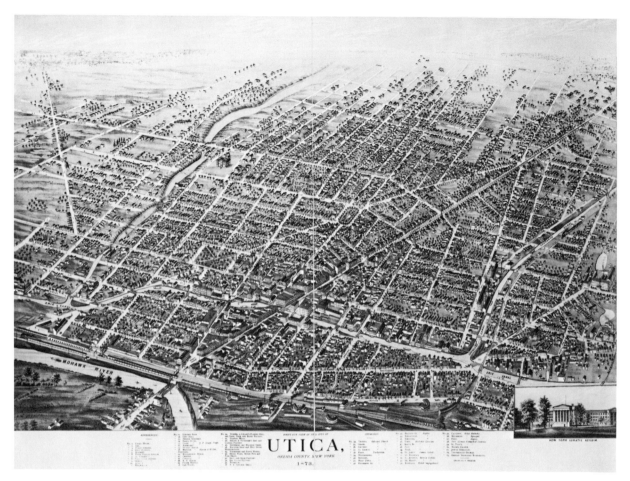

5.5. Herman Brosius, *Utica, Oneida County, New York. 1873*. Lithograph, 26½ × 36½ in. In the 1870s several itinerant viewmakers who had learned their craft in Wisconsin passed through New York State in search of markets for their work. They included T. M. Fowler, H. H. and O. H. Bailey, Augustus Koch, and Brosius. All of them produced views that showed their subjects from high-level viewpoints. Courtesy of the Division of Geography and Maps, Library of Congress.

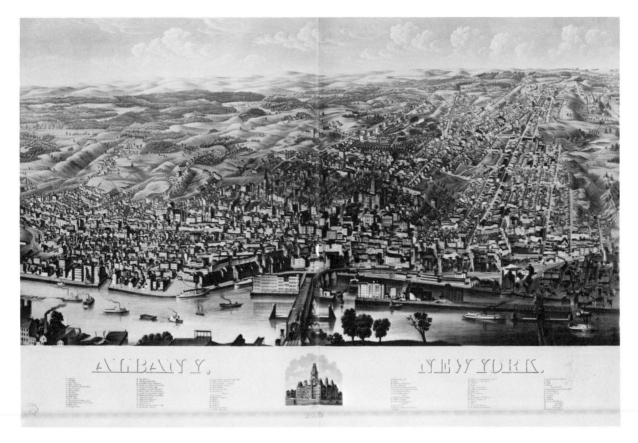

ALBANY, NEW YORK.

5.6. H. H. Rowley, *Albany, New York. 1879*. Lithograph, 28¾ × 44⅛ in. Printed by Beck and Pauli, Milwaukee, and published by H. H. Rowley and Co., Hartford, Connecticut. This is one of eleven prints of upstate cities issued by the Rowley company. They included one of Canajoharie that newspaper accounts indicate was drawn by L. R. Burleigh. Burleigh probably drew or assisted Rowley with the Albany lithograph, as well as one of nearby Troy, where Burleigh settled and began his own printing and publishing business specializing in city views. Courtesy of the Division of Geography and Maps, Library of Congress.

large view of Troy in 1881, printed by Beck and Pauli, but bearing no publisher's imprint, resembles the other Rowley views and probably came from this firm as well.[19]

Not more than half a dozen views issued from 1873 through 1881 came from New York publishers. One of Buffalo in 1880, a large and handsome print, was both printed and published in that city. An equally large view of Cohoes in 1879, produced by Galt and Hoy of New York City, provides an extraordinarily detailed glimpse of this textile manufacturing town at the eastern end of the Erie Canal. Both prints offer splendid opportunities for interpretive studies of industrial and commercial buildings and districts.

Before 1882, therefore, no individual viewmaker had established upstate New York as his domain. In that year residents of Batavia, Schenectady, Binghamton, Elmira, and Ithaca saw the first signed work of Lucien Rinaldo Burleigh, who would virtually monopolize the field during the next decade and a half. In that time he drew, printed, or published (by my count so far) 126 city views of the region, as well as dozens of others in New England, Pennsylvania, Ohio, and North Carolina. Twenty of these showed towns in Vermont, easily reached from Burleigh's place of business in Troy, where he first appears in the city directory of 1881 listed as "civil engineer."[20]

Burleigh studied this profession at Worcester (Mass.) Technical Institute, graduating in 1875. That institution placed an emphasis almost amounting to an obsession on field sketching and studio drawing. According to a modern historian of the school, Professor George Gladwin's instructional methods achieved such renown that "educators came from far and near to see the class in session." Perhaps they—and surely Burleigh—heard Gladwin's vigorous admonition in what must have been instruction in perspective: "Converge! Converge! Make those lines converge!"[21]

Lithography itself may have been part of the curriculum. One of the sixteen seniors in the first graduating class of 1871 submitted a thesis entitled "Drawing on Stone." At the very least this tells us that lithographic printing was regarded as a respectable subject for study at a school of advanced technology.

Burleigh's obituary states that before coming to Troy he found employment with a Milwaukee firm as a "sketch artist." My guess is that when he graduated in the pit of the depression he could not find work as a civil engineer and offered his skills as a draftsman and artist to secure a job. For reasons that are as yet mainly circumstantial, I believe that Burleigh worked in Milwaukee for Beck and Pauli or C. H. Vogt.

These two firms printed the Rowley views of upstate towns, and this may be how Burleigh came to be associated with this Hartford publisher—a business, however, strangely absent from Hartford directories as is any listing of Mr. Rowley himself. Burleigh was working for Rowley in December 1880, and his employment may have begun as early as the summer of that year after Burleigh completed his duties as a teacher in a Connecticut school.[22]

How many of the Rowley views were drawn by Burleigh has not yet been determined. We do know that he was the artist of the firm's lithograph of Canajoharie. The January 20, 1881 issue of the Canajoharie *Radii* identifies Burleigh in this capacity, adding that it was to be "published by the Hartford, Conn. Art Publishers." Although this lithograph has no publisher's imprint, it surely came from the firm owned by the elusive Mr. Rowley.

The following year saw the appearance of Burleigh's first signed city views. Those of Ithaca (figure 5.7) and Schenectady, and probably of Binghamton and Elmira, were published by the Syracuse firm of D. Mason and Company, known mainly for its county histories. On at least four of the six prints executed in that year and on his view of Salem, Massachusetts a year later, also drawn for the Mason firm, Burleigh's name appears only in the body of the print.

In 1882 Burleigh struck out on his own, drawing and publishing views but having them printed in Milwaukee by Beck and Pauli or in Cleveland by Vogt. There are forty-one views of this period: one in 1882, four in 1883, twelve in 1884, twenty-one in 1885 and three in 1886. Canastota and Richfield Springs, both printed in 1885, illustrate the quality of Vogt's lithographic work.

Burleigh's Camden view, also in 1885 but printed by Beck and Pauli in Milwaukee, bears his signature in the stone as well as identifying Burleigh as the artist in the imprint. Several others of this period are similar in this respect. Did Burleigh ship heavy and valuable stones, drawn on by him and ready for printing, to his midwestern associates? Or did he travel to Ohio or Wisconsin to put his drawings on stones at his printers? Two other possibilities suggest themselves: the substitution of zinc plates for lithographic stones, or the use of transfer paper, either of which could be dispatched to the printer with less danger of damage and at lower cost.

In 1886 Burleigh installed his own press in Troy at 86 Congress Street. From the latter part of that year through what must have been the early months of 1890, Burleigh issued more than thirty upstate views on which he identified himself as artist, printer, and publisher. The 1888 view of Saratoga Springs belongs to this group. For nine other views, where the imprint gives his name in

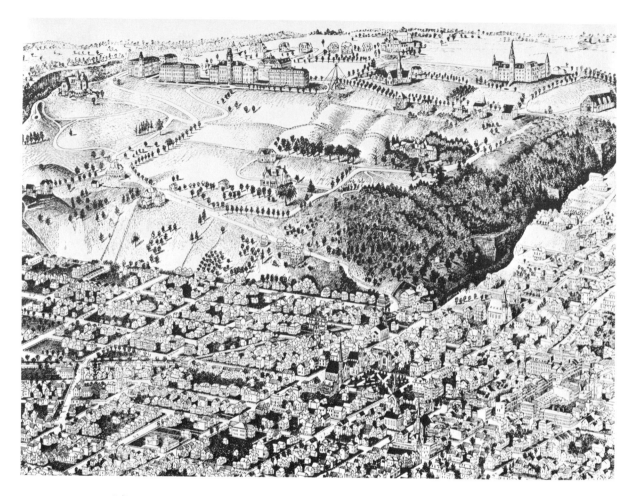

5.7. L. R. Burleigh, *Ithaca, N.Y. 1882*. Lithograph, 20 × 29 in. Lithographed by J. Lyth. Published by D. H. Mason and Co., Syracuse, New York. Burleigh's name first appeared in 1882 on this and four other prints of towns in upstate New York. All exhibit the linear character that is apparent in this detail of a portion of Ithaca showing the hilltop location of Cornell University with the town below. Courtesy of the Tompkins County Trust Company, Ithaca, New York.

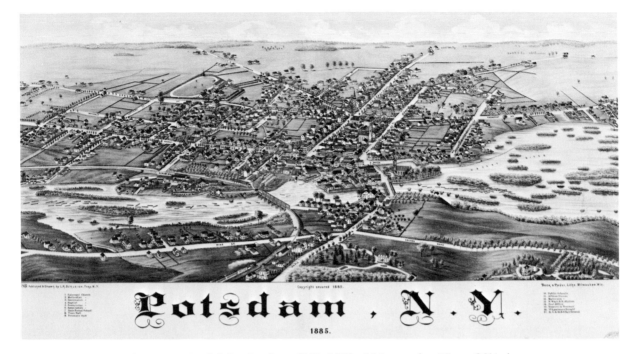

5.8. L. R. Burleigh, *Potsdam, N.Y. 1885*. Lithograph, 16 × 26½ in. Lithographed by L. R. Burleigh. Printed by Beck and Pauli, Milwaukee. Published by L. R. Burleigh, Troy, New York. Burleigh drew, printed, or published some 130 views of towns and cities in the upstate region during hiw viewmaking years that ended in 1899. His depiction of this northern community is representative. Courtesy of the Division of Geography and Maps, Library of Congress.

only two of these categories, he probably served in the remaining capacity as well. Further, some of the views during these years have his name signed in the stone, indicating his total involvement in all aspects of print production.

Only four of the nineteen views published in 1890 bear Burleigh's name as artist; he is not so identified on the remaining eight views both printed and published by him through 1892. They were probably drawn by Christian Fausel, who makes his first appearance in the Troy directories as a lithographer in 1886, the year Burleigh established his press. Previously Fausel worked in Cleveland, and Burleigh may have met him there and brought him to New York. Fausel probably put on stone some of the views drawn in the field by Burleigh, as well as those he drew himself. The Cooperstown print of 1890, with no artist identified but which was printed and published by Burleigh, may have been one of these.

Finally, there are the last views—a dozen or so from 1892 to 1899—where Burleigh did only the printing. Fausel signed two of these, including the Platts-burgh lithograph of 1899; George Norris drew one and published a second for which he probably served as artist as well. On others, like that of Phelps in 1892, the imprint does not identify the artist.

Burleigh's involvement in the views where his name appears shows a well-defined progression. Starting as an artist only, he soon began to publish his own work. With the opening of his press in 1886, he added printing as well. After 1890 he seems to have lost interest in drawing and publishing, mainly providing printing services for others. His business continued for many years after the turn of the century, but city views were not among its products.

Toward the end of his years of concentrated viewmaking, Burleigh issued several lithographs in two states. In addition to the normal print on heavy paper, he offered impressions on lighter stock that were folded and protected by stiff covers. Apparently Burleigh intended these as pocket street maps, a form that sheds light on the uses to which views were put in the last century.

Technically, the Burleigh views printed by him or in Milwaukee and Cleveland deserve no more than passing study. His early prints published in Syracuse, however, deserve further consideration. On several of them one can note a curious feature: two almost imperceptible vertical disjunctions dividing each print into three essentially equal sections. They are neither stain nor fold lines; indeed, they are scarcely lines at all but minute separations or discontinuities between the drawn elements of the design.

Along with Burleigh's name as artist one can find that of J. Lyth, followed by "eng." While this is surely an abbreviation for "engraver," the prints, in my

opinion, are printed lithographically: no plate marks can be seen, the decorative border common to all must have been created by the transfer process, and what I have referred to as disjunctions are probably too few and too slight to be caused by the separate blocks of a wood engraving.

I believe these clues point to the use of three photographic plates made from a drawing and used to create the image on a photo-sensitized lithographic stone or a zinc plate treated in similar fashion. Duval experimented with these techniques in Philadelphia as early as 1857. English and Australian pioneers published the results of their work two and three years later, and Julius Bien in New York advertised in 1868 his firm's *"Photo-Lithographic* process . . . [as] the best and most reliable in practice, for the almost instantaneous reproduction of all kinds of . . . line drawings."[23]

John Lyth was one of nineteen artists listed in the Syracuse directory of 1882–83. His business address at 24 East Washington St. was the same as Daniel Mason's publishing house. The 1883 directory identifies him as "architect" and in 1884 as "draughtsman, designer and photoengraver." The 1884 directory includes a full page advertisement for "Lyth's Bureau of Engraving," stating that he specialized in "Photo-Electrotype Engraving, A superior substitute for Wood Cuts."[24]

Lyth's role in these early views drawn by Burleigh, therefore, was probably that of a photographer, using his skills to transfer final drawings to either stone or zinc for printing on a lithographic press. Or these prints may indeed be examples of electrotype engraving, although I doubt that the relatively small number that would have printed would have justified the cost of this process.

The Burleigh-Lyth-Mason prints exhibit a distinctive style, with precise, rather spare lines. No tone stone provides sky or shadow effects. Tonal quality is achieved almost in an engraver's style rather than by the softer lines and wash effects of the lithographic crayon and pen. These characteristics, too, suggest that the original was a pen-and-ink drawing that was transferred to stone or zinc photographically.

Interesting as these early examples are of changing technology in print making, or as appealing as his later and more conventionally printed city views seem to us now, Burleigh's work can scarcely be regarded as significant if judged by usual artistic standards. His talents were those of a skilled topographic draftsman—certainly very competent, but nothing more. Hill and Bradley, for example, clearly surpassed him as an artist in every respect.

Nonetheless, Burleigh's views provide a record of upstate urbanism that

for several reasons is unsurpassed in value. First, their very number offers opportunities to examine villages and cities having a wide variety of backgrounds, economic activity, and urban form. Second, the spatial distribution of the places depicted includes all the settled parts of the state, with a special emphasis on the historic transportation corridor formed by the Hudson and Mohawk valleys. Third, the short period from 1882 to 1892, after which Burleigh virtually abandoned his viewmaking activities, makes it possible to compare one community with another without time being a significant variable.

Finally, Burleigh's views are accurate and reliable almost beyond belief. A pilot study by Charles Uhl using the Groton view of 1885 compared details of the one hundred structures still standing with their corresponding images on the print. In every case, Burleigh's handling of roof style, structural shape and size, number and placement of windows, location and form of porches, architectural style, and even some elements of the manmade landscape proved completely reliable.[25]

The city views of Lucien Burleigh thus constitute a graphic archive of upstate cities in the late Victorian era unrivaled in accuracy and unexceled in diversity and scope. With the aid of his prints and those from earlier years drawn by other artists, we can, in imagination, approach almost any upstate town of our choice, visit its neighborhoods, walk its streets, admire its buildings, and begin to appreciate the richness and variety of the upstate urban scene as recorded on stone by the region's viewmakers a century and more ago.

NOTES

1. The cataloging project referred to has now been completed and the results published. See John W. Reps, *Views and Viewmakers of Urban America: Lithographs of Towns and Cities in the United States and Canada, Notes on the Artists and Publishers, and a Union Catalog of their Work, 1825–1925* (Columbia: University of Missouri Press, 1984). It includes descriptive entries for 4480 views. Inevitably, some have been overlooked, perhaps as many as several hundred.

2. Donald Karshan, "American Printmaking, 1670–1968," *Art in America* 56 (July 1968): 22–55.

3. For some suggestions about how views can be used by scholars see Reps, *Views and Viewmakers*, pp. 73–86.

4. Cadwallader David Colden, *Memoir . . . at the Celebration of the Completion of the New York Canals* (New York, 1825). Colden identifies the two views of each city as "drawn from nature and lithographed by Geo. Catlin, Esq." and printed at the establishment of "Mr. Anthony Imbert, 79, Murray Street." Imbert is described as "professionally a Marine Artist; originally he was a French Naval Officer, but long a prisoner in England, where he devoted this time of leisure, to the improvement of his talents." Colden, pp. 354, 358–59.

5. My information concerning Young comes from a brief biographical note by Howard S. Merritt in *The Genesee Country* (Rochester: Memorial Art Gallery of the University of Rochester, 1975), p. 92, note for exhibit item 56. This catalog reproduces the three views. For Bufford's important career see David Tatham, "John Henry Bufford, American Lithographer," *Proceedings of the American Antiquarian Society*, 86, pt. 1 (April 1976): 47–73.

6. Sowerby's view is reproduced in color in Merritt, *Genesee Country*, p. 93, item 59.

7. Such scraps of biographical information about Walton that exist have been gathered in Leigh Rehner, *Henry Walton: Nineteenth Century American Artist* (Ithaca: Ithaca College Museum of Art, 1968). Her exhibition catalog essay has been reprinted with some notes by John G. Brooks on Walton's Ithaca scenes in Rehner, *Henry Walton, An Early Artist* (Ithaca: DeWitt Historical Society of Tompkins County, 1969).

8. *The Jeffersonian* (Watkins Glen, N.Y.), December 25, 1847.

9. This quotation and virtually all of my information about Whitefield come from Bettina A. Norton, *Edwin Whitefield: Nineteenth-Century North American Scenery* (Barre, Mass.: Barre Publishing, 1977).

10. These and the quotation in the following paragraph are taken from a scrapbook kept by Whitefield which is now in the collections of the Boston Public Library.

11. The Whitefield–Smith Brothers relationship will probably never be fully understood. Norton, *Whitefield*, pp. 46–47, deals with the subject, but she was not able to find much information about it.

12. For Hill's work on the field of city views see my biographical note in Reps, *Views and Viewmakers*, pp. 183–84. There is a brief note about Bradley in Munson-Williams-Proctor Institute, *Made in Utica* (Utica: Munson-Williams-Proctor Institute, 1976), p. 36.

13. Many Sachse prints are illustrated and discussed in Lois McCauley, *Maryland Historical Prints, 1752 to 1889* (Baltimore: Maryland Historical Society), 1975. My paper on his city views, "Cities by Sachse," presented in 1983 at the North American Print Conference in Baltimore, sponsored by the Maryland Historical Society and other institutions, and which will be published in the proceedings of that conference, focuses more sharply on the firm's urban lithographs and includes a discussion of views outside of Maryland. I have summarized this material in Reps, *Views and Viewmakers*, pp. 204–206.

14. Biographical notes on the two Baileys and Hazen can be found in Reps, *Views and Viewmakers*, pp. 161–65, 182.

15. For Koch, see ibid., pp. 184–86.

16. For Brosius and Poole, see ibid., pp. 165–66, 199–200.

17. Fowler was the most prolific American lithographic viewmaker. I have summarized his long career in *Views and Viewmakers*, pp. 174–77. Most of the details of his life are known only because

of the research carried out by the late James Raymond Warren, Sr. Warren also was responsible for biographical material on the Bailey brothers and their associate, J. C. Hazen. Warren's work is recorded in two articles: James Raymond Warren, Sr., "Thaddeus Mortimer Fowler, Bird's-Eye-View Artist," Special Libraries Association, Geography and Map Division Bulletin no. 120 (June 1980), pp. 27–35; and Warren and Donald A. Wise, "Two Birds-Eye-View Artists: The Bailey Brothers," ibid., no. 124 (June 1981), pp. 20–30. Each article contains a list of places drawn by Fowler and the Baileys. The Fowler checklist includes thirteen views that I believe were not his work and omits about seventy others that are recorded in my *Views and Viewmakers*. The Bailey checklist omits about one-hundred views recorded in my own study and misleadingly attributes to O. H. Bailey and Co. about fifteen prints published in the early twentieth century by the firm of Hughes and Bailey.

18. For Ruger see Reps, *Views and Viewmakers*, pp. 201–204, and for Denslow see ibid., pp. 170–71.

19. For Rowley, see ibid., p. 201.

20. Details of Burleigh's life and career appear in ibid., pp. 167–70.

21. As quoted in Mildred McClary Tymeson, *Two Towers: The Story of Worcester Tech, 1865–1965* (Worcester: Worcester Polytechnic Institute, 1965), p. 51.

22. Burleigh to C. O. Thompson, December 28, 1880, Gordon Library, Worcester Polytechnic Institute. The annual directory of the institute lists Burleigh as a teacher in Plainfield in the 1878–79 issue. The 1879–80 issue identifies him as a map and view draftsman for H. H. Rowley.

23. As quoted in Peter Marzio, *The Democratic Art* (Boston: David R, Godine, 1979), p. 58.

24. Richard N. Wright, president of the Onondaga Historical Association, Syracuse, N.Y., provided me with several useful bits of information about Lyth.

25. Charles Uhl, " 'Every Building is Accurately Represented': An Examination of Five Bird's Eye Views of Upstate New York," Master's thesis, Cornell University, 1983. Uhl's first study dealt with only Burleigh's Groton view, but his thesis included an examination of Burleigh's Ithaca view as well. This view also was judged to be highly accurate.

"This Bridge of the Yankees"
Engineers and Indians at the Niagara Frontier

BETTINA A. NORTON

The print entitled *Queenston and Lewiston Suspension Bridge/The Largest in the world!!!* is a typical American topographical lithograph of the mid-nineteenth century. Drawn by Frederick L. Knight, about whom little else is known, it is of no particular distinction artistically. It was printed in 1850 by Serrell and Perkins, minor lithographers among a large field of more prominent New York City printing firms like that of Nathaniel Currier, whose shop was a block or so away. From a large family of surveyors and civil engineers, Henry Serrell specialized in printing plans, elevations, and an occasional view of engineering works, straightforward commercial lithographs with no pretensions to sentiment or beauty. The subject of the print, the bridge itself, was designed and built by Edward W. Serrell, also of New York City and undoubtedly kin to Henry. The print that both Serrells had a hand in producing was intended to advertise two things—the technical achievement of modern engineering science and Edward Serrell's own expertise in the field.

But the particular impression of the print discussed here has a message penned across part of the sky. When this impression was originally donated to the Marine Museum in Salem (now the Peabody Museum, which later transferred the print to its neighbor across the street, the Essex Institute), the clerk wrote on the print:

> Presented by Maungwudaus.... Maungwudaus of the Chippeway Indians, while standing in the middle of this Wire Bridge, said, "I have seen many wonderful works in Europe, but this Bridge beats all. —What would

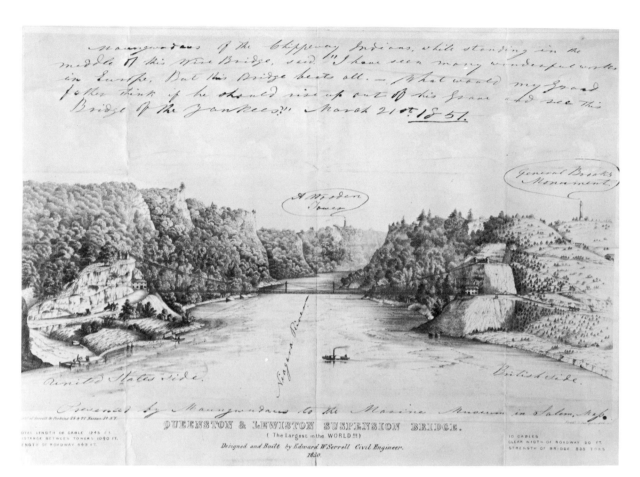

6.1. Frederick L. Knight, *Queenston and Lewiston Suspension Bridge, The Largest in the world!!!* 1850. Lithograph, 13¾ × 21¾ in. Printed by Serrell & Perkins, New York. Courtesy of the Essex Institute, Salem, Mass.

my grandfather think if he should rise up out of his grave and see this Bridge of the Yankees?!!" March 21st 1851.

Through this inscription the print becomes a vehicle for the consideration of two issues, neither of them concerned with aesthetic values: the print becomes a tale of engineers and Indians. The main image of the print, a suspension bridge across the heights of the Niagara River, is a paean to the capabilities of mechanical engineering in the 1840s; yet there is among those admirers and beneficiaries gathered around the bridge no one of the race that until a few years earlier had derived its living from the area. Where were the Indians? This chapter looks at both the bridge and the missing Indians and then makes some assumptions about what Maungwudaus' grandfather might have thought had he risen from the grave.

The setting of the print is worthy of the *Leatherstocking Tales*. It is the Niagara River, for centuries the most important and continuously used highway to the interior of the continent. It first served the Indians, then the French, then the British, and finally both emigrants from New England and new immigrants to this country who sought a better living at what was then the frontier. The very concept of "frontier" assumes that the area beyond it is uninhabited. This was a peculiarly self-centered attitude of the colonial Europeans who settled America, and it strongly colored their relations with the indigenous population.

The Niagara region was a northern hardwood forest of mostly birch and maple on a plain that undulated with slight relief across what is now the north-west corner of New York State and the southernmost part of Ontario. Before the white settlers came, networks of trails ran throughout the region. It was hunted and fished by a people highly developed compared to their counterparts in other areas. An important portage ran down the east bank of the river for eighteen miles or so along its lower, unnavigable portion.

Though Ojibway (or Chippewa) lived in the area, the main tribe was Seneca. Most of the Ojibway, long settled near Lakes Superior and Huron and observed there by Jean Nicollet in 1634, had migrated west to what are now Wisconsin, Minnesota, North Dakota, and Saskatchewan. (As of 1972, they were the largest native American population north of Mexico.[1]) But a small number moved south to the area near the Niagara River and displaced some Iroquois on the northern shores of Lakes Erie and Ontario around 1690. The Ojibway were a tribe in the sense that they had a common language, Algonkian, and a common

culture, but they were not tightly organized. They consisted of widely scattered autonomous bands who hunted, fished, and trapped in family groups.[2]

Early in the seventeenth century, the French began a lively trade with the Indians, primarily in beaver fur. A major trading center for the Great Lakes and lower St. Lawrence regions developed at the Niagara River. The French built a trading house, "Joncaire's," at Lewiston Heights overlooking a way station on the portage route. Around 1707, as the fur trade became more active, some Ojibways moved closer to the river to take part in it. The British coveted this lucrative trade and, with the appointment of William Burnet as governor of the colonies of New York and New Jersey in 1720, a zealous campaign was initiated to secure the frontier against the French. In one letter, the governor complained that they were "seducing our Indians to their Interests & have built trading Houses in their Country." To counter the influence of Joncaire's trading house, the British built one of their own at Oswego. The French retaliated by building Fort Niagara. Trade, its attendant intercommunication, and these escalating rivalries soon caused the Indians to protest that their foot trails were being chewed to pieces by the Europeans' horses.[3]

Basically nomads, the Indians who roamed these parts hunted, fished, and gathered wild rice, blueberries, and sap for maple syrup. They did little cultivating of crops, and spent their summers making birch bark canoes to ferry themselves and their families from one fishing and hunting ground to another and from their summer to their winter homes. As they began to concentrate near the active trade areas, their material culture rapidly changed from one of stone, wood, bone, bark, and simple pottery to one of more sophisticated and diverse items of foreign manufacture. They began to make more birch bark canoes than they needed in order to use the extra ones for barter. The Indians, intermarrying with whites, began to lose their group identity.[4]

The European rivalries soon erupted into the French and Indian War, and some Ojibway from the Thames and Grand River area in Canada made an alliance with the Six Nations in New York State and joined with Pontiac to try to rout the British.[5] The result of the wars was the loss of French control in North America. Indian trapping ground in the Niagara area began to disappear as the British imposed their land policies on the natives. After the British themselves lost control to the American colonies in the Revolution, the commonwealth of Massachusetts, which had laid claim to part of New York State, sold its preemptive rights to 6,000,000 acres to the latter, and the Holland Land Company soon bought the western half and laid out roads and settlements. Buffalo was

founded, and immigration from the east and Europe was encouraged. The Indians were forced into reservations set up "for their benefit" by the Americans and Canadians who soon heavily outnumbered them.[6]

In the War of 1812 the Niagara area was a major site of conflict. Indeed, more battles have been fought in that area than in any other throughout our history, with the possible exception of Tidewater Virginia in the Civil War. For the Niagara area, the War of 1812 meant a check on its development, the temporary cessation of immigration, and the impoverishment of local settlers. Many villages, including Lewiston, were laid waste. Soon after the war, the chief interest of the area became the development of a canal west of the river from Lake Erie to Lake Ontario to carry commerce around Niagara Falls. As a result, what had long been the most populous district on the Niagara frontier, the portage route along the north section of the east bank of the river, became the least important to the region's developing industrialization. In the 1840s, the few Ojibway around Niagara were still supplying white settlers with fish and game. They were concentrated west of the Niagara, though they occasionally crossed from Canada into New York State.[7] But by 1851, the year that the Queenston and Lewiston suspension bridge was opened, all but a few had deserted the area for land near the headwaters of the Mississippi.

The bridge that Edward Serrell designed (figure 6.1) was erected because the town of Lewiston, which had long handled most trans-Niagara River traffic via ferry, was anxious to maintain its business, threatened in 1848 by the erection of a suspension bridge some miles upstream near the falls. Both bridges were typical suspension bridges of the era. A system of chains hung between two piers carried the weight of a platform and any traffic, pedestrian or vehicular. The chains were anchored firmly to the ground at either end. This kind of bridge was ideal for rivers with swiftly flowing currents and high, precipitous banks, like the Niagara.

The origins of suspension bridges made of iron can be traced to Tees, England, around 1740, but their more important development occurred later in the century in America.[8] One of the earliest and most important was the Essex Merrimac Suspension Bridge, built a few miles north of the center of Newburyport, Massachsetts, in 1792, and of which the Essex Institute owns several contemporary illustrations.[9] One of its chief investors was a character—Timothy Dexter—who turns up in almost any chronicle of early Newburyport. When this eccentric and wealthy man died, one of the more important assets in his will were his shares in the chain bridge.[10]

Although Americans and the French dominated the building of suspension bridges for the next thirty years, an English engineer, Thomas Telford, designed the bridge that was the model for Serrell's. One of the outstanding civil engineers of the early nineteenth century in England, Telford had constructed many conventional cast iron bridges, the largest of which, however, spanned only 150 feet. But for the Mersey River, he proposed a suspension bridge with a center span of 1,000 feet. Whether his patrons lacked confidence in his complex design, or whether they found it too expensive, the bridge was never built. But it did awaken Telford to the possibilities inherent in the principles of suspension, and he spent much time experimenting with the tensile strength of malleable iron as opposed to cast iron under compression. The suspension bridge that he designed for the Menai Straits was built, and this became, with modifications, Serrell's model for the Queenston-Lewiston bridge.[11] Modified further, it later became the model for the Brooklyn Bridge and many others. It is still in use.

Authorization for a bridge spanning the Niagara River first came about in 1836, when both the legislature of the state of New York and the Parliament of Upper Canada granted charters to build a bridge which, it was then claimed, "will be one of the proudest triumphs of art in the known world," a comment which reflects the nineteenth century's belief in the affinity of art with science. The bridge was to extend from Queenston to Lewiston. The proposal stated that, if the whole bridge were covered cheek to jowl with oxen, the total weight would be 350 tons less than that which it was estimated the bridge could sustain.[12] But that bridge was never built.

The bridge that was built in 1848 was about twelve miles to the south of Lewistown, about a mile and three-quarters downstream from the falls. It was designed primarily as a footbridge, although its engineer, Charles Ellet, Jr., anxious to prove its capabilities, mounted a horse and dazzled spectators by trotting across the bridge as it swayed precariously.[13]

The town of Lewiston, eager to keep its trans-Niagara traffic, responded to this challenge by encouraging passage of an act incorporating the companies that would build a bridge between that town and Queenston. The Lewiston Suspension Bridge Company and the Queenston Suspension Bridge Company both sold shares at $100 apiece. The bridge they were to build was subject to certain conditions that in their era were not common: the safety of the bridge for the transport of teams and carriages was to be tested (how was not specified) by a judge of Niagara County or the Supreme Judicial District. If the bridge passed inspection, the companies would be allowed to erect toll gates and fix rates of

passage—no greater, however, than 25¢ for a passenger on foot, 50¢ for a horse and single carriage (additional passengers paying a slight stipend), sheep 1½¢ a head; swine, 2¢ a head; and meat cattle, 6¢.[14]

Work began in 1850. The platform of Serrell's bridge was suspended about 60 feet above the waters of the Niagara by ten cables, each 1,245 feet long. The towers were 1,040 feet apart, the greatest bridge distance in the world at the time, as the subtitle of the print claims, though the length of the deck (849 feet) was exceeded by a bridge by Ellet across the Ohio at Wheeling, West Virginia, opened in 1849. The carriage way of the Queenston-Lewiston bridge, divided for pedestrian and vehicular traffic, was 20 feet wide, and was estimated by Serrell to be able to sustain 350 tons. The total cost of the bridge was $58,000.

Serrell's bridge put Lewiston firmly back in control of traffic across the river. Serrell himself planned to head the opening day's procession across the bridge on March 20, 1851. As he and his wife prepared to cross, a local townsman, after having collected bets from his friends and hidden in a lumber pile near the entrance to the bridge, jumped out ahead of the Serrells and ran across.[15]

Unlike Timothy Dexter's success with the suspension bridge over the Merrimac, the Queenston and Lewiston Suspension Bridge had only meager financial returns. The companies had neglected to allocate funds for maintenance, as had the legislatures of New York and Canada. Further, like its model, the bridge at Menai, it was not adequately braced, and it vibrated badly. A few of the stays ruptured. Soon afterward, it was discovered that guy wires under the bridge were causing ice to clog the river, and some were removed. Finally, in a gale on April 12, 1864, the bridge was torn apart. Like a romantic ruin, the cables hung in place for thirty-five years. They were reported to have been a hand-over-hand escape route for criminals fleeing from the United States to Canada.[16]

The replacement bridge, built in the 1890s, incorporated the towers built in 1851, leaving intact the inscription with Serrell's name. The towers themselves were, however, constructed to a much greater height. That bridge was replaced with the one now in use, built in the mid-1960s.

One who claimed to cross the Serrells' bridge the day after it was opened in 1851, probably along with hordes of others, was the Indian Maungwudaus.[17] If indeed his grandfather was native to the area, he most likely came from the Thames River basin, one of the few local districts in which there were still Ojibway living. Where Maungwudaus spent his early years, what he did in them,

and whether he lived on a reservation, are unanswered questions. But it is known that he did travel in Europe with some members of his family in 1844, at first under the auspices of a Canadian entrepreneur who meant to show them as curiosities. There were eleven of them, with Maungwudaus acting as their chief. At their arrival in Paris, they caught up with George Catlin (1796–1872), the American painter who had been in Europe for five years to "awaken a proper sympathy for Indians" and coincidentally to enrich his own fortunes by exhibiting his Indian Gallery, for a fee. (The Indian Gallery was a collection of his paintings augmented by *tableaux vivants* incorporating two earlier groups of touring Indians.) Catlin later wrote that he did not wish to seem to be exploiting live Indians, but, he rationalized, it was no different than putting actors on a foreign stage.[18] He had conceived the idea of a *tableau vivant* (first dressing his own nephew as a Plains Indian) as a means of revitalizing interest in his paintings and lectures.[19] The arrival of a troupe of Ojibway unassociated with Maungwudaus enabled Catlin to make his exhibitions profitable. William Truettner, in his *Natural Man Observed*, points out that it was at this time that Catlin "became less a spokesman than a promoter."[20]

In Paris the gallery was successful at first, but nonetheless, when a group of Ioway arrived, he also incorporated them into the exhibit. The abrupt departure of the Indians in the late spring of 1844 left Catlin with his gallery empty of native Americans. Then his wife died. Left with four small children, Catlin was about to return to America when the Canadian-led group of eleven Ojibway, with Maungwudaus as chief, arrived in Paris from London. (The birth of an Indian baby shortly thereafter made their number twelve.) Catlin's terms with their agent guaranteed them a monthly wage and return passage to London; the Indians were asked to abide by a temperance pledge. Catlin felt that in appearance the Ojibway were less interesting than the Ioway, but he considered his new group's dances and other amusements at least equal to those of the Ioway. "The Chief of this party, Maun-gua-daus, was a remarkably fine man, both in his personal appearance and intellectual facilities," wrote Catlin. "He was a half-caste, and, speaking the English language tolerably well, acted as chief and interpreter of the party."[21] The new group did not, however, draw large crowds. Parisians were suspicious, thinking the Indians were an imitation to replace the Ioway.

The intercession of a French landscape painter, Jean Antoine Theodore Gaudin (1802–80) brought better times. He and his wife invited Catlin and his entourage to dinner and arranged for Catlin to have an audience with King

6.2 George Catlin, *Eleven Ojibbeway Indians*, ca. 1848. Wood Engraving, 5 × 7½ in., published in George Catlin, *Catlin's Notes of Eight Years' Travels and Residence in Europe* (London, 1948). Maungwudaus is number 1 in the group. Courtesy of Bettina Norton.

Louis Philippe, who had traveled extensively in the United States. Louis Philippe asked Catlin to set up his exhibition in a private salon at the Louvre and to arrange an interview for him with the Ojibways.[22] When Catlin returned and told them the news, they were so elated that they went out onto the streets of Paris, somehow procured a dog, and roasted him whole. It was "partaken of with a due observance of all the forms used in their country on such occasions, it being strictly a religious ceremony," Catlin wrote.[23] When they later entertained the king he rewarded them with gold medals for the leaders and silver for the rest. Yet financial problems plagued Catlin and the Indian troupe. Some of them died of smallpox.

Catlin painted fifteen portraits of his group in Paris, including Maung-wudaus, for King Louis Philippe.[24] Returning to London without the Indians, he made full-scale models "from life," he said, but actually from earlier studies, of the Ojibways and Ioways, including Maungwudaus. These were part of the Indian Gallery that Congress declined (by one vote) to purchase for the nation. By the time the collection was finally given to the Smithsonian Institution, much of it had been destroyed.[25] Among the portraits were "#618: Maun-gua-daus, a Great Hero; one of the second party of Ojibways who visited London in 1846. Head-dress very splendidly made of eagles' quills, his robe of buffalo skin, with the figure of the sun painted on it. Head moulded in plaster from life," and #531: Maun-gua-daus, a Great Hero; Chief, 41 years old."[26]

Catlin was told that Maungwudaus himself persisted in traveling about Europe with exhibitions of Indian life, and "had the singular and lamentable misfortune of burying three of his children and his wife."[27]

Maungwudaus returned to America, but little is known about his later years. He was in Salem in July 1851, when he presented the print of the Queenston and Lewiston Suspension Bridge to the Marine Museum. The purpose of his visit is not recorded in the local papers, but P. T. Barnum was in town that month with his large troupe and Maungwudaus may have been in it. Barnum had linked up with Catlin in Europe at least once—with the group of Ioways in Paris, who were, according to the showman, "exhibited by M. Catlin on our joint account, and were finally left in his sole charge."[28] Barnum may have assumed responsibility for Maungwudaus and his group. If so, Maungwudaus probably once again played the double role of picturesque native and privileged visitor to the crowned heads of Europe.

In reflecting on the enterprise of bringing Indians on these tours, Catlin thought that they were persuaded to go by promises of money, of travel at no

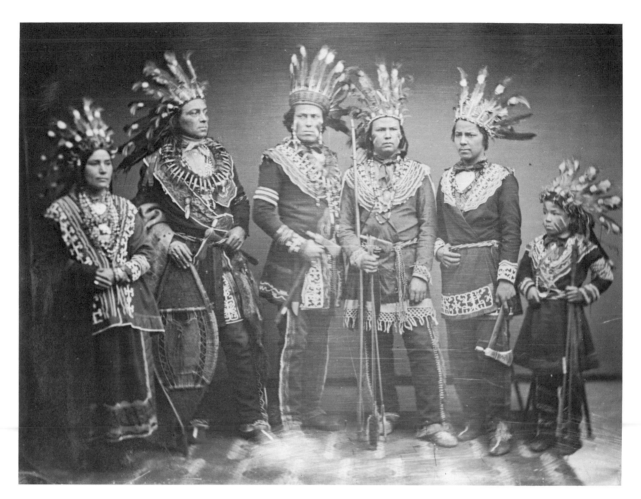

6.3. Unknown photographer, *Maungwudaus and Members of his Family*, ca. 1851. Daguerreotype, courtesy of the Chicago Historical Society, Chicago, Illinois.

expense to themselves, and of numerous presents to bring home. But he also wrote that his friends were almost assuredly induced by the promise of exposure to enlightened society and the potential that it held for making them enlightened teachers to their brethren in the wilderness. His account betrays uneasiness about the effect of all this attention in Europe on the native Americans. He noted that in addition to their medals, they had collected toys, religious tracts (which they could not read), jewelry and accessories, and prints, "views of countries they had seen, of churches, cathedrals, maps of London and Paris, views of bridges."[29]

With this background, we might well wonder, as Maungwudaus asks in his inscription on the print, what his grandfather would have thought of the bridge? He might have been impressed, even intimidated, at the engineering ability of the white man. He may have considered it folly. He might have concluded that the bridge would make trading with the newcomers easier. He might have been unhappy about this usurpation of his traditional hunting ground, and he surely would have wondered how he and his family were to fit into the new scheme of life symbolized by the bridge. He might have been puzzled and perhaps saddened to know that Ojibways had turned from their nomadic existence in nature to promote Catlin's and P. T. Barnum's sideshows. In fine, his thoughts might have been unprintable.

NOTES

1. Robert E. Ritzenthaler, "Southwestern Chippewa," in *Handbook of North American Indians*, gen. ed. William C. Sturtevant (Washington, D.C.: Smithsonian Institution, 1978– , vol. 15, *Northeast*, ed. Bruce G. Trigger, p. 743.

2. E. S. Rogers, "Southeastern Ojibway," in Sturtevant, vol. 15, *Northeast*, ed. Bruce G. Trigger, pp. 761, 760; and Ritzenthaler, p. 743.

3. Frank H. Severance, *An Old Frontier of France*, vol. 1 (New York: Dodd, Mead, and Company, 1917), pp. 147 ff., 207.

4. Rogers, pp. 762–64; Ritzenthaler, pp. 743–44.

5. Rogers, p. 763.

6. Frank H. Severance, "Indian Runner to Telephone," in *Studies of the Niagara Frontier* (Buffalo, N.Y.: Buffalo Historical Society, 1911), p. 254; Rogers, p. 763.

7. Rogers, p. 763.

8. Charles Stewart Drewry, *A memoir of suspension bridges,* . . .(London: Longman, Rees, . . ., 1832), p. 9. A history of suspension bridges could begin with the vines and ropes thrown over the marshes of the Amazon—nineteenth-century books and encyclopedias did just that. But England was the locale for the development of bridges of iron, the material which sparked the Industrial Revolution. The conventional Iron Bridge across the Severn Coalbrookdale in England, built in 1779, was the first to show the potential of iron as a building material.

9. Ibid., p. 12.

10. Samuel L. Knapp, *Life of Lord Timothy Dexter* (Boston: J. E. Tilton & Company, 1858), pp. 7, 154–57.

11. Drewry, pp. 46–54.

12. *Boston Evening Transcript,* July 28, 1836; quoted from *Boston Commercial Advertiser.*

13. "Lewiston Suspension Bridges: Lewiston State Park," typescript courtesy of Calvin C. Schultz, Town Supervisor of Highways, Water, and Drainage, Lewiston, New York.

14. "Lewiston Suspension Bridge," pp. 1–3.

15. Ibid., p. 4; quoted from *Niagara Falls Gazette,* July 21, 1899.

16. Ibid., pp. 5–6; quoted from *Niagara Falls Gazette,* March 3, 1858, and other sources, unidentified.

17. Maungwudaus (var., Maunguadaus) at some time adopted the Anglicized name George Henry; members of his family also adopted Anglicized names. Ives Goddard, Curator, Department of Anthropology, Smithsonian Institution, who provided all the phonemic transcriptions of Indian names for volume 15 (*Northeast*) of *Handbook of North American Indians* (see note 1), has phonemicized Maun-gwu-daus to *mankotta-ss.*

Various scholars have noted that the costumes worn by the man alleged to be Maungwudaus and his family in the daguerreotype owned by the Chicago Historical Society (figure 6.3), seem to be those of more eastern Indians, such as MicMac. Although the costumes are questionable as authentic Ojibway, the portraits are not. A correlation of the Indians in the daguerreotype to those in the Catlin engraving in volume 2 of his Notes of *Eight Years' Travels,* where he also gives ages, taking into account those that subsequently died, shows:

Catlin engraving, ca. 1848 Daguerreotype, ca. 1851
(depicts the Indians in 1846)

1. Maungwudaus (A Great Hero)—Chief, mankotta-ss, courageous, George Henry
41

6. A-wun-ne-wa-be (the Bird of Thunder), awana-pe, mist man, John Tecumseh Henry
19.

7. U-je-jock (the Pelican), 10. acica-kk, crane, George Henry

9. Noo-din-no-day (the furious Storm), 4. no-tino-kke, wind maker, William Henry

11. Uh-wus-sig-gee-sigh-gook-kway (Woman of the Upper World)—wife of Chief, 38.

awassidi-siko-kkwe, beyond-the-sky-woman, Hannah Henry

18. George Catlin, *Adventures of the Ojibway and Ioway Indians in England, France and Belgium* (London: Published by the author, 1852), 3rd ed., p. vi.

19. William H. Treuttner, *The Natural Man Observed: A Study of Catlin's Indian Gallery* (Washington, D.C.: Smithsonian Institution, 1979), p. 41.

20. Ibid., p. 44.

21. Catlin, pp. 203–77, 278–79.

22. Ibid., pp. 281–86.

23. Ibid., p. 285. When the Indians arrived at St. Cloud, the king asked them to participate in a canoe race to test an Ojibway canoe owned by the Duchess of Orleans against one made by whites. The Ojibways were not pleased to be put in this position, but Catlin persuaded them to compete and they lost. They regained their stature by showing their skills in archery and ball-toss, and charmed everyone with their war dance.

24. Ibid., pp. 293, 316–17; Thomas Donaldson, *The George Catlin Indian Gallery in the U.S. National Museum (Smithsonian Institution)* (Washington, D.C.: USGPO, 1887), p. 701.

25. Donaldson, pp. 5, 386. The American art colony in Paris, which included John Vanderlyn, Thomas P. Rossiter, William Morris Hunt, Thomas Hicks, and John Kensett, petitioned the United States Congress in April 1846 to purchase Catlin's Indian Gallery for the nation. Congress declined (by one vote) to appropriate the $65,000 purchase price. In 1852 Catlin's debts were so great that he was obliged to turn over his collection as collateral to Joseph Harrison of Philadelphia. On 19 May 1879, Thomas Donaldson took possession of that part of the collection which had not been destroyed by fire, insects, and water, and sent it to the Smithsonian Institution.

26. Ibid., p. 387; Catlin, p. 294.

27. Catlin, p. 302. Catlin took pains to note that the Indians' conduct while with him was exemplary and that they had consistently displayed what he considered most notable characteristics—"strict adherence to their promises and never-ending garrulity."

28. P. T. Barnum, *Barnum's Story, the Autobiography of P. T. Barnum* (rpt. New York: Dover, 1961), p. 246.

29. Catlin, pp. 305–308.

7

Comic Drawing in New York in the 1850s

BERNARD REILLY

Throughout the long history of graphic satire, two basic approaches are evident. One approach is that of caricature and other farcical distortions of concrete things. The other is allegory, in which essentially abstract political opinions or principles are given figurative form. The first approach is best adapted to direct attacks on the personal character of individuals or classes of people (the clergy have always been favorites). Like the old moral satires of the Reformation, this approach involves characterization of an individual or type as wicked or ludicrous. Caricatures generally have an active or dramatic quality and much cohesiveness. The relationship of this form of graphic political satire to theatrical characters and the excesses of farce has always been intimate. The alleged personal motives, faults, and idiosyncrasies of a public figure are laid bare and exposed to general ridicule or contempt. In America, the anonymous authors of the many anti-Stamp Act cartoons in the 1760s were adept at this type of pictorial sniping.

The second approach, which employs allegory or metaphorical modes of expression, has been traditionally reserved for conveying more complex political ideas. It assumes a more didactic role than does satire, sending its message in symbolic or figurative terms. Benjamin Franklin's *Magna Britannia* of 1765 is an early American specimen of this genre.

Political art has vacillated from one to the other of these approaches since its earliest days. During the first half of the nineteenth century in the United States, a hybrid genre of popular satire flourished, combining farcical and figurative elements in proportions which varied from picture to picture. The art did, however, lean decisively toward the metaphorical, and the broadside cartoons produced in New York, Philadelphia, and Boston during the 1830s and 1840s—

147

the Jacksonian era—were inspired by work of British comic artists, the polite, conversational tableaux of John Doyle, and the somewhat ruder fantasies of George Cruikshank. The American prints relied less on personal characterization and real caricature than on attacks on legislative issues and foibles of party politics. Cartoons issued by H. R. Robinson, James Baillie, John Childs, and other publishers usually presented, in metaphorical form, the gist of a political situation. The cartoon's effect usually turned on the figurative image.

The Jacksonian cartoonists, of whom Edward W. Clay was the most prolific, picture a world of visual incongruities and dreamlike absurdities. They strike us today as contrived, obscure, and decidedly unfunny, yet humor was not always the artist's primary intent. True, the caprices of statesmen and their legislative quackery were ridiculed, but the nineteenth-century cartoon involved a game of concealment and ambiguity. It displayed a delight in figurative language and double entendre matched only in the speech of stump orators of the time. This brand of expression involved a quickness of mind, and a deftness in inventing (and deciphering) verbal and visual puns, and as such held strong appeal for the Victorian mind.

Here was an age in which wit, rather than humor, was ascendant. The cartoon offered nineteenth-century readers not a straightforward statement of opinion (as do today's cartoons) but an amusing and elaborately devised conceit—a view of current political events in the form of an extended visual analogy.

Edward W. Clay's *The Government* (figure 7.1), one of the scores of anti-Jackson satires of the 1830s, is a particularly baroque example of this approach. Its rebus-like subtitle, and assortment of double images make the cartoon's meaning more conducive to an involved reading than to instant recognition. Compared to the spare, forceful sketches of modern cartoonists, *The Government* is an intricate invention indeed.

The political cartoon was first and foremost a colloquial art form—an art of the people. Its imagery was drawn from all levels of popular consciousness. The designers of cartoons tapped a reservoir of collective wisdom and lore, ranging from the Scriptures to Shakespeare. The cloven-hoofed devil of *The Great Political Car and Last Load of Patriots,* an 1845 broadside (figure 7.2), is the same demon who haunted the Sunday sermons of contemporary preachers. A venerable heritage of proverbs and aphorisms was drawn upon for imagery. And fables, supremely simple tales exalting good sense and modest virtues, made ideal vehicles for political comment. Aesop and La Fontaine had been rudimentary features of every child's education in America since the end of the eigh-

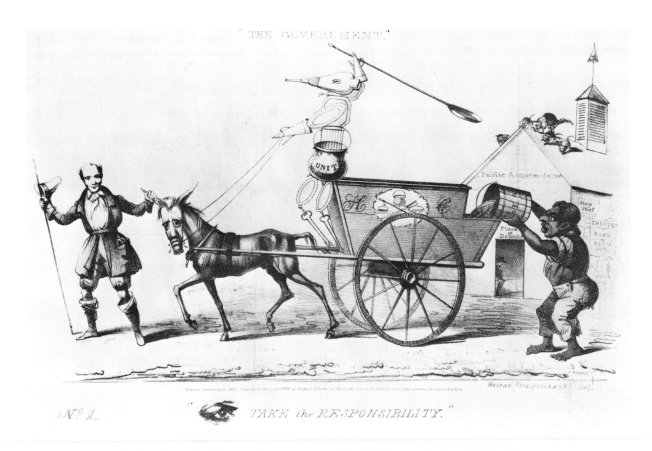

7.1. Edward W. Clay, *The Government*, 1834. Lithograph 10⅛ × 14¼ in.
Published by Endicott and Swett. Courtesy of the Library of Congress.

THE GREAT POLITICAL CAR AND LAST LOAD OF PATRIOTS.

DORR, JACKSON, SIMMONS AND ARNOLD!

"We stoop to Conquer."

"BETTER TO REIGN IN HELL THAN SERVE IN HEAVEN."

7.2. Unknown artist, *The Great Political Car and Last Load of Patriots*, 1845. Woodcut with letterpress, 23¼ × 15½ in. Courtesy of the Library of Congress.

teenth century. It is scarcely a wonder that these images made their way into the cartoonist's working vocabulary.

Perhaps most important in the makeup of American cartoons was the rhetoric of the politicians themselves. From the mouths and pens of public figures have always issued vivid metaphors—the "big stick," the "ship of state," and the "social safety net"—images that communicate effectively to large audiences. In caricature as in speech making, simpler is better.

During the 1830s and 1840s this figurative type of satire was dominant in the United States. In it one could scarcely perceive the potential for caricature later to be realized by Thomas Nast and others in the 1870s. But by the late 1840s changes were occurring that prepared the way for what many historians consider the great age of American graphic satire.

In 1850 the center of American political satire was New York City. More specifically, it was in the Chatham Square area. Here on Nassau Street, lower Broadway, Fulton Street, and half a dozen neighboring thoroughfares was an extraordinary milieu of journalists, playwrights, actors, and artists, real and aspiring. This was the heart of New York's comic theater district and the headquarters for the city's infant picture magazine industry as well. The press of the day was characterized (unflatteringly) by Charles Dickens, who visited New York at about this time, as "pimping and pandering for all degrees of vicious taste, and gorging with coined lies the most voracious maw; imputing to every man in public life the coarsest and vilest motives." (What a fertile bed for satire!) Indeed both theater and press lived on sensationalism and color. Chatham Square was a journalistic reservoir which poured out copiously to a public indiscriminately thirsty for print.

Publishers of crude woodcut satires, dime caricatures, and comic almanacs and journals operated their storefront printing plants near Chatham Square. From here newsboys and booksellers fanned out to hundreds of street corners and stalls throughout the city to vend their wares. The rails carried bundles of cheap broadsides and pamphlets to Philadelphia, Boston, and Cincinnati, extending the distribution system to distant markets as well. This fledgling industry provided a patronage, marginal though it was, for an army of young illustrators, many newly arrived from England, Ireland, and the Continent. In the drawings which these artists produced for this ephemeral trade, political satire took off in a new and promising direction.

Thomas Nast spent his boyhood years in New York amid this ferment, absorbing everything about caricature and visual irony that these tabloid car-

toons could teach him. The developments then taking place matured after the Civil War in Nast's own powerful caricatures. In his *Tweed-Le-Dee and Tilden-Dum* of 1876 (figure 7.3) we see perhaps the most diabolical character which American satire has ever given us. Nast's characterization of William Marcy Tweed possesses a villainous presence against which the caricatures of Martin Van Buren and Andrew Jackson of the 1830s pale in comparison.

The comic press of the late 1840s and early '50s forms a bridge between two rather distinct eras in American caricature, and one of the chief agents of this transition was publisher Thomas W. Strong. Strong was a talented entrepreneur, but we know little of the details of his life. He was active in New York as a lithographer and wood-engraver from about 1840, and his shop at 98 Nassau Street also specialized in comic literature and—apparently his most lucrative commodity—grotesque comic valentines. Strong has the distinction of being perhaps the single most important patron of cartoonists in America before Joseph Keppler, of *Puck*. He evidently had a fine eye for talented draftsmen, as he launched the careers of John McLenan, Frank Bellew, Augustus Hoppin, J. H. Goater, and other comic artists, many of whom later produced work for *Harper's Weekly* and *Vanity Fair*. Other superior draftsman, such as F. O. C. Darley and John L. Magee, also came under his purview.

Strong's most ambitious undertaking was the illustrated comic journal, *Yankee Notions*, which ran from 1852 through 1875. The magazine was full of crude Yankee humor and the kinds of visual excesses which characterized his comic valentines. Strong and the artists who drew for *Yankee Notions* introduced a brand of caricature the likes of which Americans had not seen before. Their works reflect, however, more than merely a shift in the aesthetic or stylistic winds of the time. They responded rather to certain broader cultural forces at work in America during the 1840s. These forces can be detected in the lively microcosm of Strong's Chatham Square neighborhood.

First among these forces was an intensified desire among Americans of the period for the individuation (at least in the media) of their public figures. Presidents Washington, Jefferson, and Adams had been deified by the people, their identities for the most part subsumed by the image of the state and its mission. The idealism of the young nation permitted them to exist, with few exceptions, in a rarefied sphere removed from the petty concerns of partisan politics and everyday life. (Perhaps this was justification for Henry James's later contention that America, being a democracy, was constitutionally unable to nourish serious satire.) But since the presidency of Andrew Jackson, the personal

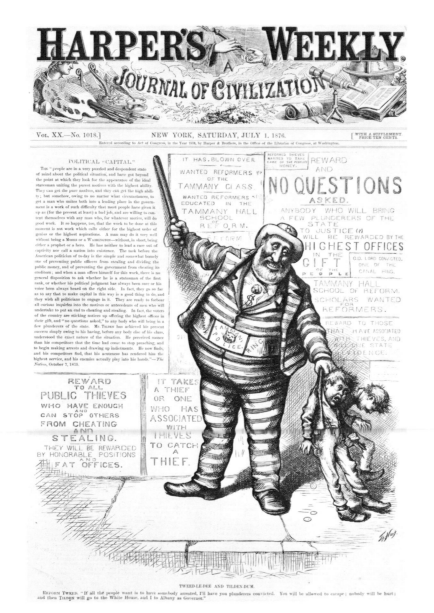

7.3. Thomas Nast, *Tweed-Le-Dee and Tilden-Dum*, 1876. Wood engraving, 10¾ × 9⅛ in. Published in *Harpers Weekly*, July 1, 1876. Courtesy of the New York Public Library.

traits of officials and candidates became an issue of increasing consequence—a phenomenon noticeable in the campaigns of William Henry Harrison and Henry Clay.

The portrait, traditionally deemed a concrete omen of character, took on a heightened significance as the century progressed. Here a statesman's public image was forged and, one hoped, cast in a mold appropriate to his office. Certified likenessess of candidates and public figures held a new fascination for the masses. The photographic portrait was the penultimate statement. The people thronged to daguerreotype galleries and photographers' studio windows to view mirror effigies of citizens Webster, Calhoun, Clay—and Jenny Lind. Daguerreotype portraits were copied and appeared on colorful lithographed campaign banners issued by Nathaniel Currier and others during the 1840s. Inevitably, the arts so employed to advocate the public figure were turned back at him by satire.

At Matthew Brady's daguerreotype gallery on Broadway in New York caricaturists had, for the first time, the opportunity to study every line and wrinkle of a celebrated face. Such familiarity bred facility: the opportunity effectively sharpened the artist's ability to animate a portrait—even a campaign banner portrait—in the interest of satire. As David Levine's drawings today still attest, photography proved quite a useful tool for caricature.

This intensified reading of the face coincided with another development which occurred, oddly enough, in the most disparate segments of creative society. This was a new understanding of expression itself. Artists, especially since Leonardo's exploration of the interrelation of emotion, anatomy, and physiology, have had keen curiosity about the nature of facial expression. Actors have always done so. Since the Enlightenment, however, when the Swiss physician Lavater codified the varieties of animal and human emotions and their manifestations, the topic received increased intellectual and clinical attention. The physician-dilettante Charles W. Bell, the natural scientist Charles Darwin, and several others conducted scientific inquiries into facial expression during the first half of the nineteenth century. This growing understanding of the power and subtlety of facial (and body) expressions increasingly informs the work of comic artists in the latter part of the century.

At the opposite end of the spectrum, comic actors began to test the limits of facial humor established by eighteenth-century dramatic conventions. The New York stage was an active testing ground for all sorts of visual humor. Ethnic and regional types (or stereotypes), many drawn from literary works, ran ram-

pant on the boards of the Olympia and Chatham theaters, just blocks from the publishing establishments on Nassau Street. Here stage Irishmen like John Brougham brought to life scores of characters whose success rested on the skills of impersonation and historionics of the actor rather than on the often flimsy literary merit of the production. Brougham's own career as an actor, producer, comic writer, and magazine publisher reflected the healthy commerce between the stage and the comic press at the time.

Comic art and satire reaped the fruits of these changes. First, the new facility and interest in manipulating facial expression to humorous effect provided the means to make public sport of the personal idiosyncrasies of public figures of the day. Second, an artist's sense of comic staging, of the ludicrous event or situation, began to count for more in his drawings. Drawings by Strong's artists have a scenic integrity absent in the often chaotic tableaux of the 1830s.

A particular beneficiary of these developments was John L. Magee, perhaps the most talented draftsman working for Strong. Magee produced a number of drawings for *Yankee Notions,* and drew on stone several lithographs issued by himself, Strong, Nathaniel Currier, and other New York publishers. His *D-Dan the Fisherman Overhauled by British Cruisers* of 1852 (figure 7.4) casts Daniel Webster as a brawny fisherman. The latter's countenance is charged with leonine ferocity, while the features of the accompanying figures have a playful expressiveness missing in the grotesque masks of earlier cartoons. In all, the print displays a more intimate understanding of the features of a public figure than had heretofore been manifested in American satire.

An earlier lithograph by Magee, the *Forty Thieves or the Common Scoundrels of New York* of 1842 (figure 7.5), provides a few hints of the artist's acquaintance with the stage. It includes a number of comic types, rather Cruikshankian in appearance, and has a pronounced sense of setting with shadows and props suggestive of the stage. Magee was, in fact, conversant with the comic theater. He produced a number of fine actors' portraits, like *Yankee Locke* in his several famous roles. This must certainly have sensitized him to the expressive nuances of comic characterizations.

For *Yankee Notion* Magee produced a number of drawings in 1852 and 1853. Some of these, like *Butcher Boys,* 1853, reflect the coarse, local color of much of the humor favored by the magazine at that time. Life in the Bowery area of New York was a subject of newly won popularity with audiences of the period. Since 1848, when *A Glance at New York* debuted, this and several other hastily conceived local sketches amused theater-goers with scenes from slum life

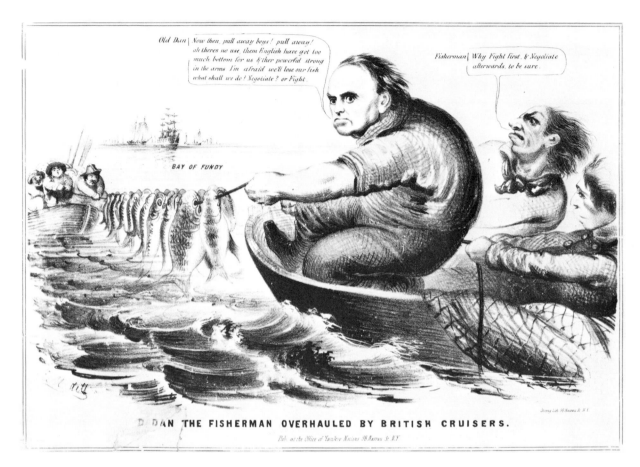

7.4. John L. Magee, *D-Dan the Fisherman Overhauled by British Cruisers*, 1852. Lithograph, 11½ × 15½ in. Published by Thomas W. Strong. Courtesy of the Library of Congress.

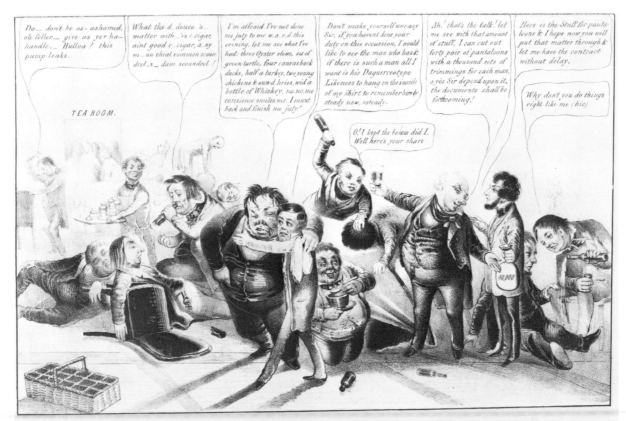

7.5. John L. Magee, *The Forty Thieves or the Common Scoundrels of New-York*, 1840. Lithograph, 12 × 16¼ in. Courtesy of the Library of Congress.

and the criminal precincts of the city. Such plays appealed to a popular fascination with local peculiarities of speech and character.

Another Nassau Street artist, James E. Brown, Jr., also drew his inspiration (and stock in trade) from the New York theater. Brown's series of character portraits of actors from *A Glance at New York* and *New York As It Is,* a sequel, are some of the finest of their genre. They lack the vitality that animates John Magee's characters, but they capture, in a subtle way, the gestures and postures which made up the unique stage presence of actors like Frank S. Chanfrau and John Winans.

Brown's encounters with the street folk of the Bowery were not confined, it seems, to their theatrical surrogates. "Butcher Boys" of 1848 is a genre study of rude Bowery youth. Brown, like Dickens, was direct and unvarnished in his portrayals. Perhaps his familiarity with this seamy side of the city's life caught T. W. Strong's attention, for in 1851 Strong commissioned Brown to produce a series of drawings of local street peddlers and merchants for *The Illustrated American News.* Studies of lower-class life by other artists, like Nathaniel Currier and Louis Maurer, proliferated during the early 1850s, continuing the somewhat sanitized form of naturalistic reporting carried on by F. O. C. Darley and others in the early 1840s.

Strong's favorite draftsman appears to have been August Hoppin, who was the chief illustrator for *Yankee Notions.* Strong issued several lithographed political cartoons after Hoppin's designs as well. The most notable was a double satire on presidential candidate Franklin Pierce, issued during the campaign of 1852 (figure 7.6). Here we have two scenes: one in a New Hampshire courtroom and one in a village. In the first, Pierce, a native of New Hampshire, is on the butt end of a repartee with a stereotypical "Yankee" New Englander. In the second Pierce confronts a wailing street urchin—not unlike Brown's butcher boys in type. In each scene the nature of the exchange of remarks is worth nothing. In both conversations an attempt is made to reproduce the peculiarities of New England dialect. The dialogue consists of a simple statement and response, and as such has more in common with theatrical repartee than the literary inventions of Seba Smith and Artemus Ward than with the balloon-enclosed remarks which float about in earlier cartoons. There is a dramatic cohesion in these scenes missing from most of the tableaux constructed by the cartoonist of the 1830s. One might say that in the earlier works the text is meant to be read, and in the later spoken.

Hoppin produced most of the major illustrations for *Yankee Notions* dur-

SCENE IN A NEW HAMPSHIRE COURT.— GENERAL PIERCE EXAMINING A WITNESS.

Pierce (to the Witness) *You are sworn to tell the truth, Sir, and how dare you say you carried that bureau out of the house, without assistance, when you know it takes three men to lift it?*

Witness (Wal, General, I did carry that bureau without help, and I did'nt faint either, as you did, before that battle in Mexico.*

(Laughter in the court. Pierce sits down in confusion.)

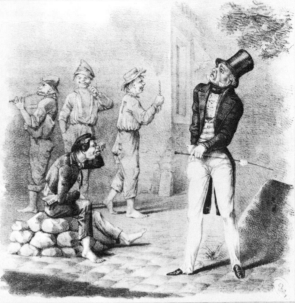

SCENE IN A NEW HAMPSHIRE VILLAGE.— PIERCE THE GOOD SAMARITAN

Pierce (to ragged boy) Halle, boy what are you crying about?

Boy them three boys is a eating sticks of candy, and I've no money to buy any Hoo! hoo!

Pierce I swow that's a hard case See, boy, you're a stranger to me, but I have a benevolent heart and cannot bear to see any one in distress without helping them So, here's a cent for you, buy a stick of candy and remember to vote for Pierce, if ever he is nominated for President.

Pub. at the office of Yankee Notions 98 Nassau St N.Y.

7.6. Augustus Hoppin, *Scene in a New Hampshire Court*, 1852. Lithograph, 11½ × 17¾ in. Published by Thomas W. Strong. Courtesy of the New-York Historical Society.

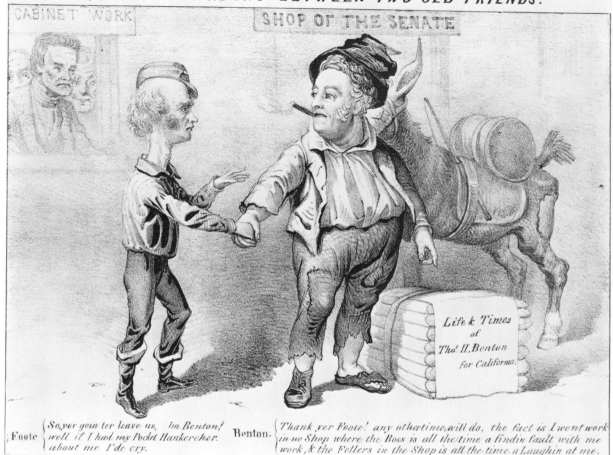

7.7. Unknown artist, *The Sad Parting Between Two Old Friends*, 1850. Lithograph, 15½ × 11 in. Courtesy of the Boston Public Library.

Entered according to act of Congress A.D. 1865 by J.L. Magee in the Clerks Office of the District Court of the Eastern District of Penn.

SATAN TEMPTING BOOTH TO THE MURDER OF THE PRESIDENT.

J. L. MAGEE, PUB. 305 WALNUT ST. PHILAD!

7.8. John L. Magee, *Satan Tempting Booth to the Murder of the President*, 1865. Lithograph, 10¼ × 15⅝ in. Published by John L. Magee. Courtesy of the Library Company of Philadelphia.

ing the years 1852 and 1853. Drawings such as *A Desperate Attempt by Office-Seekers to Sleep with General Pierce* of 1853 reveal the roots of his comic style—his formal debt to George Cruikshank and the artists of the London *Punch.* As in the earlier double cartoon, the hero Pierce has been worked quite skillfully into a ludicrous, slapstick situation.

A series of unattributed prints, apparently issued as a series entitled *The Old Soldier* in 1852, warrant inclusion here as productions of Nassau Street. In *The Sad Parting Between Old Friends* (figure 7.7), Henry Foote bids farewell to Thomas Hart Benton, who is leaving the Senate because, he says, "I wont work in no Shop where the Boss is all the time a findin fault with me." Foote and Benton are done up in the scene as Bowery types. Their dialogue is from the streets of New York, not directly but via the theater. The scene could be taken from the review *A Glance at New York,* by 1852 one of the great popular successes in the history of the American stage, or from one of its many sequels. In *The Sad Parting,* Foote is cast as a common street tough. But what is remarkable is the artist's convincing transformation of Thomas Hart Benton into a stage Irishman.

These artists have been unjustifiably neglected in the history of American prints. Their work, interesting in itself, set the stage for the appearance of one of the most original and influential pictorial satirists of the nineteenth century—Thomas Nast. Precisely what part Thomas W. Strong played in bringing about this metamorphosis in American political art is difficult to determine. The certainty is, though, that his presses provided the catalyst and the vehicle for a public exchange of visual humor, and brought the works of an extraordinary generation of artist-humorists to the light of day.

8

Satire in the Sticks
Humorous Wood Engravings of the Adirondacks

EDWARD COMSTOCK, JR.

For the illustrators of the nineteenth century's popular press, the Adirondacks, that vast mountainous plateau of northern New York State, proved to be a bonanza. Early in the century, landscape artists had satisfied urban curiosity about the wilderness; then photographers revised the painterly vision of these north woods. And, later still, as the illustrated weeklies proliferated after the Civil War, a new class of artist arose to satisfy the increasing demand for illustrations.

The best of the illustrators' work, when converted to wood engravings, exhibited a bold exuberance which suited the printed page. In the Adirondacks, as elsewhere, those illustrators who preferred human nature to Mother Nature often chose satire over straightforward reporting. What follows is an examination of the work of roughly three generations of artists who produced a record of the lighter side of life in the woods. Satirical wood engravings admittedly are not a major art form; nevertheless, their frequent insights into the true-to-life frontier Adirondacks remind us that there is more to art than the mainstream.

During the heyday of wood engraving, Adirondack illustrations, whether for newspapers or books, exhibited almost without exception a friendly spirit. Of course, one expects to see subjects of conflict, for this is the stuff of satire (for example, man against nature, city versus country), but kindliness generally overrules misanthropy. Until the Adirondack Park had been defined by the State Constitution in the 1880s (and thereafter became embroiled in political dispute), reformist subjects rarely attracted illustrators. Readers of the weeklies preferred to be amused than reformed.

The earliest humorous Adirondack wood engravings appear in C. W. Webber's *The Hunter-Naturalist,* a lively compendium of American sporting adventures first published in Philadelphia in 1852. Two chapters (out of five concerning the Adirondacks) include small wood engravings.[1] One depicts what predictably happens to anglers who imbibe brandy and troll for lake trout at the same time—they lose the fish—while the other illustrates a contretemps between a moose and three men who attempt to capture it alive. The hunters get tossed about, but ultimately, as we read, the moose loses his life. Scarcely more than decorative vignettes, both are crudely cut, and because they are located at the end and the beginning of chapters, they seem to have been illustrative afterthoughts. One source names Joseph H. Brightly (fl. ca. 1840–60) as the probable engraver in an introduction to an earlier edition of Webber's book, while Webber himself thanks John A. Woodside and Peter Kramer, whom he calls his "artists."[2]

Fish and game, bothersome insects, difficult terrain, bad weather, and the behavior of the "sports" and the "natives" are the constants of humorous Adirondack wood engravings. Thus, it comes as no surprise that the first major illustrated article on the north woods includes most of these ingredients. "An August Sporting Tour" by F. S. Stallknecht and Charles E. Whitehead, the latter of whom also illustrated the article, appeared in *Frank Leslie's Illustrated Newspaper* in two installments during November 1858.[3] The purpose of their tour was "to enjoy Nature in the Rough . . . in preference to dangling around the Ladies' parlor of a fashionable watering-place hotel."[4]

Whitehead's drawings, executed in a loose, sketchy hand, vary from small before-and-after depictions of such things as his own broad-brimmed hat to a large view showing Stallknecht catching the "arrowy" trout while Whitehead, immersed in a cloud of insects, catches the "barbed" mosquito. In another, Whitehead lampoons Bill Helms, "the celebrated trapper," who dozes propped up against a tree while the giant bear trap next to him is sprung by mouse.[5] Over twenty years later, the artist A. B. Frost (1851–1928) in one of his few Adirondack drawings, depicted a similar situation to illustrate "Adirondack Days" by Henry Vane in *Harper's New Monthly.*[6] The engraving, titled *On the Watch Ground,* shows a hunter seated at the base of a tree, peacefully puffing on his pipe, obviously pleased to be in the woods, while a deer safely crosses the clearing just behind him. It has often been said that it is not all of fishing to fish, and the same is true, Frost tells us, of hunting.[7]

In a similar vein the author and artist Thomas Bangs Thorpe (1815–78)

contributed "A Visit to John Brown's Tract" to *Harper's New Monthly* in July 1859.[8] Best known as a leading figure in the "Big Bear" school of frontier humor, Thorpe spent a part of his boyhood near Ballston Spa, New York, where he probably got to know the upstate woods firsthand. Though trained, among other things, as a portrait and landscape painter—he was a pupil of John Quidor—he retained a sharp eye for the comic. Here he pinpoints the tribulations of tramping fully loaded down across a carry (as a portage is called in the Adirondacks) by resorting to "before" and "after" views of the kind so tentatively executed by Whitehead the years before. He shows us the "pranks" an armful of oars and paddles can play on the sportsman who attempts to tote a great batch of them from one lake to another. And in the same manner he depicts a hiker carrying guns, extra boots, and duffle (figures 8.1 and 8.2). At first everything is under control but, in a second engraving, the load has grown to gargantuan size (and weight), dwarfing the struggling sportsman underneath. All in all, it is a classic portrayal of the rigors of the trail. With understatement and deft exaggeration Thorpe peppers his colorful adventure story with a series of memorable, light-hearted vignettes.

The trauma of the Civil War years apparently lessened the public's appetite for illustrated humor, at least in the north woods. Not until a decade after Thorpe's article did comic illustrations reappear in Adirondack literature. Then they graced the biggest bestseller in Adirondack history. That book was the Rev. William H. H. Murray's *Adventures in the Wilderness*, published in Boston in 1869 and illustrated mostly by Harry Fenn (1845–1911), best known for his major contribution to the monumental *Picturesque America* several years later. Of the eight wood engravings included in the volume, four are signed by Fenn. One is by F. O. C. Darley, and it has been suggested that the remaining three, although unsigned, are also Fenn's work.[9] Frank Weitenkampf has stated that "illustration must elucidate the text or adorn it; it may do both, but at all events it must be in harmony with the text."[10] Fenn's jaunty draftsmanship melds naturally with Murray's breezy prose.

Adventures was published in the spring of 1869 and thousands of tourists, taking the author at his word, flocked to the woods that particularly cold and wet summer, where what they found was at odds with the glowing descriptions they had read. To be fair to the author, he did describe the rough and the smooth, but in spite of all his excellent practical advice (including what to take into the woods and, more important, what to leave at home), the outcry and accusations of "lies" must have surprised even Murray. Overnight, *Adventures* became a target for

GUN, BOOTS, ETC.

8.1 Thomas Bangs Thorpe, *Gun, Boots, Etc.*, 1859. Wood engraving, 2 × 1⅛ in. Published in Thorpe, "A Visit to John Brown's Tract," *Harper's New Monthly*, July 1859. Courtesy of Syracuse University Libraries.

GROWTH OF GUN AND BOOTS.

8.2. Thomas Bangs Thorpe, *Growth of Gun and Boots*, 1859. Wood engraving, 2⅞ × 2⅛ in. Published in Thorpe, "A Visit to John Brown's Tract, *Harper's New Monthly*, July 1859. Courtesy of Syracuse University Libraries.

comic artists. For instance, when Will H. Low (1853–1932) drew a gallery of rustic characters under the heading "Our Artist in the Adirondacks" in 1869, he included *An Exotic,* a foolishly costumed fop who reads from Murray's guidebook, obviously his bible.[11]

The most ambitious and certainly the most sophisticated satire of Murray's efforts appeared as the lead article entitled "The Raquette Club" in the August 1870 issue of *Harper's Monthly.*[12] Author Charles Hallock, best remembered as the founder and editor of *Forest and Stream,* the leading sporting journal of the day, teamed with artist William Ludlow Sheppard (1833–1912), who drew for *Appleton's* and later *Picturesque America.* Hallock's rollicking account and Sheppard's highly imaginative illustrations combined to produce a model of good-natured satire never again equaled in the Adirondacks. Of the thirteen illustrations, of which four are signed "W. L. S.," several stand out. *The Dismisal Wilderness* depicts the puzzled denizens of the deep woods—a panther, a pair of bull frogs, a deer, and an owl—peering at Murray's opened book, while all that remains visible of the misled reader is a pair of upended boots protruding from the sylvan pool. His hat, bedecked with trout flies now attracting real flies, floats nearby. A fishing rod lies with its tip tangled in the brush. What a dangerous book, Sheppard tells us.

In *The Rush for the Wilderness* (figure 8.3), the illustrator displays equal inventiveness. Here he portrays a motley throng as it transfers from train to lake steamer. Leading the way is a Pied Piper-like figure, a tall gaunt man reciting from the book. To quote Hallock:

> The procession was continuous. It was a moving phantasm of sea-side hats, water proofs, blanket-shawls, fish-poles, old felts, mackintoshes, reticules, . . . carpet-bags, guns . . . umbrellas . . . water spaniels, etc. . . . There were old women, misses, youngsters, spinsters, invalids, students, Bloomers, correspondents, sports, artists, and jolly good fellows. . . . Two packages of "Murray" and one case of "Hamlin's Magic Oil" brought up the rear.[13]

Sheppard, too, could not resist a comparative pairing, this time a transformation sequentially entitled *Before . . .* and *After Going to the Adirondacks* (figures 8.4 and 8.5), in which a wan, knock-kneed clerk magically becomes by the end of his vacation a robust, swaggering sportsman. Unlike his predecessors, Sheppard created flesh-and-bones characters, not simply two-dimensional cartoon stereotypes.

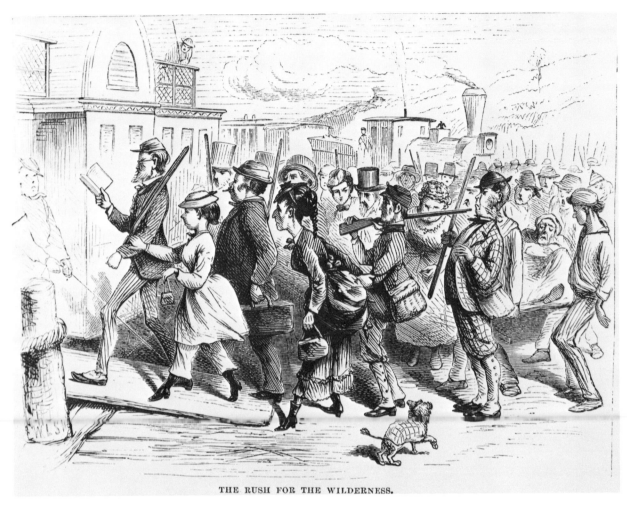

THE RUSH FOR THE WILDERNESS.

8.3. W. L. Sheppard, *The Rush for the Wilderness*, 1870. Wood engraving, 3½ × 4½ in. Published in Charles Hallock, "The Raquette Club," *Harper's New Monthly*, August 1870. Courtesy of Syracuse University Libraries.

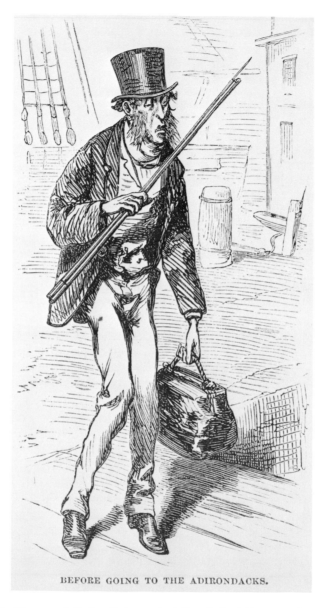

BEFORE GOING TO THE ADIRONDACKS.

8.4. W. L. Sheppard, *Before Going to the Adirondacks*, 1870. Wood engraving, 4 × 2 in. Published in Charles Hallock, "The Raquette Club," *Harper's New Monthly*, August 1870. Courtesy of Syracuse University Libraries.

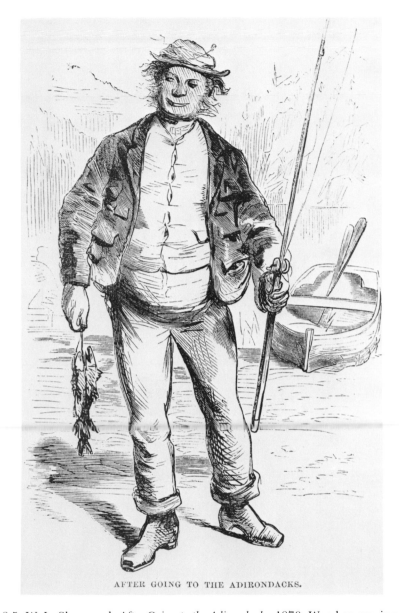

AFTER GOING TO THE ADIRONDACKS.

8.5. W. L. Sheppard, *After Going to the Adirondacks*, 1870. Wood engraving, 4¼ × 2¾ in. Published in Charles Hollock, "The Raquette Club," *Harper's New Monthly*, August 1870. Courtesy of Syracuse University Libraries.

By the late 1870s the name of Seneca Ray Stoddard (1844–1915) was almost as familiar to summer visitors as was "Adirondack" Murray. His output was enormous. From his Glens Falls studio he produced a stream of annual guidebooks, maps, and many thousands of photographic views. Although he was a master photographer, his work as an illustrator of his own guidebooks often has a hesitant, amateurish look about it. But there are some exceptions and one, his logo (figure 8.6), does stand out. At least three versions of this leitmotif exist. When it first appeared, it served as the logo on the sail of his racing canoe. In the narrative of one of his early works, *Lake George; (Illustrated.) A Book of Today*, we learn the following from two men who spot Stoddard's canoe on Lake George:

> Well, that's Stoddard, the photographer, and that's his boat, the 'WAN-DERER.' He wanders around all over the lake, taking views and money. Notice that picture on his sail, looking more like cancer in the old-fashioned almanacs than any thing else that I can think of? Well, he calls that his 'coat of arms'—*legs* would be more appropriate—and it is supposed to be himself astride of a camera (his hobby) in pursuit of wealth, there represented by a fat-looking money bag with wings, to show the nature of the game which he hopes to bring down by aid of his lance, that being, as he also claims to be an artist, a mahl stick. Now, heraldry is all right when it's plain enough to be understood; but everybody who sees that says 'Shoo fly!' thinking his little bit of sentiment intended for a joke—a good joke on him, I think.[14]

By 1879, the logo, now at the top of a page advertising Stoddard's photographs in his guidebook *The Adirondacks: Illustrated* had been modified.[15] The mahl, while still evident, has been lowered, and an oversize quill pen replaces it as the lance, no doubt an allusion to his increasing reputation as a writer. And what appeared as ordinary shoes in the first version have become pointed-toe boots with large pinwheel spurs, an addition probably meant to underline the young man's drive. A third version appears as an illustration on the cover of the paperback edition of *The Adirondacks: Illustrated* in 1888.[16] Stoddard, still astride his camera, wings over a smiling sun, with hat raised in triumph, the flying money bag firmly skewered by the quill lance. A financial success at last, he proclaims. And what a clever self-parody. Photographers, like witches on broomsticks, have magical powers.

Stoddard must have met the illustrator Augustus Hoppin (1828–96) in

8.6. S. R. Stoddard, Logo, n.d. Wood engraving, 7½ in. Courtesy of Chapman Historical Museum, Glens Falls, N.Y.

August 1880, during a stopover at Blue Mountain Lake. To his series of photographs of the lake and its hotels he added two of Hoppin's caricatures of local characters. One, with the title "Affable Adirondack Agent," depicts a grinning buffoon of a baggage man who sports a giant necktie and clutches a batch of brass baggage tags.[17] At his side is a partially demolished dome-top trunk. Pity the vacationer whose belongings were left in this oaf's care. The equally amusing companion piece, *Music in the Air,* shows a formally dressed, pompous innkeeper standing in a doorway vigorously ringing a giant bell. Stout and stern, he seems to be saying: "Dinner is ready! Latecomers will not be served!"

From the same trip "Hop," as he signed his drawings, produced a full-page cover engraved for the *New York Daily Graphic* on August 21, 1880, which detailed the exploits of one Professor Tigwissel at Blue Mountain Lake. Unlike the two caricatures Stoddard photographed, which were broadly executed wash drawings, the antics of the bumbling professor are delineated in an energetic but sketchy style. We view Tigwissel awakened by wild cats ("Felis Catus") on the roof of his lean-to, chartering a steamboat for a day's trolling, having a unsatisfactory interview with a bear, and so on. Hoppin chose captions to develop the humor of the greenhorn sportsman's misadventures, a device which lessens the punch of the individual illustrations. Even as a well known and successful illustrator, he may have felt the pressure of the *Graphics* deadlines, for it was the only daily in a world of weeklies. "Hop" is not known to have produced any other Adirondack work.

We snicker at Hoppin's professor—the very term is a joke—because of his outrageous behavior. However, it is also possible to produce an effective, humorous illustration by sticking close to the true-to-life, or to what might be termed the plausible improbable. An example is an illustration by Daniel Carter Beard (1850–1941), the great Boy Scout leader and son of James H. Beard, the animal painter. For *Frank Leslie's* in August 1891 Beard contributed *A Double Surprise—A Sporting Incident in the Adirondacks,* in which two men in a canoe, who have been concentrating on catching and landing a good-sized bass, are surprised by a large buck swimming perilously close to their boat.[18] Beard encourages us to imagine that, in the confusion, besides missing the opportunity to bag a prize stag they will probably lose their fish too.

An illustrated reversal of the man-catches-fish story appeared in *The American Angler* during August 1883, under the heading "The Sea Serpent Up a Tree in the 'North Woods' of New York."[19] The "frightful animal," properly the "Great American Godang," reportedly was a fierce, tree-climbing, fishlike beast which preyed on unsuspecting fishermen. In the illustration, L. F. Chew, humor-

ously identified as "of Port Tobacco" and perhaps an amateur artist, reconstruct-
ed the narrow escape from "deglutition" by the godang of a fellow member of
the Bisby Club, a sporting organization with headquarters in the southwestern
Adirondacks. The success of the yarn depends as much on the crudely drawn
illustration, which was originally appended to the club register, as it does on the
background notes. These include a verification by H. H. Thompson, a noted
angler, and a scientific profile of the "genus hydra apocrapha." We are even
asked to believe that the "dragon slain by the valiant St. George of England was
no more nor less than a godang."[20]

The spirit of gentle amusement was equally evident in the single known
Adirondack illustration by Thomas Worth (1834–1917), the Currier and Ives
artist, well known for his "Darktown Comics." It was reproduced as a cover for
the old *New Yorker*,[21] which touted itself as "A Weekly Journal of Humor, Wit,
Criticism, and General Literature." Worth may have been a "true hack," as James
Thomas Flexner has called him, but his drawing titled *Adirondacks*, engraved for
a "Summer Sports and Pastimes" issue, is a direct, straightforward American
joke.[22] One imagines the dumpy angler leaping into the drink the instant he
notices the bear, which stands at his side examining the contents of his creel.
Worth excluded all extraneous elements to increase the dramatic tension.

More good-natured fun involving bears comes from a sketch by Culver H.
Lewis engraved for a cover for *Frank Leslie's* during the summer of 1883.[23] Little
is known about Lewis, but if this wood engraving is any indication he was a
skilled illustrator. Titled *An Adirondack Episode—Taking Possession of the Camp*, it
depicts a hungry bruin searching for a meal amid the ruins of a picnic lunch.
The stereotypical sport—bald, short, and fat—has in his fright climbed the
nearest tree; his guide, fully clothed, swims briskly away across the pond. Lewis
has created a simple but realistic anecdote which makes us smile. This time the
hunted routs the hunter.

On the other hand, the white-tailed deer, lacking the rolypoly clownish
image of the bear, is fair game, so to speak. Thus, there are almost no humorous
depictions involving deer in the Adirondacks. One exception, in the tradition of
the C. W. Webber wood engraving of the men attacked by a moose, is a confron-
tation between a young and very green city sport and a wild stag. An unknown
artist illustrated "My First Deer Hunt" for *Frank Leslie's Popular Monthly* in Sep-
tember 1877, in which a clerk from New York City gets thrown high into the air
by a cornered buck.[24] The humor lies in the young man's ridiculous position,
upside-down in mid-air. Reality, which surely would have included a bloody
goring, is sidestepped to make a more effective illustration.

Realism, however, did intrude in an 1886 *Forest and Stream* cartoon, sarcastically captioned *Hounding An Adirondack Deer. To Make It "Shy"—So That the Still-Hunters Will Not Get It.*[25] It is signed "E.E.T.S." for Ernest Evan Thompson Seton (1860–1946), the outdoor writer and illustrator. His pictorial editorial depicts two men in a rowboat. One has grabbed a swimming deer by the tail; the other, standing in the stern with an oar raised above him, is about to strike the animal on the head. Tracking hounds bay close by at water's edge. Over forty years earlier a steel engraving after W. H. Bartlett in N. P. Willis's *American Scenery, Black Mountain (Lake George),* included a similar one-sided battle in its foreground. Bartlett, one assumes, innocently included this type of hunting for local color and thought no more of it. *Forest and Stream*'s editorializing notwithstanding, it was not until 1898 that deer hounding was finally prohibited in New York State.

Another prominent illustrator of the first rank who was drawn to the Adirondacks was William Allen Rogers (1854–1931). He too was attracted to the theme of city versus country, as seen in *Canoeing in the North Woods—"A Carry"* (figure 8.7) drawn for *Harper's Weekly* in September 1888.[26] In it a grizzled old pioneer named St. Germain confronts a canoeist whose decked sailing canoe he has agreed to transport over the carry on his horse-drawn sled. What contrasting character types: the rough-hewn French Canadian half-breed taken aback by the dashing young sport in thigh-high puttees and with a boat far different from the guide's usual working boat.[27]

At the time when Currer and Ives had a best-seller in its popular "Darktown Comics," in which blacks were depicted in slapstick routines, it is not surprising that many illustrators also caricatured other racial types and ethnic minorities. In the Adirondacks, however, ethnic diversity was limited. French Canadians were the most visible minority, but there was the heritage of the tough, roustabout voyageur and lumberjack, figures not easily poked fun at. Only one Adirondack artist resorted to a mean-spirited, unkind portrait, that of a Jewish peddler, considered then to be a "city type." This artist was W. M. Cary (1840–1922), who drew for the weeklies but is best known for his paintings of the American West. His illustration for *The Aldine* in the summer of 1873, depicts a tall, elegantly dressed artist being accosted by a peddler on a mountain road.[28] The former carries sketching paraphernalia while the latter, an uncomplimentary semitic portrait featuring a gold ring in one ear and loud checked trousers, struggles under a giant sack of merchandise. Thinking the artist a fellow salesman, the peddlar asks, "Vot Doesh You Peddles?"

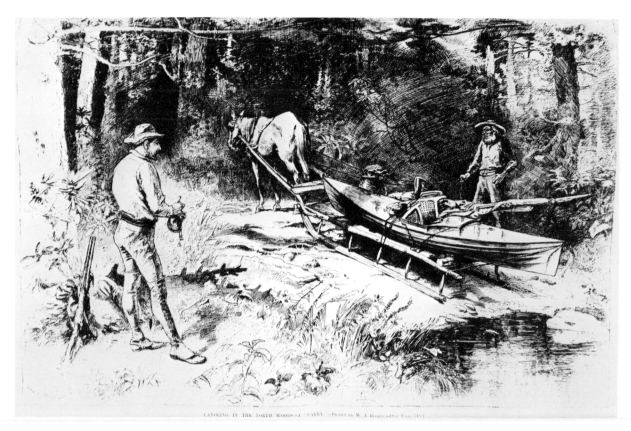

8.7. W. A. Rogers, *Canoeing in the North Woods—"A Carry,"* 1888. Drawing, 9 × 13⅜ in. Published in *Harper's Weekly,* September 22, 1888. Courtesy of Syracuse University Libraries.

W. A. Rogers, in addition to being a fine draftsman, imbued much of his Adirondack work with a genuine warmth rarely sustained by his fellow illustrators who were attracted to the woods. When, for instance, he portrayed a courtroom drama, a three-part illustration for *Harper's Weekly* in 1882 entitled *"Lawing" in the North Woods*,[29] Rogers looked upon the event not as a rambunctious, hillbilly free-for-all, but rather as a perfectly legitimate means, albeit informal by city standards, of resolving an upcountry dispute. And, most important, he saw it as a chance to portray the off-season or "real life," something generally unknown to summer tourists, or to magazine illustrators, for that matter.

The Adirondacks, like other mountain resort areas, functioned as a temporary refuge from urban problems of noise, pollution, and overcrowding. Unlike some who went to the woods to be seen, President Grover Cleveland, long the focal point of a slanderous press and bitter political opposition, sought privacy during a woodsy respite, and, if the Adirondack wood engravings are any indication, he was at least partially successful. The old *Life* magazine, which specialized in social caricature, chose not to attack Cleveland; instead it cautioned readers in its lead editorial, "Give [the President] a rest." And the accompanying illustration, furnished by W. A. Rogers, was a mercifully gentle ribbing. Called *The President's Vacation,* it shows the famous rotund figure seated at the end of a log listlessly fishing.[30] Next to him sits his bride of less than three months, identified by Cupid hovering over her head. Crowded next to the couple and occupying the entire length of the log is a horde of reporters, each with pencil poised over pad. Rogers, who presumably did not accompany the President, here created a cartoon with no confusing side issues. In a similar context Rogers once said: "After all, we cartoonists are merely reporters with a drawing pen or brush instead of a pencil. . . . We must follow the news as closely as any editor . . . I can't afford to miss the news of a single day."[31]

Compare Rogers' work to that of an unnamed staff artist for *Leslie's* who was assigned to cover the President's Adirondack vacation the previous year.[32] This man chased but never caught up with Cleveland and, as a result, had to settle for sketching local color along the way. His vignettes include a portrait of Jake Cone, the stagecoach driver who was so disappointed at not having the President as a passenger that he passed off the artist as the Chief Executive.

Rogers contributed two related political cartoons, both striking in their modernity, to the *New York Herald* during the spring of 1903. One, *Stop, Thief* (figure 8.8), shows the Wood Pulp Trust personified as a giant ogre of a lumber-

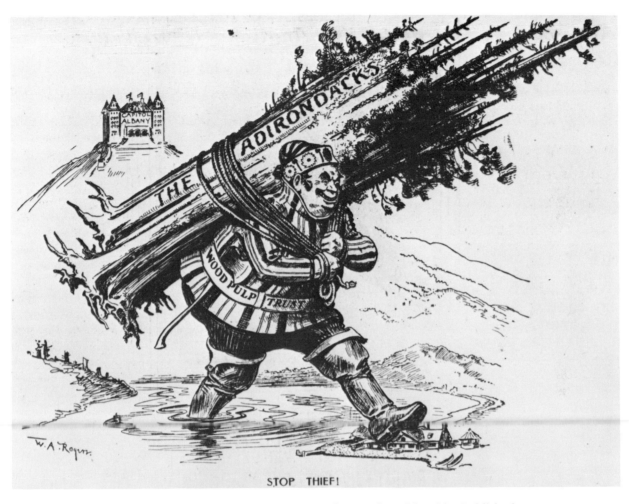

8.8. W. A. Rogers, *Stop Thief*, 1903. Wood engraving, 4½ × 6 in. Published in *New York Herald*, April 20, 1903 and reprinted in *Woods and Waters*, Summer 1903.

jack (whose wool cap is decorated with an ax and buzz-saw motif) in league with the state politicians.[33] The lumberjack is about to steal the Adirondack forest, the immense bundle of uprooted trees he has strapped to his back. On a hill top, the state capitol complacently witnesses the grab, while the voter's tiny house is about to be crushed by the giant's boot. Railing against "political and private spoliators," Rogers had created one of his most successful illustrations. To quote Weitenkamf again: "In the highest type of political caricature, humor is not likely to be of the cheaply obvious kind, but its quietly delivered satire cuts more deeply than does the whoop of the facile jokemaker."[34]

With W. A. Rogers, the most versatile of the Adirondack illustrators, this survey of humorous wood engravings ends. The era of the wood engraving, since 1880 under increasing pressure from the cheaper and more quickly produced halftone, was just about over too. Nonetheless, some memorable humorous subjects were created in halftone during the nineties. Frederic Remington (1861–1909), for one, contributed to Harper's Spring Trout Fishing in the Adirondacks—An Odious Comparison of Weights, in which two guides bemusedly witness their clients squabbling about whose catch weighs the most.[35] And on a smaller scale, James Gleeson drew City and Country for Munsey's Magazine in June 1896, also reproduced in halftone.[36] We view a city couple confidently striding down to a hotel dock, he with canoe paddle, she with fishing rod, all set for a day's outing. In the background a couple of aged, stoop-shouldered guides, one with a dog (a symbol of the soon-to-be-illegal hunting by deer hound), scowl glumly at the pair in their fancy and obviously impractical outfits. Sad but true, guides had become irrelevant in the do-it-yourself world, Gleeson tells us. Regardless of the medium, Remington and Gleeson's drawings—each a comedy of manners—are both effective illustrations. However, the zest and the linear drama of the wood engraving is gone. Gray on murky gray replaced the verve of stark black and white.

NOTES

1. Published by J. B. Lippincott & Co. Page 491 at the end of the chapter "Trolling in June" and page 515 at the beginning of the chapter "Anecdotes of Moose and Deer Hunting Among the Northern Lakes." From the 1867 edition.

2. Sinclair Hamilton, Early American Book Illustrators and Wood Engravers: 1670–1870 (Princeton: Princeton University Press, 1958), p. 83.

3. F. S. Stallknecht and Charles E. Whitehead, "An August Sporting Tour," *Frank Leslie's Illustrated Newspaper*, November 13, 1858, pp. 378–80; and November 20, 1858, pp. 394–96.

4. Ibid., p. 378.

5. For more on Helms, who became famous in Long Lake, New York, as a result of his appearance in *Leslie's*, refer to H. Perry Smith, *The Modern Babes in the Wood or Summerings in the Wilderness* (Hartford: Columbian Book Co., 1872), pp. 221–24.

6. Henry Vane, "Adirondack Days," *Harper's New Monthly*, October 18, 1881, p. 691.

7. Charles F. Orvis and A. Nelson Cheney, *Fishing With the Fly* (Boston: Houghton, Mifflin, 1898), pp. 291ff.

8. Thomas Bangs Thorpe, "A Visit to John Brown's Tract," *Harper's New Monthly*, July 1859, pp. 160–78.

9. Hamilton, *Early American Book Illustrators*, p. 126.

10. Frank Weitenkampf, *American Graphic Art* (New York: Macmillan, 1924), p. 201.

11. Presumably these sketches were drawn for *Appleton's Journal*, for which Low started drawing in 1869. The undated, unsourced page is in the print collection of the Adirondack Museum, Blue Mountain Lake, New York.

12. [Charles Hallock], "The Raquette Club", *Harper's New Monthly*, August 1870, pp. 321–28.

13. Ibid., p. 325.

14. Seneca Ray Stoddard, *Lake George; (Illustrated.) A Book of Today* (Albany: Weed, Parsons, 1873), p. 86.

15. Seneca Ray Stoddard, *The Adirondacks: Illustrated* (Albany: Van Benthuysen and Sons, 1879), opposite p. 200.

16. Seneca Ray Stoddard, *The Adirondacks: Illustrated* (Glen Falls: by the author, 1888).

17. Both caricatures as photographed by Stoddard are in the photograph collection of the Adirondack Museum.

18. Daniel Carter Beard, "A Double Surprise—A Sporting Incident in the Adirondacks," *Frank Leslie's*, August 22, 1891, p. 37.

19. H. H. Thompson, "The Sea Serpent Up a Tree In The 'North Woods' of New York," *The American Angler*, August 4, 1883, p. 68. Other related articles appear on pages 68 and 69.

20. Ibid., p. 69.

21. Thomas Worth, "Adirondacks," *The New Yorker*, August 22, 1877.

22. James Thomas Flexner, *That Wilder Image* (New York: Bonanza Books, 1962), p. 253.

23. Culver H. Lewis, "An Adirondack Episode—Taking Possession of the Camp," *Frank Leslie's*, July 14, 1883.

24. "My First Deer Hunt," *Frank Leslie's Popular Monthly*, September 1877, p. 293.

25. E.E.T.S. [Ernest Evan Thompson Seton], "Hounding An Adirondack Deer. To Make It 'Shy'—So That the Still-Hunters Will Not Get It," *Forest and Stream*, March 11, 1886, p. 127.

26. W. A. Rogers, *Canoeing in the North Woods—"A Carry,"* *Harper's Weekly*, September 22, 1888, p. 709.

27. The canoe is identified on page 718 as the "Psyche." It was built on the English Nautilus model in 1876 for Kirk Monroe (1850–1930), a friend of the artist and a writer of popular boys' books. According to the *American Canoeist* (November 1882, p. 157), "Psyche" went to the woods in August 1882. The carry is between Lake Clear and St. Regis Lake. Refer to any edition of E. R. Wallace's *Guide to the Adirondacks* published in Syracuse annually from 1872 to 1899.

28. W. M. Cary, *Vot Doesh You Peddles? The Aldine*, August 1873, p. 164. By association, the artist is probably F. T. Vance, who produced a series of mountain landscapes engraved as illustrations in the same issue.

29. W. A. Rogers, *"Lawing" in the North Woods, Harper's Weekly*, November 18, 1882, p. 725.

30. *Life*, August 26, 1886, p. 121.

31. Weitenkampf, *American Graphic Art*, p. 241.

32. "A Run into the Adirondacks," *Frank Leslie's*, August 29, 1885, an unpaginated double-page illustration.

33. W. A. Rogers, *Stop, Thief, New York Herald*, April 20, 1903. Also by the same artist *A Helping Hand, New York Herald*, March 30, 1903. Both cartoons were reprinted in an article by Warren Higby, "The Association for the Protection of the Adirondacks: What It Has Accomplished in One Year," *Woods and Waters*, Summer 1903, pp. 18–19.

34. Weitenkampf, *American Graphic Art*, p. 247.

35. Frederic Remington, *Spring Trout Fishing in The Adirondacks—An Odious Comparison of Weights, Harper's Weekly*, May 24, 1890, pp. 404–405.

36. James Gleeson, "City and Country," *Munsey's Magazine*, June 1896, p. 266.

9

R. Swain Gifford
and the New York Etching Club

ELTON W. HALL

On a winter's evening late in 1877 a group of twenty invited artists gathered in a New York City studio for the purpose of establishing an etching club. Less than half of those present knew anything about etching,

but so impatient were they to learn, that the formalities of an organization were hurried through; a constitution was offered, but time was too precious to be wasted in reading it, so, on motion duly made and seconded, it was unanimously adopted. It seems to be a very satisfactory document, for to this day no member has asked to see it.

All formalities being unceremoniously thrust out of the way, the real work of the evening began. Copper plates were produced; grounds were laid; two or three of the evangelists set to work scratching, every movement being eagerly watched by the uninitiated as they craned over the etchers. Trays were filled with acid; the slight etchings were slipped into the bath; eager eyes watched the acid bubbling at its work, and eager noses were made rebellious by the pungent fumes. An elegant brother who had "dined out" early in the evening, doffed his stylish "sparrow-tail" (as the little miss termed it), rolled from his wrists his spotless linen, manned the press, smeared the newly bitten plate with blackest ink, then wiped clean its face, spread the damped "Japan paper" sheet, pulled the cross of the press, his elbows finding scant room in the crowd that pressed upon him, and in another moment the first-born of the New York Etching Club was tenderly passed from hand to hand, while remarks were freely made

upon the beauty and promise of the child, its marked resemblance to its father, all joining in one sentiment—that it was as easy to do as rolling off a log, and, it may be added, some of those who thought it easiest, never, so far as I know, have tried to undeceive themselves.[1]

This account of the first night of the New York Etching Club was written by James D. Smillie, a founder and second president of the club. The three artists who produced the etching were Smillie, who laid the ground, R. Swain Gifford, who drew the picture, and Dr. Leroy M. Yale, who worked the press.[2]

The nineteenth-century revival of etching as an artistic medium began in France in the 1850s. Within a few years it spread to England, championed by Philip Gilbert Hamerton and practiced by James Whistler and Seymour Haden, but its development in this country did not take place for another generation. A few sporadic efforts were made by individual artists, including John W. Falconer and others in the 1850s who for one reason or another did not stay with it. In the 1860s, William Sartain, Thomas Moran, and S. J. Ferris took an interest in the medium. R. Swain Gifford produced a series of four plates depicting old trees on Naushon Island in 1864 and 1865. The following year Alfred Cadart, the print publisher from Paris, came to New York and held an exhibition of French etchings at 625 Broadway. He stimulated a brief enthusiasm and attempted to establish an American branch of the *Societé des Aqua-Fortistes*.[3] Samuel Coleman wrote to Gifford on May 27, 1866: "I have gone into etching as well as yourself and done two, have proofs that are pronounced creditable so look out. Picked it out myself, burnt my fingers, spoiled my clothes and bothered by Chapman, to say nothing of the waste of raw materials."[4] Eleven years were to pass before Coleman again took up the needle.

It was not at all surprising that etching did not catch on at that time; there were many contributing factors. As a practical matter, etching carries with it a considerable overhead. One needs a certain amount of equipment, including an expensive press if the services of a copper plate printer are not readily available. Its technical aspects, some of which Coleman alluded to in his letter to Gifford, might not appeal to many artists, and developing the ability to vary the bite so as to obtain the desired effect takes considerable experience, which translates into time and materials. It would require more than a mild curiosity for an artist to embark on it seriously.

The graphic processes in general were not in high repute at the time.

Engraving on steel, copper, and wood was primarily employed in illustration and the reproduction of art in other media. A system of lozenges and dots, together with the use of a mechanical ruler, gave the work a cold, stiff appearance in its effort to imitate the original pictures. The art world looked down on it. That the etchers who began in America in the 1870s were highly self-conscious is suggested by the way in which they and their supporters belabored the point that what they were doing had nothing to do with reproductive engraving: theirs was a fresh, original art. To be sure that there was no mistake, they typically referred to themselves as painter etchers, as distinguished from engraver etchers.

Another problem confronting the early etchers was the difficulty of getting their plates printed in a satisfactory manner. A commercial printer, used to printing engravings, might not have the skill to print an etching properly. Artistic printing is an important part of obtaining a fine print, and there is much more to it than the clean wiping of an engraved invitation. Plate tone, clean wiping of specific areas, and retroussage are among a printer's skills which are of great importance to the final effect. The best plate is worthless if not well printed. Moreover, a plate may be seriously damaged in the hands of an incompetent worker. It is unlikely that many artists acquired their own presses until they were certain that they wanted to pursue the art seriously, while at the same time there was not sufficient demand to support an etching printer in New York in the 1860s. Samuel Coleman did not return to etching until 1877.[5]

If all the obstacles to the production and publication of etchings are overcome, the remaining essential element is a paying customer. There was, however, no established market for etchings in New York in the 1860s and early 1870s. As now, most picture buyers preferred to acquire the work of artists who were well established, needing the example of others to give them confidence that they were buying the right thing. Moreover, the media of oil, watercolor, and pencil were at that time far safer than etching. The etchers needed dealers, curators, and critics to tell the picture buyers what to like. In the 1860s these individuals had not emerged.

In view of these factors, the production of artist etchings in America prior to the establishment of the New York Etching Club was limited to those few artists who worked for their own interest rather than any encouragement from the market. This was to change dramatically by the end of the 1870s.

The Centennial Exposition of 1876 marked a turning point in American art, the end of the romantic era. A younger generation of artists has been studying abroad and returning to this country with new ideas about painting.

The public was exposed to these ideas through European pictures on view at the Exposition. Included were examples of the work of modern European etchers which helped prepare Americans for the introduction of that art.

A new version of American landscape was becoming popular. In contrast to the enormous panoramic, sublime landscapes that brought fame and fortune to Albert Bierstadt and others, it was a closer, more intimate vision. Americans saw new possibilities through the contemplation of a much smaller piece of real estate. Instead of being awed by the sublime, they took a more introspective, contemplative approach. Sylvester R. Koehler, in his second article on R. Swain Gifford in *American Art Review,* began:

> A marked characteristic of much of the best landscape art of our day is its simplicity and modesty,—its self-restraint, so to speak, which prevents the painter from dealing arbitrarily with Nature, leads him to submit to her rather than to endeavor to bend her to his will, and makes him loath to grapple with her loftiest themes and sublimest effects.
> . . . Gifford's artistic life has been marked by a deliberately carried on process of emancipation from the traditions of the old school; a desire to get into closer intimacy with Nature, by seeking her out in her most familiar aspects and her least formal moods; an endeavor to pierce the secrets of her soul, rather than to study the mere outward lineaments of her form.[6]

This approach to nature is one that is highly compatible with the intimacy of the copper plate.

Another development was the gradual education of the American art world to etching as a fresh, artistic medium. The print-selling business, which had been primarily in the hands of booksellers, began to feel the demand for modern etchings, causing bookseller Frederick Keppel to move from a downtown store to a new print gallery, where modern French etchings were exhibited with the work of old masters.[7] Keppel's activity as a print dealer interested in modern work significantly affected the history of prints in the United States. For the next half century he was one of the major figures in the field.

The year 1877 was a good one for artist's clubs in New York City: the Society of American Artists, the Tile Club, and the New York Etching Club were all founded that year. Clubs added an important dimension to the lives of artists in New York, particularly for younger men from out of town. The most pres-

tigious at that time was the Century, for which artistic accomplishment was a prerequisite for election. There were a great many clubs interested in many departments of the arts: watercolor, drawing, landscape, and others. They provided a great deal for their members in the way of ready access to kindred spirits, an opportunity to meet and exchange ideas, seek technical advice, benefit from one another's experience, give each other moral support, or engage in friendly rivalry. Because of the technical complexities of etching and the sparse practical literature on the subject,[8] the Etching Club was perhaps more useful to beginners than clubs devoted to more established media. Most importantly, the clubs gave their members an organization through which to mount exhibitions and demand critical attention from the press. During the first three years the New York Etching Club held regular meetings at which more than 120 plates etched by members were discussed.

In the 1975 print conference at the Museum of Fine Arts, Boston, Clifford S. Ackley discussed the work of Sylvester R. Koehler, who, through the publication of *American Art Review* from 1879 to 1881, did more to promote the work of American etchers than anyone else. During the two years of publication, articles on the work of twenty-six American etchers appeared, each illustrated by an original etching printed from a steel-faced plate. Koehler's championship of the cause for which the Club was founded provided great encouragement for the artists.

For the first four years of the New York Etching Club's life, its members had to find other places to exhibit their work. The 1879 exhibition of the American Watercolor Society included twenty-one etchings by seven artists. The following year eighty-three were included. The Etching Club also exhibited that year with the Salmagundi Club, contributing 100 etchings by thirty artists.[9] In 1881, Koehler organized the first major exhibition of American etchings at the Museum of Fine Arts, Boston. Included were 549 prints by Americans, eighty Rembrandts, eleven Van Dycks, fifty modern French, and twenty-four by Seymour Haden. This impressive assembly of 720 etchings apparently did not attract a great deal of public attention and visitation. Koehler remarked that the response came as no surprise, for works in black and white are less interesting to the public than those in color, and etchings are the most difficult pictures to understand. Nevertheless, an exhibition of such magnitude could not have failed to leave its mark.[10]

News of the accomplishments of the American etchers had by this time reached back across the ocean, for when Seymour Haden founded the Society of

Painter-Etchers in 1881 and planned their first exhibition, he was eager to have the Americans represented. A number of artists responded to his invitation, sending over examples of their work. So well received were their prints that ten Americans were immediately elected to membership in the Society: Albert F. Bellows, Frederick S. Church, Frank Duveneck, John Falconer, Henry Farrer, R. Swain Gifford, Mary Nimmo Moran, Thomas Moran, Stephen Parish, and James D. Smillie.[11] This admiration for the work of the New York Etching Club was conveyed in a letter from Seymour Haden to Samuel P. Avery following the exhibition, in which he expressed his pleasure at the quality and quantity of the work.[12] Haden must have felt great personal satisfaction in the exhibition, for he wrote to Gifford on June 14, 1881, of "the prosecution of an object which I have long had at heart, and which l believe to be in every way [an] admirable object: namely the reimportation of the principal of originality into the art of engraving & its reconversion from a secondary into a primary art. The mechanical engravers will, of course, not thank me for this, but I ought to have, and I believe I shall have, the support of every unprejudiced artist."[13] P. G. Hamerton also wrote to Gifford to ask if he had any unpublished proofs of etchings, for Hamerton wanted to include American etchings in the *Portfolio*.[14]

The New York Etching Club held its first formal exhibition in 1882 at the National Academy of Design. Included were 284 prints by seventy-three artists, including a few old masters and modern European artists. The catalogue contains an introductory essay giving a history of the Club to that date and a list of members, which numbered twenty-eight resident and five non resident. A number of the artists made smaller plates from their entries in the exhibition from which impressions were used to illustrate the catalog.

Seymour Haden was appropriately included in the first exhibition, represented by *Old Chelsea out of Whistler's Window* (figure 9.1). The work of the American etchers derives more of its style and quality from Haden than any other source. Frederick Keppel related that when traveling through Europe, it was his habit to carry with him a selection of etchings by Seymour Haden. "When these were shown, for the first time to some artist or amateur, the comment usually was 'School of Rembrandt.' And in later years, after our own American etchers began to produce such fine work, the general remarks of these same experts, on seeing some specimens of it, was 'School of Seymour Haden.' "[15]

The best work of the American etchers is that which adheres to the unique qualities of the medium, taking full advantage of its opportunities but

9.1. Seymour Haden, *Old Chelsea out of Whistler's Window,* 1863. Etching,
5⅞ × 8⅞ in. Private collection.

not belaboring them. It is characterized by simplicity, directness, and, above all, restraint. Keppel wrote:

> Etching may be called the shorthand of art. It is the concentrated essence of a picture. In doing apparently little, it suggests a great deal—and in the case of the finest etchings, so replete with suggestion, the beholder himself must mentally do part of the work. The etcher catches and jots down the art idea while it is fresh and living, and he is wise if he stops at that. To toil over and elaborate on an idea which is already broadly indicated is fatal to the vividness of the effect, and may be compared to the disheartening operation of explaining a joke after the hearer has failed to "see the point."[16]

The very nature of the medium lends itself to freedom and spontaneity of expression, for the etcher's point moves through the wax with less resistance than paper offers a pencil. The tool is not guided by the metal as it is in engraving or drypoint and is thus free to glide and waver in any direction. The processes of biting and printing offer further opportunities to vary and enrich the lines. These qualities, together with their selection of subjects, brought the American etchers considerable acclaim for their originality.

Considering that the proponents of the movement went to great pains to explain that etching and engraving had been debased for the purpose of making slavish reproductions of paintings, it is surprising that many of the artists continued to use paintings as the subjects of their etchings. Gifford did a number of plates after paintings by Corot, Troyon, and himself. Such etchings by Gifford and by others were regularly included in the exhibitions of the New York Etching Club. Frederick Keppel stoutly defended the practice, declaring a good reproductive etching to be better than a poor original one. In such cases he claimed that originality was not what was wanted from the etcher; the painter had already supplied that. All the etcher was supposed to do was to provide a faithful translation of the original.[17] This seems to revert perilously close to the very thing that artists claimed bore no relation to the work upon which they were embarked. Even if one accepted Keppel's view that reproductive etchings could be considered meritorious works of art in their own right, in actual practice they usually were not. Even when artists made etched copies of their own work, the results were generally labored copies of the oil paintings, rather than transcriptions to copper of the vision embodied in the original work.

The decade of the 1880s was the heyday for this generation of etchers. By 1884 there were seven etching clubs in major cities, including Boston, New York, Philadelphia, Cincinnati, and Toronto. Kimmel & Voigt and other printers pulled large editions from steel-face plates. Knowledgeable, enthusiastic dealers and discerning critics praised and promoted their work to an eager public. In New York, at least, there was a large enough group of artists to sustain a considerable momentum through mutual inspiration and encouragement.

A letter from the French etcher Felix Buhot (1847–98) to R. Swain Gifford of April 1, 1887, summarizes the qualities, amenities, and cameraderie that caused this flourishing. The translation is Gifford's.

Sir and Dear Colleague:

It has probably happened to you, more than once in your career, to experience the special & delightful pleasure which you have just made me feel by your letter: that is, to receive a spontaneous expression of sympathy from another artist for one of your works. I will not send you then a commonplace acknowledgement, any more than I will, for the sake of modesty, write against the excess of your kindness toward us beginners. Even if I tell you I am, as probably you are yourself, in your heart, & as all artists are disgusted 3/4 of the time with what I do, that will not change your indulgence. I place value on your appreciation, and that the outburst of these spontaneous sympathies springing from the soul of one artist toward another artist, seems to me that sweetest, richest reward of work.

I would like to be able to reciprocate and in my turn take pleasure in your works which I know unhappily only from articles which I have read about you. The first time that your name struck my notice was, many years ago, in an illustrated Review which reproduced one of your pictures. It was the *XIX Century*, or perhaps the *Magazine of Art* of London. I do not remember now. I have indeed one of your works, but alas, it is only the reproduction of one of your etchings (An October Day) in the *American Etchers* by Mrs. Van Rensselaer, of which Mr. Keppel has wished to give me 2 copies & which I have read with much pleasure & interest. I regret that Mr. Keppel has not reproduced also your "Padanaram Saltworks" which I know only from the description.

I have many fine proofs of American etchers to which I attach much value and which Mr. F. Keppel has kindly given me or in exchange for other pieces. I should be very happy to be able to add to these a proof signed by you. If it is not obstrusive on my part I would be very grateful if you would give me one & send it to Mr. Keppel when he starts for Paris.

It is a pleasure to me to show my portfolio of American etchings not only to artists but also to Parisian printers, (to mine at least), who gladly think that outside of Paris, no one knows how to make a fine proof. It is quite the contrary. There are in Paris very few printers, 5 or 6 at most, who are capable of a fine *artists proof* of a "painter etching." It is true to say that you have a editor of your works, in the person of Mr. Fred. Keppel, a man gifted with an unusual intuition in all that concerns the printing of etching—the choice of tone, preparation & above all—a detail so important & so neglected by Parisian editors—the choice of paper & its relation to the subject.

Sincerely, I consider American etchers very fortunate in having for one of their principal agents an intelligent man who has the very rare and great merit of really loving the art which he is engaged to give to the public. We should be very glad, we others in Paris, to have here a Mr. Keppel as you have. But we, *we have no one & nothing*—What I tell you may surprise you, but it is the exact truth still. *Etching-de. peinteur, etching d'artiste,* original etching, whichever you please to call it, in short, the real etching, is almost dead in France. It has a brilliant renaissance with Meryon, Celestin, Nanteuil, Delacroix, Trimolet, then with Charles Jacques, J. F. Millet and all such people. Cadart the father being dead, his son spoiled all, scorned all, then when the style of work edited by his father was dishonored by him, he made a sudden & disastrous failure which was the death blow & the death. Our plates lent by us without charge were sold by weight in bulk. And we do not know what has become of them except those which some merchants of engraver's plates, produced at a low price to the grief of our poor eyes which could not prevent this dishonor.

We are still 4 or 5 indignant fellows who persist in loving the copper. Ask Mr. Keppel if he knows many more outside of the reproducers, or mechanicians of the school which had a short reputation 13 years ago but which has fallen into a *trade* & now produces only *neutral* things, without character, which resemble the bad woodcuts on photogravures.

I would like to send you some of the articles which from time to time I have amused myself by writing on this subject in the *Journal des Arts;* I fear that just now I have no more copies of them.

I have started out & don't know how to stop myself for I enjoy talking of our art with some one who cultivates it. Those who love & appreciate it are so so few.

I wish I had the time & the space to tell you, my dear Sir, with what zeal I have followed for some years, the development of your American Art not only in the beautiful experiments which I see each year in the salon

(I have grown able to guess at a picture by an American artist at more than 15 ft. distance, without seeing either name or title, by I know not what special warmth of tone or harmony of the whole, by their *style*) but above all by the illustrated Reviews which Mr. Keppel & Mr. S. P. Avery send me from time to time, besides those which I see in Paris. The American School, although *relatively* young, unites with great boldness much knowledge & maturity, but what to my mind distinguishes it in a distinct manner from the old school of continental Europe is its originality and this *je ne sais quoi* of fantasy & dreaminess which is seen, perhaps without the knowledge of Americans themselves, in the style of your painters, illustrators, & etchers. Your school although already mistress of a powerful rendering in the study of nature, calls out & betrays I know not what uneasiness of something beyond what our French school possessed in 1830.

You are kind enough to say that you hope my etchings will have success in your country. I thank you very much for the wish & I have a little hope; for during several years almost the only encouragement that I have received has come from the United States. Among these encouragements, one has been particularly pleasing to me, Mr. Samuel P. Avery, whose collections of many sorts are well known, has been interested in my works, & has a collection of them already numerous, which I am going to complete as far as I can.

I beg your pardon, dear sir, for my too long talk; you will be frightened now in writing to a Frenchman, to one of this talkative race as we are called. I believe an epithet which I bid fair to justify to your hurt. At heart, I believe that artists form in the world a nation by themselves, being citizens wherever Art is loved & cultivated. Governments ought to choose artists for ambassadors, as they once chose Rubens. The world would be better for it. We should only cut off the heads of some painters & classic engravers & that would be the end. I should like to propose it to the Czar of Russia whom I dislike, because I love England on account of its faith, on account of Turner, & on account of my wife.

<div align="right">
Truly yours,

Felix Buhot[18]
</div>

Written in response to a communication from Gifford, this letter is remarkable as an expression of empathy between two artists, as well as for the information it gives on the state of etching in America and in France, the problems and technical details of concern to etchers, and the confession of respect and admiration that an accomplished French etcher feels for the Americans.

Let us now turn to some of the members of the New York Etching Club and their work. These artists found their subject matter in a wide range of places along the Atlantic coast, inland, and abroad, but here we shall emphasize New York scenes even though they constitute only a small percentage of the total *oeuvre*.

Dr. Leroy M. Yale (1840–1906) was the first president of the club as well as one of the three participants in the initial meeting who conspired to produce an etching. Born on Martha's Vineyard, Yale studied medicine as a profession, maintaining an interest in drawing as a hobby. In 1866 he became house physician at Blackwell's Island and commenced etching that year, undoubtedly exposed to it by his friend Gifford, and perhaps stimulated by M. Cadart who, as we know, was promoting etching in New York that year. His particular interest was the landscape of southeastern Massachusetts, which provides the setting for much of his work. That he worked directly from nature, drawing on the plate, is indicated by his etching, "Fish House Near Dumpling Light," 1882, which shows the buildings reversed from the way they actually stood. Although not typical of his work, his etched portrait of R. Swain Gifford, probably from a photograph, recalls to us the close friendship of these two men who had so much to do with the founding of the New York Etching Club.

Robert Swain Gifford (1840–1905) was a man of practical as well as artistic interests, as shown by books on such diverse topics as engineering, photographic processes, horticulture, and naval architecture which bear his signature on the end papers. It is not surprising that he was interested in etching and began at an early age. Koehler wrote that his love for the art dated back to his boyhood when his principal success was in spoiling his clothes with acid, "but with the aid of Gregory's Dictionary of the Arts and Sciences, and afterwards with Chapman's Drawing-Book as guides, he early obtained a mastery of many of the processes employed, which stood him in good stead in his more mature efforts."[19] Perhaps more than his written praise, Koehler's choice of Gifford to provide the etched frontispiece for the initial number of *American Art Review* as well as his book on etching testifies to his admiration for Gifford's ability. By correspondence of April 1, 1879, Koehler gave Gifford his instructions for the job which amounted to no more than advising him of the page size of the journal. As part of the deal, Gifford was to have fifteen proofs on Japanese paper which he could sell as signed artist's proofs. The publishers offered unsigned proofs on Japanese paper.[20] The relatively new process of steel-facing copper plates allowed virtually unlimited editions, so that the illustration of periodicals with original etchings

became not only possible, but quite popular. The etching that Gifford made for this purpose was "Path to the Shore."

Padanaram Salt Works (Figure 9.2) was considered by most to be Gifford's finest etching. Mrs. Van Rensselaer wrote that she would

> keep within a quite undisputed fact in saying that there is not one among them [the American etchers] who shows a truer feeling for the requirements of this peculiar art than Mr. Gifford; who etches more truly in the etcher's spirit; who knows so exactly what to omit and what to insist upon, and thus produces such complete effects by such simple and synthetic means. His finest plate, to my eyes, is the "Padanaram Salt Works,"—most remarkable for quiet simplicity of manner and fullness of meaning, and for a truly artistic management of line and detail. I am only citing, of course, an individual preference; but to me this is the most perfect plate, in sentiment and execution, that has yet been done in America, though less brilliant and immediately "effective" than some others.[21]

Mrs. Van Rensselaer's high opinion was not only shared by many of her contemporaries, but a few years ago when the remaining etchings in Gifford's family were offered for sale, that print was most eagerly sought.

Although a long-time winter resident of New York City, Gifford is only known to have chosen one New York subject for an etching, *Hudson River Tow* (figure 9.3). In 1879, the Tile Club chartered a barge for their summer outing and proceeded up the Hudson River at the end of a tow rope. This etching is one of the happy results of that trip. In an article which appeared in the *Academy,* July 27, 1880, T. H. Ward wrote of the progress made by the American etchers, Singling out Gifford for special praise, he describes "A Hudson River Tow" as an instance of

> the "frankness" which has been claimed for Mr. Gifford; that gift of "telling rude truths with plain lines" which Mr. Hamerton ranks so highly among the qualities of the true etcher. Frankness springs from the artist's love of his subject, which forbids him to tamper with it, to make fancy arrangements of it. Combine it with the power of selection, and add to the combination sufficient technical skill, and you have the fitly qualified etcher; and no one who has studied Mr. Gifford's work will doubt that he possesses all the qualities in a remarkable degree.[22]

9.2. R. Swain Gifford, *Padanaram Salt Works*, 1878. Etching, 9 × 14¼ in.
Courtesy of the Old Dartmouth Historical Society, New Bedford, Mass.

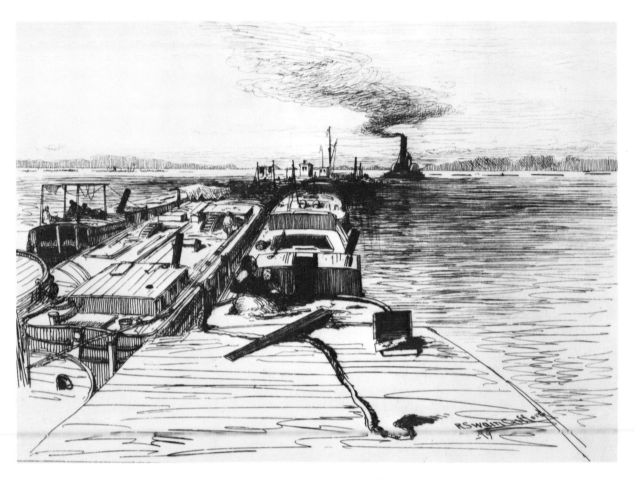

9.3. Swain Gifford, *Hudson River Tow,* 1879, Etching, 7 × 9 in. Courtesy, Old Dartmouth Historical Society, New Bedford, Mass.

James D. Smillie (1833–1900), the son of James Smillie, a steel engraver, was a native of New York City. He began work as a banknote engraver before yielding to the call of landscape, which he depicted in oil, watercolor, and on copper. He was a founder of the American Watercolor Society, an officer of the National Academy, and second president of the New York Etching Club. A prolific printmaker, he produced many reproductive as well as original etchings. Perhaps his earlier career tended to lead him towards reproductive work more than other artists, and those plates tend to have the labored look of an engraving more than his original efforts.

A good example of his landscape is this view in Montrose, Pennsylvania (figure 9.4). The plate is inscribed "etched direct from nature," which shows that Smillie, too, took his etching equipment out into the woods. This impression is printed in a warm brown ink. By varying the depth of the bitten line, Smillie has achieved a remarkable feeling of color, through the contrast between the rich, dark brown lines of the trees and rocks in the foreground and the lighter browns of the trees beyond the pond. His effort to evoke the midday sun on this September day has been highly successful, giving the print an exceptional sparkle.

Henry Farrer (1843–1903) arrived in New York from his native London in 1862. Shortly thereafter he took up etching using tools and a press of his own construction.[23] Faced with the necessity of earning a living, he largely abandoned etching in the early 1870s but returned to it with a renewed interest when the club was established. Spurred by the enthusiasm of his fellow members, he became a prolific printmaker and served as third president of the club, an office he held at the time of its first formal exhibition. More than any other member, Farrer appreciated the local scene as a place offering motifs for his work. Early in his career he did a series of eleven plates showing old buildings in New York City. These had considerable historical interest, but by the time he renewed his interest in etching, his artistic perception had matured to the degree that he no longer considered his early work acceptable and withdrew the prints from circulation, declining to have them listed in *American Art Review*. New York harbor remained his principal subject, however, and his work constitutes an impressive iconography of the harbor in the 1870s and 1880s. He particularly liked the crepuscular light against which he silhouetted the bold forms of shipping as in *Sunset, Gowanus Bay*, which was published in the March 1881 issue of *American Art Review*. *Sunset, New York Harbor* (Figure 9.5) both in choice of the subject and in its treatment is reminiscent of etchings by Whistler and Haden of shipping along the Thames. In contrast to the sharp silhouette of the ship in *Sunset, Gowanus*

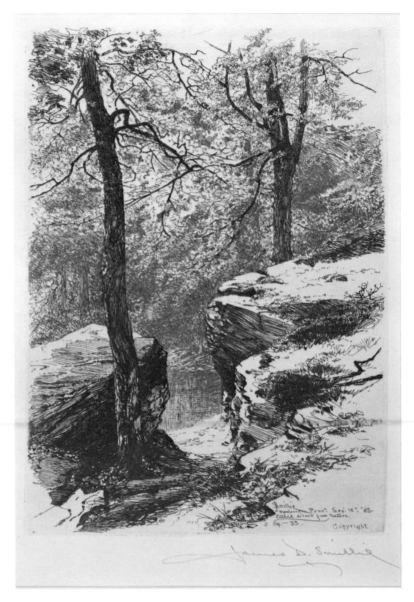

9.4. James D. Smillie, *Montrose, Pennsylvania*, 1885. Etching, 9¾ × 6¾ in.
Frederick Keppel Memorial Bequest, 1913. Courtesy of the Museum of
Fine Arts, Boston.

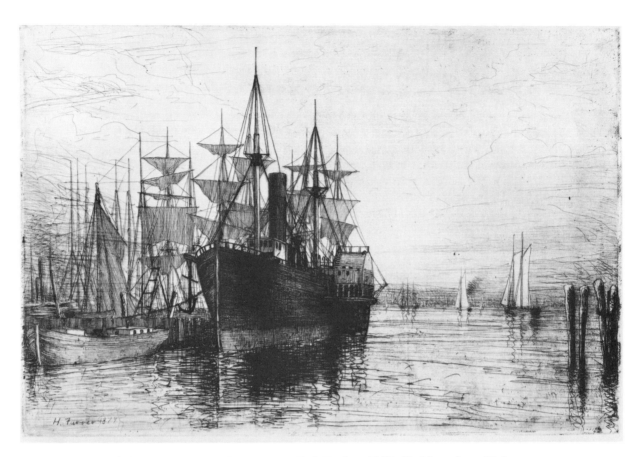

9.5. Henry Farrer, *Sunset, New York Harbor*, 1879. Etching, 8 × 12 in.
Courtesy of the Museum of Fine Arts, Boston (gift of the etcher, 1881).

Bay, the bold form of the sidewheel steamer, with its tall, natural draft smoke pipe, has been softened by placing it against a mass of sails and rigging beyond. The water looks wet and placid, contributing to the verisimilitude of this sunset view across the Hudson, for the wind usually does go down with the sun.

John M. Falconer (1820–1903) came to New York from Edinburgh in 1836. Although he practiced art as an amateur for many years until giving up business for art, he was respected by his professional contemporaries and made an honorary professional member of the National Academy in 1856. As with others, his efforts at etching were sporadic until the founding of the club. He made two plates in 1848, joined Cadart's class in 1866, and then in 1878 resumed, producing about thirty plates during the next two years.[24] He was one of the American artists elected to the Society of Painter Etchers following the 1881 exhibition in London. Abandoned buildings, desolation, destruction, and decay were among Falconer's favorite subjects. Another characteristic subject is illustrated by his landscape with the river and Brooklyn Bridge in the background (figure 9.6). Falconer did not seem to be much interested in the technical side of etching. Most of his plates are evenly, often quite roughly, bitten, with little use of the opportunities to vary the lines by deeper biting. Artistic printing was not of much interest to Falconer, for his plates are generally wiped clean. For this reason his work lacks the dramatic quality seen in the work of some of his colleagues, yet its general dreariness is in keeping with his favorite subjects.

James Craig Nicoll (1847–1919) was the principal marine artist in the club. An active member, he was secretary-treasurer for most, if not all, of the club's existence. *In the Harbor* (figure 9.7) is a typical subject for Nicoll, whose water, unlike Farrer's, tended to be cold and rough. Heavy cloud formations pierced by a shaft of bright sunlight are often seen in his work, an effect heightened by varying the plate tone. He has used a multiple liner extensively in the sky and water. This tool made four parallel lines by which the clouds and waves were modeled. When seen at a glance, close up, this treatment produces a peculiar vibrating effect.

Thomas and Mary Moran were both early members of the club whose work was enthusiastically received by the English as well as the Americans. Thomas (1837–1926) was born in England and came to this country in 1844. Remembered today more for his landscape paintings, he had a serious interest in etching and experimented widely with various techniques. He produced a number of etchings showing broad views of dunes and shoreline out at the eastern end of Long Island. In *Gleaning From the Shipwreck, Montauk* (figure 9.8)

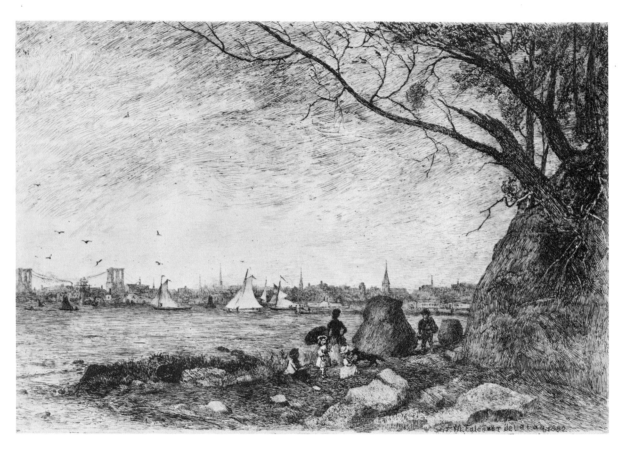

9.6. John M. Falconer, *Brooklyn Bridge,* 1882. Etching, 9¼ × 13¼ in. Sylvester R. Koehler Collection. Courtesy of the Museum of Fine Arts, Boston.

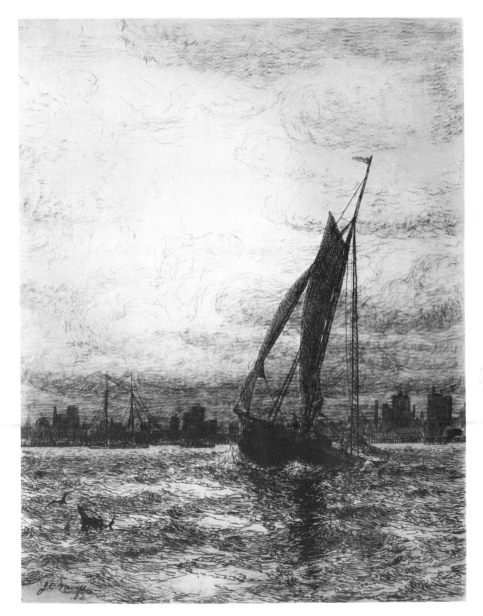

9.7. James C. Nicoll, *In the Harbor,* 1882. Etching, 12⅛ × 9⅜ in. Courtesy of the Museum of Fine Arts, Boston.

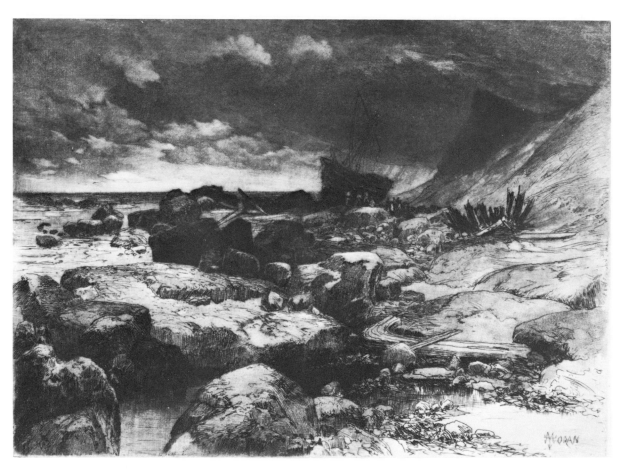

9.8. Thomas Moran, *Gleaning from the Shipwreck, Montauk*. Etching, 5¾ × 7⅞ in. Private collection.

he has made extensive use of the roulette to give a rich contrast between light and dark areas and thereby express the drama of the situation.

Mary Nimmo Moran (1842–99) came from Scotland to the United States when a child and eventually became the first woman member of the club. She had a simple, strong style, which was undoubtedly aided by her habit of working directly from her subject, completing everything but the biting right on the scene. She shared her husband's interest in the Long Island landscape with its farms, dunes, and beaches, which provided subjects for many charming plates. She often returned to the same scene capturing its various aspects under different light and weather conditions. A farm lane and windmill at Easthampton appear in several prints, some highly dramatic, others quite tranquil.

In New York City, however, she saw a far different side of humanity's condition. *Shantytown* (figure 9.9) shows a group of hovels precariously perched on an outcropping of ledge. Mary Moran's robust style and choice of subjects were well suited to etching, and her prints rank with the best of that time.

Charles A. Platt (1861–1933) was one of the younger members of the Club. His appreciation for the picturesque attracted him to Gloucester, where he found agreeable subjects along the wharves. *Shanties on the Harlem* (figure 9.10) is typical of the kind of thing that appealed to him and shows his boldness of technique and skill in selecting important details while leaving out the unnecessary. Its message is expressed with a minimum of drawing. The directness, freedom, and variation in the lines from the deeply bitten to the barely visible make excellent use of the medium.

Charles A. Vanderhoof (d. 1918) was active a little later than many of the other members of the Club. Harbors appealed to him, particularly riparian views with boat houses, wharves, shacks, small craft, and the assorted junk which forms a conspicuous part of any waterfront. New York offered plenty of this kind of material, to which Vanderhoof responded with the production of etchings like *On the East River* (figure 9.11).

There are other etchers who might well be mentioned here: A. F. Bellows, Samuel Coleman, Stephen Parish, F. S. Church, and Kruseman van Elten, to name a few. During the active years of the New York Etching Club there were usually from twenty-five to thirty resident members and five or ten nonresident members. Hitchcock's list of American etchers, compiled in 1886, included ninety who had exhibited with the New York Etching Club. The list noted that some earlier members of the club had been omitted because they appeared to have

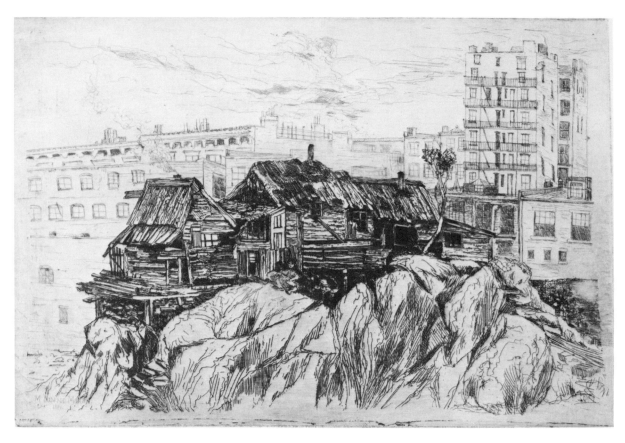

9.9. Mary Nimmo Moran, *Shantytown*, 1881. Etching, 8 × 12 in. Sylvester
R. Koehler Collection. Courtesy of the Museum of Fine Arts, Boston.

9.10. Charles A. Platt, *Shanties on the Harlem,* 1882. Etching, 4¼ × 7¾ in. Private collection.

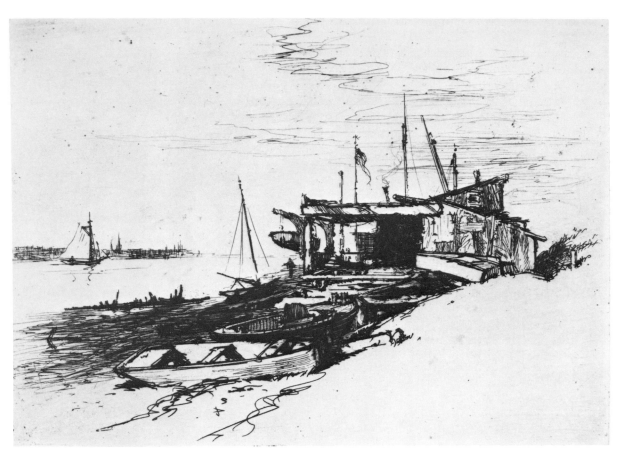

9.11. Charles A. Vanderhoof, *On the East River*. Etching, 4¼ × 6 in. Private collection.

abandoned the art by that time. Of these artists, thirty-one were members of the club.[25]

By the 1890s the great success and popularity of the etchings began to disturb those who had fostered it. When any form of art becomes popular and successful, a host of mawkish imitators scramble onto the bandwagon. Few have a true understanding and talent for what they are pretending to do, but their "get rich quick" approach is supported by a fad-crazed public looking for a bargain. Vast and mediocre quantities of anything tend to dilute and obscure that which is excellent, destroying much of the satisfaction it originally provided. In his introduction to the catalogue of the 1891 New York Etching Club Exhibition, James D. Smillie describes what had happened.

> That beautiful art is now being sore tried in the very house of her friends, or, at least those professing to be her friends. She is suffering from a popularity so wide and so fleshly in its attributes that in this embrace the breath of life is nearly pressed out of her. She is the winner of a victory so disastrous that some sorrowing friends are humbly prayerful for the healthy reaction of a wholesome defeat.
>
> Not a dry goods store upon our thoroughfares but has the enticing display of "artist proof" etchings, each decorated with one or more autographs and several "remarques," and offered at wonderously low prices. Not a mortgage-laden farm in Kansas or a liquidating cattle ranch in Texas but may show its "artist-proof" etchings; for, to supply the artcraving of a people insatiable with the greed of a new appetite, presses with relays of men, working night and day, are laboring to supply the demands of our great cities, and carloads—literally carloads—of signed artist proof etchings are being sent to plains and prairies, Rocky Mountain homes and for Pacific slopes.

The exhibition of 1893 appears to have been the last of the New York Etching Club. One hundred four prints by thirty-four artists were included, quite a step down from the 184 prints by seventy-three artists eleven years earlier. Some of the original members had died; others went on to other things. Gifford's last dated plate was etched in 1891, even though he was as active as ever in other media for the remaining fourteen years of his life.

Louis A. Holman summarized the rise and decline of etching as follows:

Etching was throttled by its own popularity, and it was flung aside with as little thought as was a last year's wheel, or a shapeless old hat.

The dawn of that fatal popularity was surely coming when in 1878 the *Art Journal* triumphantly told its readers that "most persons of education know an etching when they see it," and further rejoices that many can distinguish between an etching and a pen and ink drawing. But it weeps over the fact that only a fortunate few "can explain the difference between an etching by Whistler and a woodcut by Birkit Foster." A woodcut by Birkit Foster! Five years later not only had the dawn come but high noon. Everybody knew an etching at half a glance, and everybody wanted several. Had not Mr. Hamerton taught the great public that etchings were more artistic than photographs? Then, cried the public, let us have etchings! To our shame be it said that the public got what it lusted for and more. For years we got etchings as the Israelites in the wilderness got quail, even until they were loathsome to us, and we fervently wished that we had not murmured for them. Then—that was some years ago—the night of ignorance and indifference settled down swiftly, and today many persons of education do not know an etching when they see it.[26]

The history of etching has been one of alternating periods of enthusiasm and neglect. It declined after the age of Rembrandt and remained in a low ebb until the nineteenth century when Whistler and Meryon began to produce prints of such power and excellence that others were prompted to take an interest. By the end of the nineteenth century it had all but died out, leaving only a few American artists working at it. A younger generation of artists coming along did not seem very much interested.

The next day occurred between the two World Wars. A number of excellent artists including John Sloan, Edward Hopper, Reginald Marsh, and a host of others who chose architectural subjects sprang up on both sides of the Atlantic. There was a renewed interest in collecting the work of the old master printmakers. Two journals, *The Print Collecter's Quarterly* and the *Print Connoisseur,* as well as the annual *Fine Prints of the Year* sustained publication for that generation. The Crafton Collection published a dozen monographs in its *American Etchers Series* and again most major cities had active print clubs with competition shows and many prizes, of which the Brooklyn Society of Etchers with its Nathan Bijur Prize, the Philadelphia Print Club with the Sesnan Gold Medal, and the Chicago Society of Etchers with the Logan Prize were among the most prominent. But once again the bubble burst. By the end of the 1930s the market was

glutted with the junk produced by hacks, and the public turned its interest to other things.

Within the last decade a new generation of print collectors has taken a fresh look at the work of printmakers of all periods and once again the best examples are regaining a measure of recognition. The work of John Sloan, Martin Lewis, and others of the 1920s has shown a dramatic increase in the auction galleries and print rooms, much more so than the work of the earlier generation, which was perhaps more deeply buried, more widely scattered, and more totally neglected, thereby making its rediscovery more difficult.

Now that a century has passed since Koehler organized the exhibition at the Museum of Fine Arts, Boston, we can look at the work of the members of the New York Etching Club with some perspective. While their ranks did not produce a Rembrandt or a Whistler, they did include a number of meritorious artists who contributed many prints of originality, vitality, and artistry, which again deserve to see the light of day in museums and galleries, where they may afford considerable pleasure to those who take the trouble to seek them out.

NOTES

1. James D. Smillie, "The New York Etching Club," in *Harper's Weekly* 34, March 13, 1980.

2. Ripley Hitchcock, *Etching in America* (New York: White, Stokes, & Allen, 1886), p. iii. The etching is illustrated as the frontispiece. It is also illustrated in Elton W. Hall, *R. Swain Gifford* (New Bedford: Old Dartmouth Historical Society, 1974), p. 69.

3. Hitchcock, *Etching in America*, p. 29.

4. R. Swain Gifford papers, Old Dartmouth Historical Society.

5. S. R. Koehler, "Samuel Coleman," *American Art Review* 1 (July 1880): 387–88.

6. Ibid., (August 1880): 417–18.

7. Hitchcock, *Etching in America*, p. 12.

8. P. G. Hamerton's *Etching and Etchers* was published in 1868; Maxime Lalanne's *A Treatise on Etching* of 1866 was translated by Koehler in 1880.

9. S. R. Koehler, *Twenty Original American Etchings* (New York: Cassell, 1884).

10. Articles about the exhibition by Koehler appeared in the *Boston Advertiser,* April 26 and May 2, 1881.

11. Mrs. Schuyler Van Rensselaer, "American Etchers," *Century Magazine* (February 1883).

12. Gifford papers.

13. Ibid.

14. Ibid., November 21, 1881.

15. Frederick Keppel, *The Modern Disciples of Rembrandt* (New York: Frederick Keppel, 1888), p. 3.

16. Ibid., p. 7.

17. Ibid., p. 8.

18. Gifford papers. The original letter is in French and is accompanied by a translation, in Gifford's hand, which has been transcribed here.

19. S. R. Koehler, "R. Swain Gifford," *American Art Review* (November 1879).

20. Gifford papers.

21. Van Rensselaer, "American Etchers," p. 494.

22. Quoted in *American Art Review* 1 (September 1880): 504.

23. S. R. Koehler, "Henry Farrer," *American Art Review* 1 (December 1879): 55.

24. S. R. Koehler, "J. M. Falconer," *American Art Review* 1 (March 1880): 190.

25. Hitchcock, *Etching in America*, pp. 89–93.

26. Louis A. Holman, "The Etchers of America," *Appleton's Magazine* (December 1, 1907), pp. 738.

10

Bolton Brown
Artist-Lithographer

CLINTON ADAMS

During the early years of the twentieth century, lithography was at low ebb as a creative art in the United States. Although the medium had attracted the interest of a number of artists who were excited by its potential—among them Albert Sterner, George Bellows, and Arthur B. Davies— it was not until after World War I, when George C. Miller opened his workshop and Bolton Brown set up "The Artists' Press," both in New York, that conditions were established in which lithography could develop and prosper.[1]

In recent years, although some deserved attention has been given to Miller's work as a printer,[2] Bolton Brown's equally important and more diverse accomplishments have been neglected.[3] Brown's present obscurity seems all the more strange when placed in contrast with his earlier prominence.[4] His work as an artist-lithographer was but one aspect of a long and complex career as teacher, painter, scholar, mountaineer, writer, and social critic—a career which brought him recognition and acclaim. He was a member of the faculties of Cornell and Stanford universities; he was among the founders of Byrdcliffe, the utopian art colony in Woodstock, New York; he was awarded an honorary degree as Doctor of Literature in 1920 by his alma mater, Syracuse University;[5] he was author of numerous articles and three published books, one of which became the standard American work on artists' lithography during the 1930s and 1940s.[6] He created a large body of paintings and lithographs which were exhib-

Portions of this chapter have been included in different form in my book *American Lithographers 1900–1960: The Artists and Their Printers* (Albuquerque: University of New Mexico Press, 1983).

10.1. Ernest Watson, *Bolton Brown,* 1919. Lithograph, 10 × 12¼ in. Printed by Brown at Pratt Institute, March 1919. Courtesy of Lauris Mason.

ited in leading New York galleries and were the subject of high critical praise; he was elected to a lifetime membership in the National Arts Club and was chosen Scammon Lecturer at the Art Institute of Chicago. He was honored as have been few American artists (I can otherwise think only of Thomas Moran) by the naming of Mt. Bolton Coit Brown, a high peak in the main range of the Sierra Nevada.

Although Brown was not to begin work in lithography, the art with which his name is now associated, until he had passed his fiftieth birthday, his dedication to drawing began at an early age. He was born in Dresden, New York, in 1864. While young, he lived with his family in upstate New York.[7] He spoke of his mother as "my first drawing teacher"[8] and fondly recalled the days when "all through my childhood and youth, I, a country boy, used to take paper and pencil and go out and draw from nature. Thousands of drawings I made—not one for any purpose other than my own satisfaction."[9]

Brown was quickly convinced that his own satisfaction was the ultimate criterion: a sufficient condition, not only in the making of art, but in all aspects of life. As a quality of temperament and personality, the extreme self-assurance—which others often read as an unconscionable arrogance—that runs as a thread through his letters, journals, and published writings, was to play a central role in his career. It made it possible for him to climb mountains that had not been climbed before; it contributed importantly to his success as a teacher and artist; but it also contributed to the disappointments and bitterness of his later years.

Brown's sister, Ellen, once described her brother as "a smart child, but contrary" and told this anecdote: "The first time Mother took him to church she wanted to take off his hat like other gentlemen and boys. He would not let her. 'Why, Bolton, nobody wears their hat in church.' But he said, 'Bolton Brown wears his hat in church.' She had to leave it on."[10]

Throughout his life, as it were, Bolton Brown wore his hat in church. He had nothing but contempt for conventions of which he did not approve, and never hesitated to express that contempt fully and forcefully. His first great opportunity to do so came while he was professor and head of the department of drawing and painting at Stanford University.[11]

It was presumably upon Ellen's recommendation, or that of her husband, Leslie, that Brown's appointment at Stanford came about. Ellen was married to Leslie Elliott, a teacher of English at Cornell University, where Brown was also a member of the faculty from 1885 to 1888. In 1891, Elliott was invited to Bloomington, Indiana, first to become secretary to David Starr Jordan, president of

Indiana University, and then to accompany him to California, where Jordan was to be installed as Stanford's first president. Bolton Brown also came west in that year "to establish here," Ellen wrote, "a famous art school rivaling the schools of Paris, only more up-to-date." That ambition, she added, "was concealed in Bolton's head at the time, he came to teach drawing, and did."[12]

He taught drawing as he believed it should be taught, with the use of nude models in Stanford's coeducational classes, and with consequences that were inevitable in the moral climate of the 1890s. The community, in the person of Mrs. Leland Stanford, was outraged, and Brown was forced to abandon mixed classes, despite his vigorous objections, set forth in a long letter to President Jordan:

> I have never seen a look of consciousness or shame on any student's face—nor any look but one of earnest and delighted interest. The other day—after orders had been given me—I met the class as usual at 1:30—the model stood on the stand waiting to be given the pose—nobody was paying any attention to her—the boys and girls were conversing and sharpening their pencils—I told them, in a word, that on account of outside criticisms, the boys and girls must separate to draw that woman there. And then—for the first time—I *did* see shame in their faces. . . . It was a horrid moment: everybody felt silly or angry or insulted—or all three. The false attitude and the impurity of the false and the impure had been thrust upon those whose attitude was right and whose thoughts were pure.[13]

But though Brown may have lost the battle (nude models were soon abolished, not only in mixed classes but in separate ones as well), his confidence was unshaken. In that same letter to President Jordan he backed down not at all in asserting both the quality of his department and his work as a teacher:

> I assure you . . . that there is *no* school—anywhere—that does as good work—hour for hour, student for student, opportunity for opportunity—as this one. . . . My knowledge of work done elsewhere has left me able to say that to the best of my knowledge and belief, I am now the best teacher of art in the United States. This is not a boast, but a judgement: nor, except conventionally, is it reprehensible for me to say it. I happen to have been born with gifts that enable me to do it—that's all.[14]

Controversy aside, life on "the farm," in the green California hills south of San Francisco, was very good in those days. In 1896, at the age of thirty-two, Brown was married to Lucy Hines Fletcher, an attractive and intelligent young woman who had come to Stanford to organize a girl's boarding school. Ellen Elliott later described their marriage:

> Perhaps it was inevitable that Bolton should fall in love with Lucy Fletcher, she being the most beautiful thing in sight. They were married in Castilleja parlor with our family and a few friends attendant, and Father and Mother who had by then come out to California from Burdett. The wedding was strictly characteristic. Bolton managed everything. He directed where people were to sit or stand; his own hands laid on Lucy's dusky hair the chaplet of white star-flowers he had made, the minister who read the ceremony which Bolton had composed was brought by him from afar for the occasion. Afterward, he carried off the bride (like a cat with a captured mouse) for a two-months' honeymoon in the high Sierras, where they camped and tramped and lived their arduous solitary days according to his plan. We have no reason to doubt the sympathetic co-operation of his bride—else why did she marry him?[15]

The mountains, like art, were a passion with Brown. He enjoyed the rigorous life (he had been active as an athlete while a student at Syracuse),[16] and soon after his arrival in California set out to explore and conquer the deep canyons and high peaks of the Sierra Nevada, including the then remote fast-nessess of what are now Kings Canyon National Park and the John Muir Wilderness.[17]

Perhaps the mountains provided a respite from his work at Stanford. By 1896, the year of his marriage to Lucy, Brown already had the thought that he should, "for a time at least, retire from teaching," and, he wrote, "while I was yet young, go on with my own art, and write out some of the ideas that seem to harass me and of which I seem to be a sort of prophet."[18] Increasingly, he felt frustrated by academic restrictions and disillusioned as to the possibility of creating within the structure of a university the art school of which he had dreamed.

In these same years, he became engrossed with Japanese prints, the finest examples of which he could then purchase inexpensively in San Francisco. Ellen Elliott, who shared her brother's enthusiasm, tells of how Bolton managed to acquire Hiroshige's "Upright Takaido Series":

He was canny enough to find out when the ships were expected that carried them, presented himself at their arrival, and saw the cases opened in the storerooms. For this alacrity his reward was to be given first pick by the dealer and "any one for a dollar." As the "Upright Tokaido Series" comprises fifty-two prints, he may have paid for the whole book five dollars or so.[19]

Brown soon became a serious scholar and collector of Japanese prints, and in 1901 he made a decision finally to break loose from his comfortable but ultimately unsatisfying position at the university. In February 1902, *The Stanford Alumnus* announced that decision:

> Professor Bolton Coit Brown, of the department of Drawing and Painting, has resigned his position on the University faculty to enter the active practice of his profession. As soon as his work here can be put in such a shape as to admit of his departure, he will leave with his family for Japan, there to make a permanent home. The land of the Mikado he terms "the most artistic country in the world," and it is his purpose to study the aesthetic side of Japanese life and ultimately to exercise his own creative ability.[20]

But if this was Brown's intention, he never carried it out. Instead, he went with his family to Woodstock, New York.

He did so as a result of an invitation from Ralph Radcliffe Whitehead, who, aware of Brown's dreams of an ideal art school, sought his help in founding one.[21] An Englishman of wealth, Whitehead had been profoundly affected by the ideas of William Morris and John Ruskin while a student at Oxford in the 1870s. He had since come to America and married a socialite wife, Jane Byrd McCall of Philadelphia (Byrdcliffe's name was to derive from her name as well as his); built an Italianate villa in Montecito, California, on the outskirts of Santa Barbara; published articles advocating the views of Morris and Ruskin; established connections with principal figures in the socialist movements of the day; and determined that he would once again endeavor (he had tried earlier in Europe) to bring about formation of a true community of artists. Whitehead was soon joined by a young novelist, Hervey White, whom he had earlier met at Hull House in Chicago, and together the two men made an abortive attempt at the

founding of an art colony in Oregon. It was after this failure that Whitehead approached Brown, who later described their meeting:

> I had a home in Palo Alto, and functioned as a professor in Stanford University. One day . . . a gentleman appeared in our sitting room, stranger to me, but who presently became this man Whitehead. Art in general and art in particular we discussed and in the end there emerged this colony notion. When we had sounded each other out and came down to cases, he revealed that it was his desire to try to put this idea into effect, somewhere in the east, and offered me a salary to help get it going. His first figure I declined, as also his double of it; but when he tripled it, I accepted. Ours was purely a gentlemen's agreement; no papers were drawn.[22]

It could not have been easy for Lucy Brown, then mother of three small children,[23] to contemplate an exchange of life at Stanford for the speculative and uncertain possibilities of Byrdcliffe, although the salary offered by Whitehead at least gave promise of security greater than she might have found in Japan. "I sold my Palo Alto property," Brown wrote, "boxed my stuff, took the wife and three babies on the overland train for the east. . . . That was in the spring of 1902."[24] He carried with him a letter from President Jordan, who spoke of Brown's effectiveness as a teacher, "rising in many regards to the rank of genius."[25] They parted amicably, though doubtless with mutual relief. Brown was never again to hold a continuing academic appointment; that part of his career was ended. He was thirty-seven years old.

Convinced that for success the new art colony must be located in proximity to New York City, Brown set off to explore the hills of his youth. Late in the spring he found what he thought to be a perfect site, high on a slope in the Catskills, above the village of Woodstock. Whitehead came east, gave approval to Brown's discovery, and returned to California. Brown and Hervey White were left to buy the land and build the colony.

Frictions soon arose. The three men and Jane McCall Whitehead had already disagreed with respect to the structure, aims, and priorities of the colony. But now, as construction began, at enormous cost (all of it Whitehead's money), there was serious trouble. Brown, it turned out, planned an ambitious house of his own. To be called Carniola, it would be a residence of splendor appropriate to the high position he would occupy as director of the school. With its large, sky-

lighted central gallery and its spacious rooms, it would be in every way a worthy rival to Whitehead's own residence, White Pines. Modesty, as has been seen, was not prominent among Brown's virtues, and for his ambition he paid a price. Whitehead quickly decreed that Brown was not to live in the new mansion, but in a smaller house instead, Nor was he to be the school's director; he would now be its "drawing master," no longer in Whitehead's favor. But if Brown suffered from this demotion, even more did Byrdcliffe. However arrogant Brown may have been, he was a gifted teacher and an experienced administrator. Whitehead was neither, and by the fall of 1903 it was evident that the school could not succeed. Brown moved out of Byrdcliffe, down the mountainside. Hervey White also left to found his own version of an art colony, calling it "The Maverick."[26]

Brown now, of necessity, embarked upon the precarious life of a painter. He divided his time between Woodstock and New York City. He painted, exhibited, and during the summer months, taught.[27] As a means of support, he and Lucy were forced to sell many of the fine Japanese prints they had acquired in San Francisco.[28] During this period, Brown undertook extensive research into the materials and techniques of the artist and in 1913 published his first book, *The Painter's Palette and How to Master It*.[29] Then, in the winter of 1914–15, he encountered lithography:

> Passing down Lexington Avenue[30] in New York, I came upon an exhibition of lithographs by Albert Sterner in the gallery of the Berlin Photographic Company. As I now look back . . . it seems to me very likely that seeing those prints furnished just the last push needed to send me, in the spring, off to study lithography in London. Etchings I had made and printed from youth, but to this other art I was as yet a stranger.[31]

During Brown's first weeks in London, he studied the print collection at the British Museum, read extensively on the subject, purchased a copy of Joseph Pennell's newly published book on lithography,[32] and then, this "mental background" established, enrolled in a class taught by F. Ernest Jackson, a prominent member of the Senefelder Club, at the County Council School.

> In the fresh and pleased possession of [Pennell's] treatise I emerged into the lithographic class. It was a mistake. At the sight of it, upon some remark of mine, Professor Jackson glowered, "Joe Pennell knows nothing

whatever about it," he promptly stated. "All he knows he learned standing by my press." . . . I hastened to observe that I knew very little about the gentleman and nothing at all about lithography. But even then something in the atmosphere warned me that a man with Pennell's book under his arm was a dubious person.[33]

After a brief stay in Jackson's class, Brown determined to learn the process in his own way and by himself. He purchased a press, a supply of stones, and other equipment, and installed them on the top floor of a private house where he found a furnished flat. There, in wartime London, he taught himself lithography.[34]

Brown remained in England for a full year, during which time he worked obsessively, day and night. In his meticulously kept technical journal he made almost daily entries describing his problems, false starts, successes, and failures as he sought, largely by informed trial and error, to master the intricacies of an obstinate, difficult process.[35] Later he told a reporter for the *New York Times* that in that "one year he lost twelve pounds in weight and gained two inches across the chest manipulating lithograph stones."[36] It was a formidable undertaking for a man who had by then passed his fiftieth birthday.

On 29 August 1915, Brown made this entry in his journal:

I have been doing a good deal of thinking—in the silent watches of the wakeful night and at other times—about lithography, and I have come to see that I cannot think my way to a mastery of it unless I take it completely apart and get it reduced to its absolute elements. . . . For me, the ideal lithographic print is that which most absolutely reproduces what I draw. . . . This bars all juggling with the printing and playing with it childishly "to see what will happen" (as is declared, erroneously, to be the beloved method of "artists" by Pennell). . . . My business is simple—make what I want on the stone and then print it. Nothing more.[37]

But though the business of the printer, conceived in these terms, is simple in theory, it is far from simple in practice, and the nearly eighty stones which Brown drew, proofed, and printed during his stay in England give testimony to that fact. Some are superb, as the remarkable *Sifting Shadows* (figure 10.2), in which a delicate veil of crayon tones creates a drift of tenuous light across the

10.2. Bolton Brown, *Sifting Shadows*, 1916. Lithograph, 15⅝ × 11¾ in. [Brown 54]. Courtesy of the Syracuse University Art Collection.

flesh of the model; some are comparative failures; some are technical experiments that attest to the range of his study.[38]

By the end of his year abroad, when he returned to the United States, somehow managing to ship his press and equipment as well—this in the midst of World War I—he had indeed mastered the printer's art. Following a period of "rustication" at a family farm on Seneca Lake, he set up his press in Woodstock and began to print again.[39] As in London, his aim was no less than total control over the medium.

It was apparently late in 1918 or early in 1919 that Brown first printed for artists other than himself.[40] He tells of a visit to the galleries of the Brown Robertson Company, then his agents in New York; there he saw a proof of George Bellows' lithograph, *Murder of Edith Cavell.*[41] As Brown relates the story, "the Brown Robertson people were dissatisfied with the printing of Bellows' lithographs . . . [and] said they wished I were printing for him."[42] Brown volunteered his willingness to do so, and arrangements were made for him to meet Bellows at the artist's studio:

> I was there: prints under my arm; George, of course, his usual frank and genial self. . . . Having looked at my prints, he said, "I have the best proof puller in the American Lithographic Company [George C. Miller] and I can't get what you get right along." I asked, "What is the matter? Can't you get what you put on the stone?" "No, that's just what we can't." Then we examined some of his prints: They seemed pathetic; they also seemed puzzling; I couldn't make out how they "got that way." Textures of extraordinary coarseness and black marks quite without autographic quality, not even suggesting lithographic crayon, left me guessing. . . . George said he did not like them but what could he do? "Let me print for you," I answered.[43]

They went on to make arrangements. Brown expected to be paid one dollar an impression, much more than Miller was then charging, but Bellows agreed to it. Brown printed an edition of fifty impressions of "a very rich design, 'Gramercy Park,' "[44] and went on after that to print all of Bellows' work, principally in New York, at Bellows' own lithographic workshop, "a corking little place," which he had installed on a studio balcony on the top floor of his house at 146 East 19th Street.

At about the same time—probably slightly later—arrangements were

made for Brown to give a public demonstration of the lithographic process in the main exhibition gallery at Pratt Institute in Brooklyn:

> I became an exhibit. The walls were covered with my prints. I arranged with John Sloan, George Bellows, Ernest Watson, Albert Sterner, and others, to appear here in public on stated evenings and make a drawing on stone. . . . John Sloan's lithograph was an artistic success: I printed an edition for him.[45] Sterner drew a nude, with a background intended for trees. Bellows evolved a memory of the "men's night class," a chaotic scene—an old stove, easels, one youth consuming a sandwich, another guzzling something out of an upturned bottle, and; as a centerpiece, the nude female model, standing.[46] When, as usual, I put this stone on view with the others, it so shocked the sensibilities of the Institute that someone took it from its place and turned it modestly to the wall. "I don't see what George wanted to go and do a thing like that for," said one. I called George up; he was surprised but let the matter pass. That winter I maintained a press, for public printing, at Mr. Bechtold's place, at 32 Greene Street.[47] I called it the Artists' Press, and claimed that it was the smallest and best press in New York. The plant remained there, functioning at intervals, for several seasons.[48]

At his press in the city—and occasionally in Woodstock during the summer months—Brown printed for Sloan, Sterner, John Taylor Arms, Arthur B. Davies, George William Eggers, Rockwell Kent, Troy Kinney, and others. It was his practice, unlike that of George Miller, to sign in pencil each impression that he printed: "Only perfect impressions will be allowed to leave the shop," he wrote in his announcement of the Artists' Press, "and upon all such I place my signature or seal—which, in time, may come to have a value."[49]

As Brown tells it, Sterner, as well as Bellows, came to him because of dissatisfaction with Miller's printing. This is but one side of the story, however, for there is evidence that many artists preferred to work with Miller.[50] Though both printers were highly skilled, they were polar opposites in style and temperament.

For Bellows, Brown was the perfect printer. The artist drew almost constantly on stone during January, February, and March of 1921, and Brown came regularly to the 19th Street studio to proof and print Bellows' editions. Bellows' daughter Jean describes their collaboration:

I clearly recall the huge printing press in the balcony overlooking the studio . . . and Mr. Brown working at printing the lithographs. The floor was always strewn with discarded prints—which Anne and I would grab to use for drawing paper! I also remember posing for several of the portraits—drawn on large white, thick stones—among the clutter of that upstairs balcony. . . . Bolton Brown was almost like a member of the household—or, at least a part of the house—as he seemed to be always there—working the big press.[51]

To meet Bellows' requirements, Brown made up batches of specially formulated crayons which permitted the artist to achieve the greatest possible tonal range, from a delicate and silky fineness to a deep and velvety black. Bellows himself grained the stones. "By this time," Brown wrote, "we had worked so much together that each knew precisely what his part was and how to play it. We made a gorgeous team. . . . The literary critics do not know it, naturally, but the work I printed for George Bellows constitutes an entirely new chapter in lithography; nothing like it was ever done before, nor could have been, for none of his forerunners had the same materials."[52]

Though Brown kept busy during the winter months as a printer in New York, he looked forward each year to spring and to the opportunity to resume his work as an artist in Woodstock. He usually left the city in April or May and remained in Woodstock through late fall. He had separated from Lucy some years earlier and lived alone. "My housekeeper went away and got married. My children went away and got married. I became a hermit. It is not a good life, but it had in my case some advantages. It left me completely free of any household arrangements other than those related to my work."[53] And work Brown did, completing more than fifty drawings on stone—and printing fifty editions—during an average summer. John Taylor Arms, who spent two weeks working with him in Woodstock during the summer of 1921, described the experience:

We arose early and went forth to draw in the fields, taking with us in a wheelbarrow (which could be up-ended and converted into an excellent easel) those stones whose properties . . . Bolton Brown expounded so ardently. . . . We drew in sunshine and in pouring rain, the latter made possible by the fact that among the literally hundreds of lithographic crayons which Bolton invented and made, were a number with which the artist might draw, with perfect facility, on a stone placed under water. We

came home in the twilight . . . and always, before we went to bed, we sat and talked for a while about the great lithographers of the past, whom we knew and loved as if they were living today. . . . Those days and nights were perhaps the most strenuous, and certainly among the richest, of my professional life.[54]

In his journal, Brown recorded in great detail his experiments in the formulation of lithographic crayons. Inside the cover of the eleventh volume of his journal he inscribed a sentence from John Ruskin: "All art, working with given materials, must propose to itself the objects which, with those materials, are most perfectly attainable." Brown believed as Ruskin did that the materials were paramount: the stone itself, and the crayon that drew on it, *crayonstone,* a total unity. His intent in the lithographs he made was to explore every aspect of the materials that he used, and he did this with such intensity that, as David Tatham has observed, "perhaps the most distinctive quality of his prints considered as a group is a didactic one. Brown's lithographs constitute a long, elaborate, and fascinating lesson in the possibilities of the medium—of kinds of crayons and textures of stones and properties of papers, and the effects of etches, inks, and presswork."[55]

But perhaps, as one looks back at Brown's work as an artist, he was too much the prisoner of principle, too often confined by his knowledge, skills, and convictions. His close friend and fellow artist, George William Eggers, made this observation:

> Emotionally, Brown was the direct heir of the New England poets and the painters of the Hudson River School. The things he loved with an extraordinary love were the things all these men loved: the exquisite detail which fringes the big forms of the Highlands . . . the subtle variety of light that hangs in the Catskills. . . . [But] constituted as he was, Brown's art was inevitably the result of a struggle between two forces: the beloved material of the scene and the stern, exacting science of the craft. He could not be blithe about it as many of his contemporaries were and ride the one and forget the other; he must break the two recalcitrants to the single yoke.[56]

Eggers perfectly characterizes the genuine dilemma of the artist who is also the printer, for all too often art and the craft of printing refuse to mix. This is clearly

seen in Brown's work, particularly in the more "studied" pieces in which he set out to demonstrate his incredible control of silvery tonalities, the satin-smooth line of a newly invented crayon, or the process that he proudly called the "new method in lithography," in which he forced the medium—somewhat uncomfortably and unnaturally—to emulate the wiped plate and retroussage of the etcher.[57]

Weakest among Brown's works are those subjects to which he returned upon the basis of earlier drawings or sketches to reconstruct a fading memory: often the high ranges of the Sierra Nevada which he had left so long before; strongest are the works in which his experience of the subject is most direct. Often these were lithographs made on days when he would draw directly on a stone that he had trundled out into the countryside near his studio. There, perhaps with a firm, pencil-like crayon such as the one he used to draw *Zena Mill* (figure 10.5), he would capture the luminous light and shadow of his immediate surroundings. Such lithographs were made, in Brown's words, with "the incontrovertible and unescapable guidance of the materials themselves. A medium is like Mary's little lamb: if you love it, it will love you."[58]

This love of medium, of craft, of the simple pleasure of surfacing a fine stone, was combined in Brown's best work with his intense powers of close visual observation as filtered through an essentially romantic temperament. It permitted him a range of statements: sparkling, unassuming landscapes; stormy mountain vistas; and tender, nostalgic fantasies, as when at the age of sixty he drew the lovely *Lake Ladies* (Figure 10.6), seated in the sunlight beside a forest stream.

> These lithographs are the result of these attitudes and experiences against a background of early disciplines and memories of landscape drawing—trees, leaves, clouds, earth, rocks, stones, water, air, light—in terms of human design—the whole natural world was mine. I love it all: I always shall. I shall sit around outdoors trying to bring into terms of human design something of the fascination of the way a tree trunk grows, the land lies, the foliage hangs and shatters the glittering sunshine, the fall of shadows in fantastic patterns, the gleam of the white body of the bather among the dark rocks—these are my simple pleasures. In these I shall live and die.[59]

Brown worked intensively with Bellows during the winter of 1923–24, then in the summer of 1924 moved into his new studio at Zena, just east of

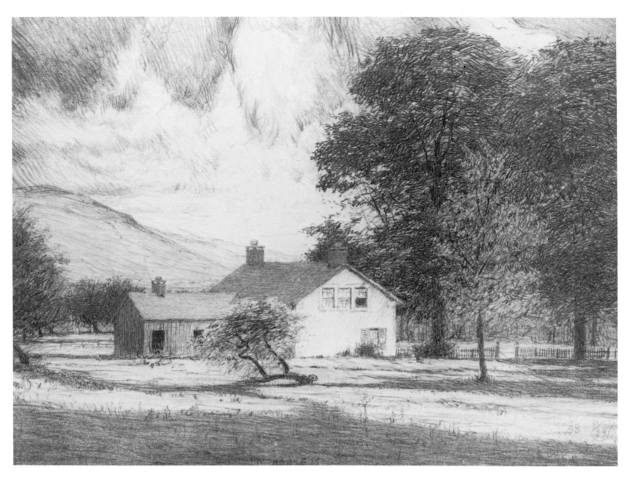

10.3. Bolton Brown, *My House,* 1921. Lithograph, 10 × 13⅜ in. [Brown 291]. Courtesy of the Syracuse University Art Collection.

10.4. Bolton Brown, *My Pasture*, 1922. Lithograph, 12⅝ × 9 in. [Brown 343]. Courtesy of the Syracuse University Art Collection.

10.5. Bolton Brown, *Zena Mill*, 1923. Lithograph, 12½ × 9⅞ in. [Brown 491]. Courtesy of the Syracuse University Art Collection.

10.6. Bolton Brown, *Lake Ladies*, 1924. Lithograph, 8½ × 12 in. [Brown 564]. Courtesy of the Syracuse University Art Collection.

Woodstock.[60] By late fall of that year he had entered in his journal more than 560 lithographs completed during the ten years that had passed since his studies in London. Then, suddenly, in January 1925, Brown received an emotional blow: George Bellows died at the age of forty-two, a victim of peritonitis following surgery. It is as if Bellows' death also signaled the end of Brown's work as a creative artist-lithographer, for although he continued to work during the summer of that year, it was seldom with his earlier intensity. The entries in his journals became sporadic, sketchy, and disorganized, then came abruptly to a stop.

Brown seldom worked on stone again after 1925, though he was still much occupied with lithography. He set out to write a book in which he would summarize his experience in the medium. "Books telling how to make an etching have been published in considerable numbers," he wrote, "but of works intended to enable an artist to make a lithograph, with his own hands, there exists not one."[61] He determined to fill that gap, and in the process produced a detailed account of the lithographic process. In the writing of the book he drew heavily upon the technical notes he had entered in his journal over a period of more than ten years, and wrote with the aim to "offer this book to my fellow-artists knowing that none can get out of lithography all there is in it unless he does his own printing—and does it fully understanding the resources of the craft."[62]

It is likely that the book was substantially completed by 1926 or 1927. Brown then sought over a period of time to find a publisher either in England or the United States. He was not successful in doing so, for even those who were interested in the manuscript—Erhard Weyhe among them—felt that the number of prospective purchasers of so technical a treatise was too small to justify its publication. Time passed. Then, in the late 1920s, he received a letter from Robert B. Harshe, director of the Art Institute of Chicago, who wished to visit him in Woodstock:

It was arranged and presently this gentleman and his son drove into my maple-shaded door yard. We sat on the front porch, talking and looking at prints and at the manuscript of the book. It was, he said, his wish to have one series of the Scammon lectures devoted to lithography and he wanted me to be the man that gave that series. I was reluctant, because as I pointed out, I had not enough to say, to a general audience, to occupy the six hours of the Scammon lectures. He steadily overrode me on that point, and in

the end the tentative agreement was reached that I was to give the lectures.[63]

It was agreed, furthermore, that Brown's book on lithography would be printed in place of the text of lectures he would give. This agreement was reached, however, only after an argument about money and, more important to Brown, about his right to control the editing of the book. Harshe, who was himself an etcher, was concerned about what he felt to be an undue attack upon Joseph Pennell, a former Scammon lecturer. Brown was equally concerned that the manuscript be published unchanged:

> What I had written was not an "attack" [on Pennell], but merely a correct statement of an important fact, namely that, "when Mr. Pennell writes that 'you can do anything on paper that you can do on stone," he writes what is not true." If this statement were true it would be a very important truth, but as it is not true it becomes simply an important lie. . . . Pennell had been playing the devil with lithography for years and I was the man that knew of it, and it was not right that I should be choked off from saying so.[64]

Ultimately, in order to secure the book's publication, Brown was forced to give in. "Under clear and strong protest, I formally signed over to the Institute the right to edit, that is, to change, my book in any way it pleased."[65] Much as Brown resented this, when he received the galley proofs he found that they were essentially unchanged from what he had written. "The words 'not true' were translated into 'mistakenly,' and that was all. The whole fuss had been about nothing."[66]

Brown delivered the Scammon lectures early in 1929 and agreed to return to Chicago in February 1930 to instruct a special course in lithography at the School of Art Institute.[67] While Brown was in Chicago for the class, the Albert Roullier Gallery arranged to hold an exhibition of his lithographs, an exhibition which proved to be financially the most successful of his career.

Lithography was not then a part of the curriculum at the Art Institute, although etching had been taught there for some time. It was necessary to equip a small workshop to accommodate the class that Brown would instruct:

> Brown conducted the class with great vigor and enthusiasm. He was very specific about the technical aspects of lithography. . . . Members of the class made their own crayons and tusche. . . . The mixture had to be cooked for an extended period and it let off a heavy sweet smell which penetrated throughout the area. . . . Because of this, it had to be cooked on Saturdays when there was no school in session in that part of the building.[68]

Though the class was small and lasted only for a period of weeks, the combined effect of this class, the publication of Brown's book in 1930, and of the apprentice-students accepted by Brown in his Woodstock studio during the late 1920s and early 1930s was to have an immense influence upon the development of American lithography in subsequent years.[69]

In the Epilogue of his book Brown summarized his reflections about the medium to which he had contributed so much:

> What excites me [is] not what has been, however fine, but what might be. This is what makes me a missionary. . . . Here is an art of which we have but touched the hem of the garment. . . . Bellows is the only one who has taken it up wholeheartedly and shown something of what it can do. I mean, besides myself. The resources of the thing, as a method, are most fully demonstrated in my own prints, taken as a total, not in any one print. . . .
>
> I have peddled it, written it, exhibited it, hawked it and talked it, lectured it, "demonstrated" it, and done it. Wherewith, I make my bow.[70]

He went back to Woodstock and in his last years lived a lonely and impoverished life. He made very few lithographs.[71] He set up ceramic kilns and gave himself over to the making of pottery. He wrote still another book, a history of lithography since Whistler, containing an account of his own ten years in lithography and a scathing chapter, "Pennellism and the Pennells," in which he set out once and for all to debunk the Pennell "myth" and to contest the notion that transfer lithography—as practiced by Pennell—could ever be more than a mere shadow of his beloved crayonstone. It was not published in his lifetime.[72]

On November 27, 1934, Brown reached his seventieth birthday. His health was failing; his work, he felt, was accomplished. His recent winters had

been "spent in a small Southern village in South Carolina." There, his sister Ellen wrote, "he mingles sociably with the people of the tiny community, Negroes and Whites (minority), relates what was said and done, makes drawings, quite often 'the best I have done in this medium.' Finds one girl . . . [and] teaches her to draw and paint—and think (if possible). The chocolate colored hound dog wanders in and out. He goes to a service in the Negro Church and gets a tremendous thrill out of that."[73]

Brown prepared for his death as he had prepared for everything: methodically and carefully. He arranged for a large boulder to be taken from the Sawkill River to the artists' cemetery in Woodstock, where, despite his illness, he personally saw to its placement and carved his name into the rock. It would rest upon his grave. He summoned Victor Lasher, the local undertaker, and instructed him. When he died, Brown insisted, there was to be no fuss; he was to be rolled in a blanket and taken to his grave.

> Victor agreed to do as he wished and then, like all of us in the Depression years, they dickered about the price. Bolton had very little money and he didn't want to saddle his wife and daughter with a large funeral bill. He didn't even want a hearse. "Just put me in the back of your pick up truck, take me to the cemetery and put me in.[74]

Summer moved to its end, and on September 15, 1936, Bolton Brown died at the age of seventy-one. But if he truly wished to be carted off, unceremoniously and somewhat surreptitiously, that was not to be. True, a casket was not used. "He was buried at sundown yesterday," the *New York Times* reported, "on a pallet made of white birch by his son-in-law, Lloyd Woods of Zena."[75] The funeral was an echo and reminder of Woodstock's early days. Hervey White, with whom Brown had shared the Byrdcliffe adventure, was among the pall bearers; the others were his long-time artist friends, John Carlsen, Carl S. Linden, and Henry Lee McFee. A large gathering was at the graveside and, though Lucy Brown knew that Bolton would not have wanted it, she asked the Reverend Todd of the Dutch Reformed Church to conduct a brief service there.

During his last years, Brown had formed a friendship with Grant Arnold, a much younger artist-lithographer who had been printing for local artists in Woodstock since the summer of 1929.[76] Following Brown's death, Arnold bought from Lucy Brown the Fuchs and Lang press—Brown's "American press,"

as he called it—most of his stones, and his stock of papers. Brown's voluminous, handwritten journals and the manuscript of his unpublished book, "Lithography Since Whistler," she placed in the hands of John Taylor Arms. "These volumes," Arms later wrote in a memorial tribute to his friend,[77] "now [repose] in my library awaiting a proper repository where they will do the most good.[78] [They] contain the whole technical story of what has been discovered about lithography up to the present time . . . [and] constitute a truly remarkable monument."[79]

> A strong man, with strong convictions, he fought always against weakness, ineptitude, and insincerity. . . . With unlimited inclination and capacity for work, he expected the same from all serious minded people. He was not known to his fellows as he should have been, for he gave his friendship not easily but only to those he believed would value it and give him of their best in return, but those he did admit to his world found in him a forceful and courageous spirit, strong for honesty and truth, kindly in his judgments, generous in his nature, unfailing in his loyalty, profound in his knowledge.[80]

NOTES

1. Miller first opened his workshop in 1917 but later closed it during a period of service in the Navy. Brown set up his press during the winter of 1918–19.

2. See Janet Flint, *George Miller and American Lithography* (Washington: Smithsonian Institution Press, 1976); Alfred P. Maurice, "George C. Miller and Son," *American Art Review* 3 (March–April 1976): 133–44; E. W. Watson, "George Miller, Godfather to Lithography," *American Artist* 7 (June 1943): 13–15; and Stow Wengenroth and Lynd Ward, "George C. Miller, Master-printer: Tribute to a Lithographic Craftsman," *American Artist* 30 (May 1966): 12–13.

3. Between 1938 and 1979, the work of Bolton Brown received little attention. Since then the following have appeared: Dale S. Phillips, "Bolton Brown: A Reminiscence," *Tamarind Papers* 2 (Spring 1979): 34–35; Alf Evers, "Bolton Brown, Artist-Explorer of the Catskills," *Catskill Center News* (Arkville, N.Y., Winter 1981): 12–13; *Bolton Brown, Lithographer* (Syracuse: Lowe Art Gallery,

Syracuse University, 1981), introduction by David Tatham; Rosemarie Romano, "Bolton Brown, A Preliminary Bibliography," mimeographed (Syracuse: Department of Fine Arts, Syracuse University, 1981); and Clinton Adams, *The Woodstock Ambience, 1917–1939* (Albuquerque: University of New Mexico, 1981).

4. I have relied heavily upon correspondence and interviews in the writing of this paper. I am indebted to all whose names are cited in the footnotes; to three members of Bolton Brown's family: his daughter, the late Marian Brown Woods, and his granddaughters, Millicent Coleman and Marian S. Sweeney; and additionally to Grant Arnold, Jean Bellows Booth, Peggy Coesfeld, Alf Evers, Bernard Karpel, Samuel S. Klein, Lauris Mason, Dale S. Phillips, Andrée Ruellan, Arnold Singer, David Tatham, and Ralph Wickiser. The primary sources of information about Brown's work as an artist-lithographer are his journals and unpublished papers now in the John Taylor Arms Collection, gift of Ward and Mariam Coffin Canaday '06, Bryn Mawr College Library. The whereabouts of these papers has long been unknown (see note 78 below). I am deeply grateful to those who assisted me to locate and study them: Jeff Earl, Wooster, Ohio; S. William Pelletier, Athens, Ga.; and Leo M. Dolenski, manuscripts librarian, Bryn Mawr College, Bryn Mawr, Penn.

5. On June 15, 1920, in celebration of its fiftieth year class, Syracuse University awarded forty-one honorary degrees. Bolton Brown, the only artist so honored, was one of four to receive the Doctor of Literature degree. Citations and correspondence related to these degrees are missing from the Syracuse archives, possibly as a result of a later fire in the registrar's office.

6. Bolton Brown, *Lithography for Artists* (Chicago: University of Chicago Press, 1930).

7. Brown was born on November 27, 1864, son of the Reverend Edmund Woodward and Martha Day Coit Brown. His ancestors had come to America in 1635; his great-great-grandfather Peter Woodward was a lieutenant on George Washington's staff.

8. Brown's first book, *The Painter's Palette and How to Master It* (New York: Baker & Taylor, 1913), bears this dedication to his mother.

9. *Catalogue of an Exhibition of Lithographs by Bolton Brown, with an Introduction and Notes on the prints exhibited, by the Artist* (New York: FitzRoy Carrington, 1924), pp. 2–3 (hereafter cited as *Catalogue Notes*).

10. Ellen Coit Elliott, *It Happened This Way* (Palo Alto: Stanford University Press, 1940), p. 31.

11. Brown was appointed instructor in 1891, assistant professor in 1892, associate professor in 1894, and professor and head in 1895; he served in that capacity until his resignation in 1901.

12. Elliott, *It Happened This Way*, p. 199. Brown set forth his views in detail in an article, "What An Art School Should Be," *Overland*, 2nd. ser., 19 (March 1892): 301–17.

13. Brown to Jordan, January 1900. Stanford University Archives, David Starr Jordan Papers, SC58, pp. 20–21.

14. Ibid., pp. 14–15.

15. Elliott, *It Happened This Way*, p. 256. Lucy Fletcher Brown also found her place on maps of the Sierra Nevada. Lucy's Foot Pass is a high pass across the Kings-Kern divide, west of Mt. Ericsson.

16. In 1935, at the age of seventy-one, when Brown responded to a Syracuse alumni questionnaire, he proudly wrote: "I am the man that *started* athletics at S.U. Instigated the *first* field day. Held five track records when graduated." Syracuse University Archives.

17. Mt. Bolton Coit Brown, elevation 13,538 feet, is on the divide between Kings Canyon National Park and the John Muir Wilderness, south of the Palisade peaks. Brown wrote extensively of his mountaineering experiences, including a number of articles in the *Sierra Club Bulletin*.

18. Brown to Jordan, November 14, 1896. Stanford University Archives, David Starr Jordan Papers, SC58, pp. 5–6.

19. Elliott, *It Happened This Way*, p. 254.

20. *The Stanford Alumnus* (February 1902), p. 70.

21. In later accounts of his move to Woodstock, Brown made no mention of his earlier intention to move to Japan, apparently content to give the impression that he resigned from the Stanford faculty as a consequence of Whitehead's invitation. See Bolton Brown, "Early Days at Woodstock," *Publications of the Woodstock Historical Society* 13 (August–September 1937): 3–14.

22. Brown, "Early Days at Woodstock," pp. 3–4.

23. Eleanor, born May 25, 1897; Marian, born June 2, 1900; and Robert, born July 19, 1901.

24. Brown, "Early Days at Woodstock," p. 4.

25. Letter, February 19, 1901. This letter, with others, is included in a printed resumé apparently prepared by Brown in 1906 or later. Archives of the Woodstock Artists Association.

26. For a description of the rise and fall of the Byrdcliffe Art Colony, see Karel Ann Marling, *Woodstock: An American Art Colony, 1902–1977* (Poughkeepsie, N.Y.: Vassar College Art Gallery, 1977), unpaged. In her account of the first meeting between Whitehead and Brown, Marling states that Brown's "work in lithography was well known." This statement and the date ascribed to Brown's lithograph, *Sylvia,* "ca. 1905," are incorrect; Brown made no lithographs before 1915; *Sylvia* was drawn in 1924–25.

27. In 1906 Brown published a flyer announcing a Summer Art School in Woodstock, where he would "offer expert instruction in the theory and practice of the fine arts of Drawing, Painting, Designing, Composition, and Harmonious Coloring" at a fee of "twenty dollars each four weeks."

28. Brown published an advertisement in *International Studio* (June 1905) announcing a "Sale of Old Japanese Prints: Important Private Collection" at his studio, 51 West Tenth Street. Lucy Fletcher Brown later opened a business in New York City as a dealer in Oriental art and maintained it for some years.

29. See note 8.

30. Brown's memory is at fault; the Berlin Photographic Company was located at 305 Madison Avenue.

31. Bolton Brown, "My Ten Years in Lithography," *Tamarind Papers* 5 (Winter 1981–82): 9. This autobiographical account of Brown's work in lithography is one section of a manuscript, "Lithography Since Whistler," in the John Taylor Arms Collection, gift of Ward and Mariam Coffin Canaday '06, Bryn Mawr College Library. The Manuscript consists of a total of 169 typewritten, double-spaced pages and is dated 1933. "My Ten Years" was published in *Tamarind Papers,* with an introduction and notes by Clinton Adams, by kind permission of Bryn Mawr College Library.

32. Brown could refer either to Joseph Pennell, *Lithography* (New York: Frederick Keppel & Co., 1912) or, more likely, to the revised edition of *Lithography and Lithographers*, written by Pennell in collaboration with his wife, Elizabeth Robins Pennell (New York: Macmillan, 1915).

33. Brown, "My Ten Years," pp. 9–10.

34. On the basis of a statement made by Frederick N. Price in "The Etchings and Lithographs of Arthur B. Davies," *Prints* 1 (November 1930): 8, and later repeated elsewhere, it has been incorrectly assumed that Brown studied lithography with Thomas Way. He did not.

35. The journal in which Brown recorded his lithographs and technical studies, together with occasional observations on other subjects, is in twelve handwritten volumes, containing a total of 814 pages (hereafter cited as Journal). John Taylor Arms Collection, gift of Ward and Mariam Coffin Canaday '06, Bryn Mawr College Library.

36. *New York Times*, March 9, 1922, p. 16.

37. Brown, Journal 2:57 (entry dated August 29, 1915).

38. Brown assigned a serial number to each lithograph. The serial number was usually written within the image on the stone and encircled. A separate series of numbers appears on some lithographs, not encircled, and often prefaced by the letter "C"; these numbers, which should not be confused with the serial numbers, refer to crayon formulas given in his Journal.

39. Brown returned from London to the United States in May 1916. During the summers of 1917 and 1918 he worked extensively in lithography in his studio at Zena (near Woodstock) and completed about seventy-five stones. The dating of his Journal entries during this period is unclear.

40. Brown seldom made note in his Journal of printing done for other artists. The principal source of information as to the dates at which he first printed for Bellows, Sterner, and other artists is "My Ten Years." In that account, however, Brown does not always put dates to events, nor does he always discuss events in the order in which they took place. In "My Ten Years" he describes the demonstration at Pratt Institute before mentioning his visit to Bellows' studio, although his wording strongly suggests that the visit came first, either late in 1918 or in January or February of 1919.

41. Mason places this print (Mason 53) in 1918. Lauris Mason, *The Lithographs of George Bellows: A Catalogue Raisonné* (Millwood, N.Y.: KTO Press, 1977).

42. Brown, "My Ten Years," p. 38.

43. Ibid.

44. There is no lithograph in Bellows' oeuvre titled *Gramercy Park*, nor has it been possible thus far to identify with certainty any of Bellows' lithographs as the one printed by Brown on this occasion.

45. Sloan's lithograph was *Saturday Afternoon on the Roof*. Reproduced in Peter Morse, *John Sloan's Prints* (New Haven: Yale University Press, 1969), p. 217.

46. Brown's description of Bellows' image corresponds in every detail to the lithograph which Mason titled, *The Life Class, First Stone* (Mason 8), previously thought to have been one of Bellows' earliest lithographs. It appears, instead, that this is the lithograph printed by Brown at Pratt Institute in 1919.

47. Louis Bechtold was president of the Senefelder Litho Stone Company.

48. Brown, "My Ten Years," p. 18–19.

49. Bolton Brown, "Lithography: Advertisement of The Artists' Press," (New York: May 1919), two pages.

50. Sterner spoke of Brown as "too damned fussy" (Brown, "My Ten Years," p. 38), and Davies, after working with Brown, chose Miller as his printer.

51. Jean Bellows Booth to Adams, August 8, 1978.

52. Brown, "My Ten Years," p. 39.

53. Ibid., p. 47. Bolton and Lucy Brown had separated before Brown's year in England and long before the children were of an age to marry.

54. John Taylor Arms, "Bolton Brown: The Artist and the Man," in *Catalogue of Lithographs by Bolton Brown* (New York: Kleeman Galleries, 1938), unpaged.

55. David Tatham, *Bolton Brown, Lithographer,* (Syracuse: Lowe Art Gallery, 1981), unpaged.

56. George William Eggers, "A Brief Essay on Bolton Brown," in *Memorial Exhibition of the Works of Bolton Brown* (Woodstock, N.Y.: Woodstock Art Gallery, 1937), unpaged.

57. Brown wrote in *Catalogue Notes*, p. 16: "I have had the pleasure of inventing a usage by which one may 'assist the drawing', with results comparable to 'retroussage' in etching. . . . Senefelder left little for anybody to invent, but he did leave this, and completely. Neither in his work nor that of any who have followed him is there so much as a hint of anything like this. At present, it is my own secret. When my book on the technique of artistic lithography comes out, I expect to describe it." See also Brown, *Lithography for Artists*, pp. 66–67.

58. Brown, *Catalogue Notes*, p. 4.

59. Ibid.

60. 1923 and 1924 were active years for Brown: during that two-year period he created more than 200 lithographs. His second book, *Lithography*, an essay on the character and qualities of the medium (27 pages), was published in 1923 (New York: FitzRoy Carrington). In 1924 a large exhibition of his lithographs was presented at Carrington's gallery on Fifth Avenue in New York.

61. Brown, *Lithography for Artists*, p. 1.

62. Ibid., p. 2.

63. Brown, "My Ten Years," p. 46.

64. Ibid., p. 51. Harshe's sensitivity to Brown's criticism of Pennell may have been conditioned by Pennell's death on April 23, 1926.

65. Ibid.

66. Ibid.

67. In 1920, in the sixth of his Scammon Lectures, Pennell had congratulated George William Eggers, then director of the Art Institute of Chicago, on his intention to establish a "School of Lithography" (Joseph Pennell, *The Graphic Arts: Modern Men and Modern Methods* [Chicago: University of Chicago Press, 1921], p. 276). Even so, when Brown went to Chicago lithography was not taught at the School of the Art Institute.

68. Merlin F. Pollock to Adams, July 6, 1981. Pollock remembers the class as having had no more than eight students, among them Pollock, Francis Chapin, William Dickerson, Davenport Griffin, and Theodore Roszak.

69. When Brown's workshop ended, Francis Chapin became instructor in lithography at the School of the Art Institute; many of the artist-lithographers active in the midwest during the 1930s

and 1940s studied with Chapin or with his students who taught elsewhere. William Dickerson participated in the Prairie Print Makers in Wichita, Kansas, and printed for artists there. Among Brown's apprentice-students in Woodstock were (1) Theodore "Ted" Wahl, later a lithographic printer at the graphic arts workshops of the Federal Art Project in New York and Newark. Wahl also served as lithographic technician for a class at the Colorado Springs Fine Arts Center in which Lawrence Barrett was a student. As a printer he collaborated with many artists, notably Jackson Pollock; (2) S. Dale Phillips, an artist-teacher of lithography at Iowa State University, and a printer for artists there; and (3) Albert W. Barker, whose work as an artist-lithographer was closely related to Brown's. Brown's book, *Lithography for Artists*, was the principal reference in the field for a number of years following its publication.

70. Brown, *Lithography for Artists*, p. 87.

71. Entries in Brown's Journal suggest that he completed fewer than fifteen lithographs after July 1925. The last entry which refers to a lithograph by a serial number (608) is dated August 7, 1932.

72. "Pennellism and the Pennells" was first published (slightly abridged) in *Tamarind Papers* 7 (1984): 49–71. Aside from "My Ten Years in Lithography" and "Pennellism and the Pennells," the other sections of Brown's manuscript are "Senefelder Brings the Art into Existence," "The Old Lithography," and "Conclusion." See note 31.

73. Ellen Coit Elliott to H. C. Reed, September 26, 1950. Department of Manuscripts and University Archives, Cornell University Libraries, No. 1580.

74. Grant Arnold, "Woodstock: The Everlasting Hills," unpublished manuscript, p. 121.

75. *New York Times*, September 17, 1936, p. 23.

76. See Clinton Adams, "Grant Arnold, Lithographer: New York and Woodstock, 1928 to 1940," *Tamarind Papers* 3 (Spring 1980): 38–43.

77. Following Brown's death, three memorial exhibitions were held: New York Public Library, December 1936–January 1937; Woodstock Art Gallery, September–October 1937; and Kleeman Galleries, New York, January 1938.

78. Subsequently, the papers which Lucy Brown placed in Arms' keeping were acquired by Ward and Mariam Coffin Canaday, who then gave them as a part of the "John Taylor Arms Collection" to Bryn Mawr College Library. At Bryn Mawr they were for some years catalogued under Arms' name and were not until recently identified as the papers of Bolton Brown.

79. Arms, "Bolton Brown," unpaged.

80. Ibid.

11

Grace Woodworth's Portrait
of Susan B. Anthony
"Outside the Common Lines"

AMY S. DOHERTY

Late in the nineteenth century, photographic images printed by photomechanical means began to replace wood engravings as the major means of reproducing portraits in books and periodicals. One important but little-known example of this alliance of photography and pictorial printing is the portrait of a major figure of the women's rights movement, Susan B. Anthony, taken from a photograph by Grace Woodworth.

On February 15, 1905, Grace received as a gift two volumes of the three-volume set of *The Life and Work of Susan B. Anthony*. On the flyleaf of the first volume was written:

> As a slight token of my thankfulness for the beautiful photographs of myself and my sister Mary, I present these volumes. Affectionately yours, Susan B. Anthony.

Volume II contained the inscription:

> This is given in slight recognition of my pleasure at your success in the art of photography. I rejoice over every young woman who achieves an accomplishment in any direction outside the common lines. With the best wishes of your friend, Susan B. Anthony.

243

Grace never received a copy of the third volume, the one in which she was most interested:

> After receiving the first two volumes from Miss Anthony I could not succeed in buying the 3rd volume of her life. However, after the convention held here in 1923 I met Mrs. Ida Husted Harper, Miss Anthony's biographer, who said she was having a volume sent me from the publishers with her compliments. This last volume contains the photograph which I made.[1]

Grace Adelle Woodworth was born in Seneca Falls on March 17, 1872. Her father, Josiah C. Woodworth, was in the dry goods business in partnership with one of his brothers, A. O. Woodworth. In 1851 the partnership was dissolved due to the ill health of A. O. Woodworth, and Josiah carried on the business with another partner, Henry T. Seymour, until 1880. Prior to entering the dry goods business, Josiah had taught "common school" or at least had been licensed to teach for the years 1840 through 1842. After giving up the dry goods business he traveled extensively for the firm of Rumsey and Company and later for the Rising Sun Yeast Company. He neither drank nor smoked and Grace was herself a member of the Seneca Falls Christian Temperance Union. Josiah was of a scholarly nature and recorded in 1858 the titles of the eighty-three books in his library. Another brother, Stephen A. Woodworth, was one of the signers of the Declaration of Sentiments presented at the first Women's Rights Convention held in Seneca Falls in 1848. Josiah retired from business in 1890 and died at the age of 83 on May 1, 1906.

In 1963, at the age of 91, Grace granted an interview to the local paper:

> She remembers her father, Josiah Woodworth who once had a drygoods store on Fall Street. She recalled the high ceilinged rooms where all the sounds of life in a household seemed to converge, echo, retreat and return. She can describe a whole series of scenes by heart. Standing tiptoe in the north bedroom to see her mother's new baby, sleeping by the hot kitchen stove when you had croup in the winter, and running breathless and scared past a dim old barn that used to stand on the property because a hired man for a joke told her one day that he would feed her to the horses.[2]

Grace's mother was Edna A. Woodworth. Grace had two sisters—Edith, who married a Mr. Kirkpatrick and moved to Peoria, Illinois, and Jeannie, three years older than she, who was also supposedly interested in photography and may have worked with Grace at some time during their lives, although no evidence has been found to support this view. Her brother, Elmer, made his home in Seneca Falls.

Of Grace's early life in Seneca Falls only a few stray details are known—a Sunday school library card filled with notations of books checked out, and a small book dated 1891 when Grace was eighteen years old, describing "square dances and round dances with special descriptions of particular square dance figures." She must have been a child who liked to read, or at least liked to check books out of a library, as well as a young girl who liked to dance and wanted to be sure she knew all the latest figures. Another clue to her early life comes from the newspaper interview—"as a girl she loved to paint. Another memory is of her brother putting his feet through some of her paintings as they leaned against a fence"[3]—a strong memory to be retained by Grace into old age. One wonders at the scene which must have followed. Grace in tears running to her mother, Elmer defiant or contrite? Were Grace's artistic efforts considered seriously? Judging from her background one suspects that she was taken seriously and received a great deal of support from her family.

"Photography came naturally to her," the article continues, "and she studied it seriously after working as a retoucher for a photographer in Batavia. Soon other photographers who saw the girl's work told her that she was good enough to strike out on her own and she took their advice." Photography "was one of the few businesses that a woman was permitted to engage in. And if you were restless, as she was, it allowed you to roam a little."[4]

A further picture of Grace begins to emerge: a child who liked to read, a girl who liked to dance, and a woman with a restless, adventurous spirit.

In 1897, at the age of twenty-five, Grace purchased the photo studio of George H. Richards in Union Springs, New York. Did she save enough for the purchase on her own or did her family advance her the money? At any rate a clipping from the Union Springs *Advertizer* of May 13, 1897, reads,

Miss Woodworth is a young lady of several years experience in the photographic business and in conducting a first class studio, here gives to the public an opportunity to obtain photos in any of the latest styles or finish,

at the lowest prices that first class work can be made. You are invited to call at the studio and examine work, and also to become acquainted.[5]

After about two years of running her studio at Union Springs she moved to Rochester, New York, where she purchased the well-known photographic gallery of Ranger and Whitmore at 30 Main Street East.

Woodworth Studio Opening. An informal reception Tuesday afternoon and evening. Attractive work displayed. Souvenirs given. 30 Main Street East. Formerly Ranger and Whitmore.[6]

In Rochester she boarded on Alexander Street with a Quaker family "who regularly attended the Unitarian Church." Grace accompanied them to church, and it was there that she first met Susan B. Anthony, who had been born and educated as a Quaker and was a friend of Grace's boarding family.

Grace was obviously impressed by Susan B. Anthony. Draft after draft exists of an article describing her meeting and first visit with Susan and Mary Anthony.

In meeting Miss Anthony she seemed only a sweet lovable old lady with cordial friendly manner and wonderful smile that relieved her rather severe mouth and square chin. Her blue eyes behind her spectacles were keen and kind and her voice gentle.

Grace's article goes on to describe her first visit to the Anthony home.

The first time I went out to Miss Anthony's home I called by appointment in the late afternoon. Miss Susan admitted me herself and conducted me to the living room, where she and her sister were sitting in their confortable old rocking chairs, before a cheerful blaze in the fireplace, knitting. I had a very lovely visit with these pleasant social old ladies, in their large home, with fine old furniture, many books, pictures, and magazines, and a flood of light.

Miss Susan entertained me with a book of photographs of herself

made at many places and times and I asked her to allow me to add one more to her collection, but she said she and her sister were too old for any more pictures. She was then 85. So we talked of many things, their trip abroad, where she was received like a queen and entertained by royalty and honored by all the crowned heads, and of Seneca Falls and her remembrance of many pleasant visits here with Elizabeth Cady Stanton; and of my people and Miss Anthony recalled my father and that his brother was one of the signers of the first Declaration of Rights here. Then, unexpectedly, Miss Anthony told me that because I was from Seneca Falls and because I was a woman in business, they would come to my studio and have me make the appointed last photographs. Miss Susan asked me if I wanted her to wear her garnet velvet dress for "state occasions" or her black satin, but I left the choice with her. I told them I would send a carriage for them and Miss Susan said, "O no, don't send a carriage for us, save your money, we can come on the street car just as well and prefer it."

They came exactly at the time appointed. Miss Anthony wore her velvet with the old rose point lace, which she told me she had had for 22 years. Her white hair was parted in the middle and rolled over her side combs, and over her shoulders, she wore her well-known little red shawl, under her black silk wrap. She laid aside her bonnet very carefully and said "now you must make us look very handsome" and we started to work. I made photographs of both Miss Susan and Miss Mary separately and together. When Miss Anthony thought I had exposed the last plate she dropped into the relaxed attitude of the pose her friends chose. The reporters heard of the making of the negatives, it's a way they have, and there was an avalanche of calls for prints, but I had promised Miss Anthony the inspection of the proofs before any were finished. When I took them to her she said she could not tell how she looked and asked me to take them to Mr. & Mrs. Garnett, a Unitarian minister to select one. I have several personal letters from Miss Anthony. One concerning the photographs, she says, "Your photographs of my sister Mary and me together are excellent, but those taken separately, it seems to me are not so perfect. The fault was in both of ourselves, not in the picturetaker, unless you could have made us look better and different,—but they please the friends exceedingly and it is the friends who are the best judges after all. They are beautifully taken,—if you succeed as well with others you will give the best of satisfaction. Yours sincerely, Susan B. Anthony."

At a later time in January, she wrote at the end of a letter, "I do wish I could sit or stand for some pictures full length, but I am too lazy to get dressed and go down to your studio, but maybe if I live till warm

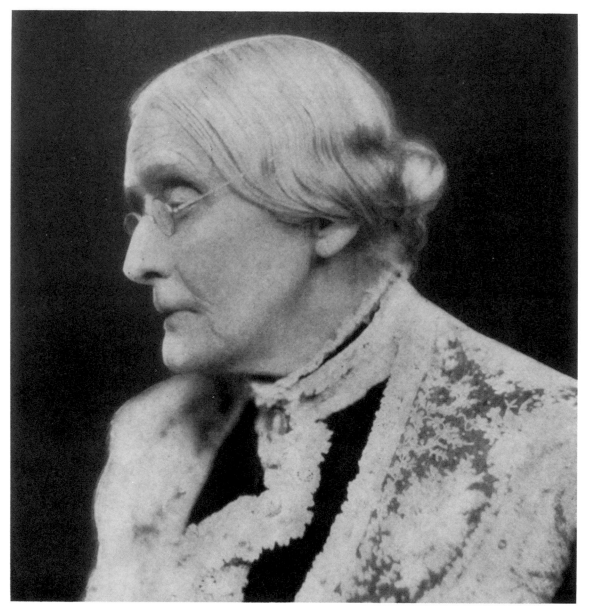

11.1 Grace A. Woodworth, *She Gave Her Life for Women*, portrait of Susan B. Anthony. Published in Ida Husted Harper, *The Life and Work of Susan B. Anthony*, vol. 3 (Indianapolis: The Hollenbeck Press, 1908).

weather comes I will accomplish the feat." But she did not live till warm weather; she died two months later in March 1906.

One time when Miss Anthony invited me to her home for supper, I was the only guest and Miss Susan sat at the head of the table and poured the tea from a beautiful old silver teapot into china cups that were part of her mother's wedding dowry. I sat at Miss Susan's left and her sister Mary sat at her right in their usual places. The serving was done by a maid. They were so very hospitable that extra places were always laid ready for an unexpected guest. They were made to feel at home, never any fuss about company, but sometimes they were short of food. When Miss Susan found a poor person at the back door she never turned anyone away from the house hungry.

But it made little difference whether the food was elaborate or plain, when Miss Anthony and Miss Mary were at the table, as they talked of their experiences and some of the great people of the world, as one talks of personal friends. After supper they showed me the study where so much writing was done and where their mother's little spinning wheel stood by the side of the desk and Miss Susan showed me the sampler and the quilt she made when she was eleven. When I was coming away she presented me with the two volumes of her biography and set down at her desk and inscribed the front page of each volume.

Miss Anthony was at all time kindness itself to me and at her reception would pass me down the line as "My Photographer." At a very large reception at the Powers Hotel she kept me by her for some time and through her I met most of the notable women associated with her, Rev. Anna Howard Shaw, Mrs. Carrie Chapman Catt, Harriet Stanton Black [*sic*] and her daughter and many others whose names are familiar.[7]

Around 1912 Grace moved back to Seneca Falls and opened her final studio on the main street in town, at 85 Fall Street. Here she was to work at her craft until finally one day in the thirties "she just stopped working and relaxed around the house. . . . She says she enjoyed it so much she'd been doing it ever since."[8]

Grace apparently had a good business sense, probably inherited from her father, and was not at all shy about advertising the studio and her abilities as a photographer. Nor was she reticent about charging for her work, as the following letter dated June 22, 1921, indicates:

Dear Madam,

I am sending to you by this post the photograph you sent to me of a group of members of the Wesleyan Church. Miss Cowing had told me of an interior showing the church as it was in 1848 with *High Pulpit* and sounding board. It was a copy of that which I ordered.

I am surprised too at the charge you made for striking a copy from a negative. In this fashionable center of Greenwich the best photographer took tripod and camera in a taxi to my daughter's house, and devoted three hours to getting a very wonderful photograph of an oil painting of my mother, and charged five dollars for the operations.

The leading photographer of Albany is making, on similar terms, a trip to the Court of Appeals and taking a special photograph of my grandfather, Judge Cady, so your charge seems to me very high.

But in any case the photograph is not what I ordered and unusable I am sorry to say.

Can you send the other interior to me at 106 East 52nd Street. I enclose a check for the Stanton House.

Very cordially yours,
Harriet Stanton Black[9]

In 1963 Grace and Jeannie sold their house at Number 16 Johnston Street and moved to the Johnston home. Grace at that time was ninety-one years old and Jeannie ninety-four. Jeannie's signature on the transfer of deed appears shaky and only the first "*J*" remains on the line. The rest of the signature veers sharply and tremulously upwards. Grace's on the contrary is strong and unwaveringly bold and right on the line to the end.

Grace died on February 7, 1967, and the following May was buried in Restvale Cemetary near the graves of her mother and father.

She worked hard throughout her life, took pride in her work, and left behind in her photographs the evidence of that life and pride. I close with a letter written to her by a friend in the year 1900:

Lost

Somewhere between this place and Seneca Falls, or further west,—one girl—of prim and proper demeanor, but not so prim as she looks.

Probably still continuing to retouch negatives and to assist people to be beautiful. Heard from twice in the last five months.

Kindly trace this girl and send any information to Eleanor Pratt, 7 Ogden Street, Binghamton, New York.[10]

NOTES

1. Grace A. Woodworth, typescript of an essay about her acquaintance with Susan B. Anthony, one of several versions. Woodworth Collection, Seneca Falls, New York, Historical Society.

2. Jay Featherstone, "Miss Woodworth," *Geneva Times*, August 23, 1963. Woodworth Collection, Seneca Falls Historical Society.

3. Ibid.

4. Ibid.

5. Ibid.

6. Ibid.

7. Woodworth, typescript. Woodworth Collection, Seneca Falls Historical Society.

8. Featherstone, "Miss Woodworth."

9. Woodworth typescript. Woodworth Collection, Seneca Falls Historical Society.

10. Ibid.

EPILOGUE

Woodstock in the 1930s

GRANT ARNOLD

My association with Woodstock began at the Art Student's League of New York, where I was a student in Charles Locke's lithographic class. Although I had studied drawing with Boardman Robinson, and painting with Kenneth Hayes Miller and Max Weber, I found in lithography and printmaking the medium that completely absorbed me.

In May 1930, the Woodstock Artists Association sent an inquiry to the Art Student's League asking if there was a student there who could set up a lithographic printing shop in the basement of the Association's gallery. The lithographic press that was located there hadn't been used for many years because no one at the Association really knew how to print from stone. Some of the Woodstock artists had, during the Depression years, been in Paris where Edmond Desjobert, the famous French printer, printed their drawings. They felt that if they could have high quality prints made inexpensively in Woodstock, they would be able to sell them in New York City at prices that would make their effort worthwhile.

I went to Woodstock after being interviewed by Arnold Blanch, the representative of the Woodstock Artists Association. While there, I examined the shop and found a Fuchs and Lang geared flat bed press like the one I printed on at the League. There were ten stones of various sizes, a large stone suitable to use as an ink slab, and a broken graining table. A partition separated the press area from

the storage space in the rear of the basement. A ten-by-three-foot table was set against the partition. The press was rusty and needed a new linoleum bed. The water supply came from a brook several yards away in the back yard. A picture window gave good light. Outside the basement door was a patio shaded by the overhang of the gallery floor. An old round table, six feet in diameter, occupied a corner of the patio. No other materials for printing were available there.

I made a list of things that I would need to get started. After my discussion with Arnold Blanch, I agreed to come back to Woodstock after the spring session at the League ended in early June. I was to have the studio rent-free, and the Association agreed to pay for enough supplies to get me started. After that, I would have to pay for supplies out of my earnings. My discussion with Blanch took place at Hervey White's home at the Maverick, a colony where many of the Woodstock artists lived. White, one of the founders of the Woodstock art colony and a well-known author, told me that I could have one of his cottages and that I could take my meals with him. This was a good arrangement. I left eager to try my hand at operating my own shop. I spent the summers of 1930 and 1931 in Woodstock, and then in 1932 I began to live there year-round.

In Woodstock I found two other artists who drew and printed lithographs. One was Bolton Brown, whose book, *Lithography For Artists,* I had read and admired. The other was Emil Ganso, who was a painter as well as a printmaker. He worked in etching as well as lithography. I was fortunate to get to know both of these fine artists and often went to their studios, where we talked about technical problems connected with lithography.

During my decade in Woodstock, I printed for many artists. I acquired impressions of these lithographs by purchase and exchange, and as part payment for printing. Each artist for whom I printed gave me a signed print so that I would have examples of my printing skills to show to others. I also acquired impressions of lithographs by Bolton Brown and Emil Ganso that had been printed by these artists. All of these prints are now in the Grant Arnold Collection of Fine Prints which is part of the permanent collection of the State University College at Oswego, New York. The 425 prints in the collection include 360 that I printed in New York City and Woodstock in the 1930s. Some of the prints were made as part of the Woodstock branch of the Federal Art Project. Among the artists represented, in addition to myself, are: Mike Able, Cecil Bell, Abraham Birnbaum, Emil Bistram, Arnold Blanch, Ivan Bobrinsky, Aaron Bohrod, Jan Bols, Clarence Bolton, Grindage Boyer, Ross Braught, Bolton Brown, Bernarda Bryson, John Carroll, Hy Cohen, Percy Crosby, Adolph Dehn, Eugene

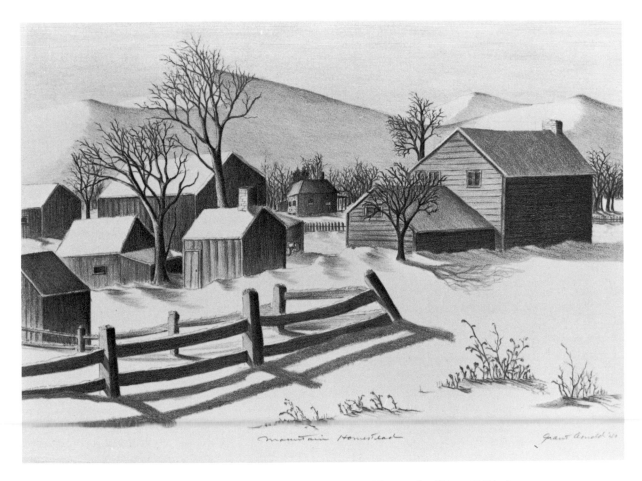

1. Grant Arnold, *Mountain Homestead*, 1940. Lithograph, 9⅞ × 13¹³⁄₁₆ in. Courtesy of Tyler Art Gallery, State University of New York College at Oswego.

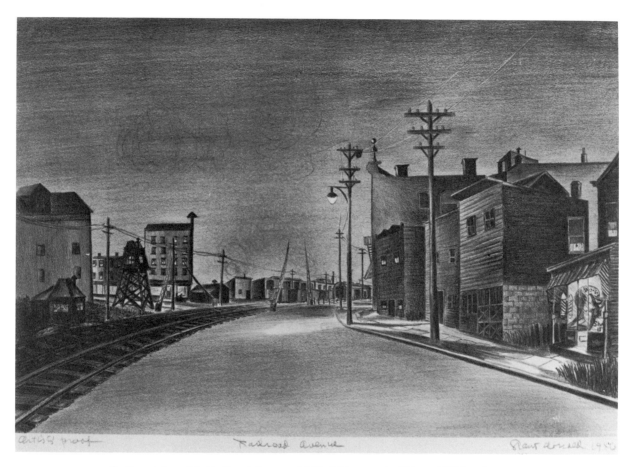

2. Grant Arnold, *Railroad Avenue,* 1940. Lithograph, 9½ × 13¾ in. Courtesy of Tyler Art Gallery, State University of New York College at Oswego.

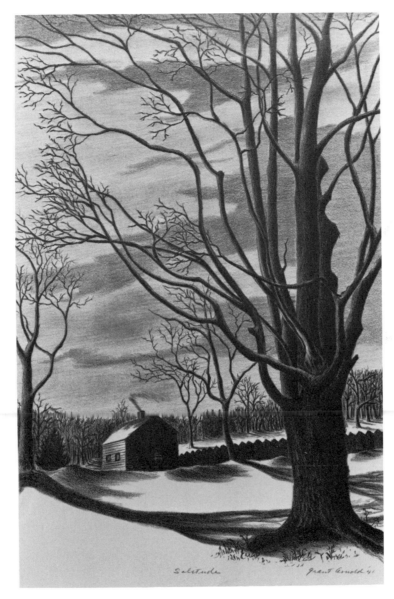

3. Grant Arnold, *Solitude,* 1941. Lithograph, 14⅞ × 9¾ in. Courtesy of Tyler Art Gallery, State University of New York College at Oswego.

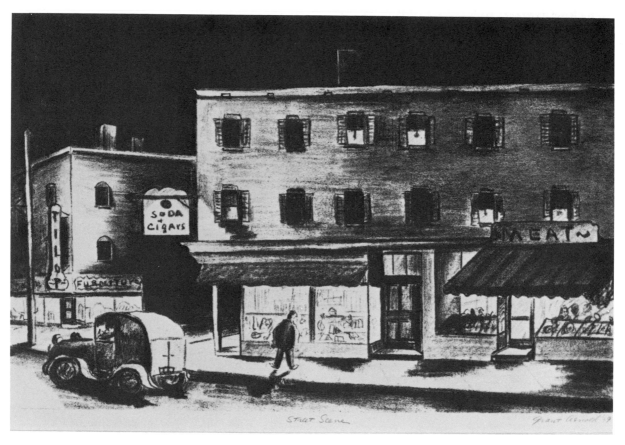

4. Grant Arnold, *Street Scene*, 1939. Lithograph, 9 × 13¾ in. Courtesy of
Tyler Art Gallery, State University of New York College at Oswego.

Fitsch, Karl Fortess, Walter Frank, Don Freeman, Aline Fruhauf, Emil Ganso, Harry Gottlieb, Marion Greenwood, Rosella Hartman, Guerdon Howe, Alfred Hutty, Yasuo Kuniyoshi, Charles Locke, John McClellan, David McCosh, Eugeni McEvoy, Paul Meltzner, Ira Moskowitz, Roland Musseau, Grace Paull, Charles Pollock, Maurice Rawson, Clarence Shearn, Barbara Sherman, Donald Streeter, Prentiss Taylor, Hoyt Wilhelm, and Elizabeth Bush Woiceski.

I met many of these artists in Woodstock. The first to come into the printing shop was John Carroll, then a well-known painter. I was impressed that he would come to me for advice. He had never made a lithograph before, and I showed him how to draw on stone. Many others followed.

Nearly all of these artists were active members of the Woodstock Artist's Association. That organization opened its summer exhibition season each year with a membership show. This was an important art event of the period and was reviewed by a number of critics, including some from New York, Boston, Washington, and Chicago newspapers. The critics often arrived a day in advance to attend the party held the evening before the opening. This was a huge affair with plenty to eat, but in the early years of the decade, when Prohibition was still in force, there was normally not much in the way of convivial drink beyond homebrew and bathtub gin. The event was important enough, however, that one year two members of the association, after collecting funds from their colleagues, drove to a small cove on Lake Ontario near Watertown, New York, where, at a two A.M. rendezvous with a Canadian motor launch, they procured an ample supply of wine and spirits for the party.

The opening exhibition was an important one for the impressive number of American painters, sculptors, and printmakers who came to Woodstock each summer. Following the opening, they waited anxiously for the Sunday papers The critics did not shy from saying what they liked and what they did not like, but the worst blow that could befall a Woodstockian was not to be mentioned at all. Even a bad review was preferable to none. Any kind of mention was attention that could be put to good use by sales galleries in New York.

Bolton Brown was of an older generation and for the most part remained aloof from these events. I first met him in 1933, when he was sixty-eight. Some local artists had discouraged me from seeking him out, saying that he was cranky and would not welcome a new printer of lithographs. They predicted that he would shut the door in my face. But my wife Jenny and I talked it over and then walked to his place in Zena, an outlying section of Woodstock. He opened the door, and when I introduced myself he said, "I know who you are. I've been

wondering why you haven't come to see me." He couldn't have been more gracious. He showed us his prints and we talked on and on. He was a very warm and remarkable man.

He had eased away from the practice of lithography because his declining health prevented him from lifting the heavy stones and from cranking them under pressure through his hand-operated press. Even the muscle power needed to roll ink on the stones was not easily summoned. He still taught lithography to an occasional student, but his chief interest was now directed to working in clay and experimenting with glazes. He had built a kerosene-fired kiln and a potter's kick-wheel and taught himself to throw clay. He exhibited his ceramic work on shelves in his studio, each piece with its price on a small tag. His wife Lucy occasionally came to Woodstock with an empty suitcase, filled it with pieces, and took them to New York City where she sold them to dealers. Fine as his ceramic work was, our interest was in his prints and all that he had contributed through his teaching, writing, and work to the art and craft of lithography.

The following year, 1934, when payment for printing a couple of editions arrived unexpectedly, giving me twenty dollars I hadn't counted on, Jenny and I walked over to Zena and asked Bolton Brown if we could see some of his prints. "Why not?" he said, and brought out a large selection, including several we hadn't seen before. We looked at them all and then told him we would like the buy one. He asked why we hadn't said so earlier. "If I had known that you wanted to buy one, I would have shown you only five or six. It's very confusing to people to have to make up their minds after they have seen so many."

We picked a print of an approaching rainstorm, *Summer Shower.* "You have picked one of my favorites," he said. "How much do you want to spend?" I told him of our twenty-dollar windfall, adding, "I know it isn't enough for your print, but it is all the money we have." "You don't have any more than that?" he asked. Jenny and I searched our pockets and came up with less than a dollar and a half in change. "Do you mean to tell me that you want to spend all the money you have to buy a print of mine?" "Yes," we both answered. He shook his head and said, "Well, I usually get more for my prints than twenty dollars," but he took the money and then said that he wanted us to have two other small prints because they were successful experiments. So we walked home with three Bolton Brown lithographs and a kind of happiness about the man and about Woodstock that I still feel half a century later.

꙳

APPENDIX
North American Print Conferences

A series of locally organized conferences held in the United States and Canada on subjects relating to the history of prints in North America.

 I *Prints in and of America to 1850.* March 19–21, 1970. Winterthur Museum, Winterthur, Delaware. Proceedings, edited by John Morse, published by University Press of Virginia, 1970.

 II *Boston Prints and Printmakers, 1670–1775.* April 1–2, Colonial Society of Massachusetts, Boston. Proceedings, edited by Walter Muir Whitehill and Sinclair Hitchings, published by University Press of Virginia, 1973.

 III *American Printmaking before 1876: Fact, Fiction, and Fantasy.* Library of Congress, June 12–13, 1972. Proceedings published by the Library of Congress, 1975.

 IV *Philadelphia Printmaking: American Prints before 1860.* April 5–7, 1973. Free Library of Philadelphia; Historical Society of Pennsylvania; Library Company of Philadelphia; and Philadelphia Museum of Art. Proceedings, edited by Robert F. Looney, published by Tinicum Press, 1976.

 V *Eighteenth-Century Prints in Colonial America.* March 28–30, 1974. Colonial Williamsburg, Virginia. Proceedings, edited by Joan Dolmetsch, published by the University Press of Virginia, 1979.

 VI *Art & Commerce: American Prints of the Nineteenth Century.* May 8–10, 1975. Museum of Fine Arts, Boston, in association with other Boston institutions. Proceedings published by University Press of Virginia, 1978.

VII *Prints of New England.* May 14–15, 1976. American Antiquarian Society and Worcester Art Museum, Worcester, Massachusetts. Proceedings, published by the American Antiquarian Society, edited by Georgia Brady Bumgardner, forthcoming.

VIII *American Maritime Prints.* May 6–7, 1977. Old Dartmouth Historical Society Whaling Museum, New Bedford, Massachusetts. Proceedings, edited by Elton. W. Hall, published by The Whaling Museum, Old Dartmouth Historical Society, 1985.

IX *Prints of the American West.* May 4–6, 1978. Amon Carter Museum, Fort Worth, Texas. Proceedings, edited by Ron Tyler, published by the Amon Carter Museum, 1983.

X *American Portrait Prints.* May 15–17, 1979. National Portrait Gallery of the Smithsonian Institution, Washington, D.C. Proceedings, edited by Wendy Wick Reaves, published by the University Press of Virginia, 1984.

XI *Canada Viewed by the Printmakers.* May 6–8, 1980. Royal Ontario Museum, Toronto. Proceedings, edited by Mary Allodi, forthcoming.

XII *New York State Prints and Printmakers, 1825–1940.* May 14–16, 1981. Syracuse University; Everson Museum of Art, The Erie Canal Museum. Proceedings, edited by David Tatham, published by Syracuse University Press, 1986.

XIII *Mapping the Americas.* October 15–17, 1981. The Historical Society of Pennsylvania. Proceedings, edited by Peter Parker, forthcoming.

XIV *The American Illustrated Book in the Nineteenth Century.* April 8–9, 1982. Winterthur Museum, Winterthur, Delaware. Proceedings, edited by Ian Quimby, forthcoming.

XV *Images by and for Marylanders 1680–1940,* April 27–30, 1983. The Maryland Historical Society, Baltimore, in association with other Baltimore institutions. Proceedings, edited by Laurie A. Baty, forthcoming.

XVI *The Graphic Arts in Canada after 1850,* May 9–12, 1984. Public Archives of Canada and National Gallery of Canada in cooperation with National Library of Canada and Remington Art Museum, Ogdensburg, New York. Proceedings, edited by Jim Burant, forthcoming.

XVII *Aspects of American Printmaking, 19th and 20th Centuries,* April 25–27, 1985. Grace
 Slack McNeil Program in American Art, Wellesley College and the Museum of
 Our National Heritage, Lexington, in cooperation with the Boston Athenaeum,
 the Museum of Fine Arts, and the Boston Public Library. Proceedings, edited by
 James O'Gorman, forthcoming.

XVIII A conference on American historical prints relating to New York City. April 10–
 12, 1986. New-York Historical Society. Proceedings, edited by Wendy Shadwell,
 forthcoming.

֍

BIBLIOGRAPHIC NOTE

The literature of the history of prints in North America has increased dramatically since the 1960s, but it does not yet include a comprehensive survey of American printmaking from colonial times to the present. Readers seeking to learn the full scope of the subject must consult several sources. The essential guide to many important publications, cited with annotations, is Bernard Karpel, ed., *Arts in America: A Bibliography* (Washington: Smithsonian Institution Press, 1979), volume 2. The section on the graphic arts of the seventeenth through the nineteenth centuries was complied by Georgia Bumgardner, that of the twentieth century by Elaine Johnson. This bibliography, selective as it is, and including no studies published after 1976, remains a foundation work of reference.

The history of the literature of American prints is easily summarized. The first significant body of publications appeared during the 1870s and 1880s, inspired by the etching movement. Most of these articles, books, and exhibition catalogues concerned the movement itself and paid scant attention to earlier American prints. The most important of the publications, several of which were written or commissioned by Sylvester Rosa Koehler, are described in Thomas Bruhn, *American Etchings: The 1880s* (Storrs: The Benton Museum of the University of Connecticut, 1985). The first important monograph on the history of any aspect of American printmaking was William J. Linton's *History of Wood Engraving in America* (Boston: Estes and Lauriat, 1882), a work that remains full of interest, for it was written by a master wood-engraver who was also an able historian and critic.

While Koehler, Linton, and other writers of the 1880s were primarily interested in contemporary prints, and only secondarily in the American history of the media they worked in, the next wave of publications, which crested in the 1920s, came from collectors whose interests were essentially, if not exclusively, with the past. They viewed prints as

265

documents of popular culture. Though their work often reflected a romanticized and even sentimentalized understanding of earlier times in America, it was also based on the concept that in a democratic society the arts of the masses are as worthy of study as the arts of the elite. These authors were tireless collectors and list-makers. David McNeely Stauffer's *American Engravers Upon Copper and Wood*, 2 vols. (New York: Grolier Club, 1907) is an early and important example, supplemented in 1917 by a third volume compiled by Mantle Fielding. Grander in scope as well as in format, and perhaps the clearest example of a romanticized view of popular prints, are two works by Harry T. Peters: *Currier & Ives: Printmakers to the American People*, 2 vols. (New York: Doubleday, 1929) and *America on Stone* (New York: Doubleday, 1931). Though the omissions and inaccuracies that are inescapable in pioneering works such as these limit their reliability as reference works, they are of very great importance to the historiography of the graphic arts.

What Stauffer, Fielding, Peters, and others accomplished in the first thirty years of the twentieth century served as a foundation for sustained attempts to compile, organize, and analyze discrete groups of prints. Koehler had done so earlier on a limited scale, and check-lists of a single artist's prints had occasionally been issued in the nineteenth century, but a more thorough-going scholarly approach to the task arrived in the 1930s. Allen Everts Foster's "Check List of Illustrations by Winslow Homer in *Harpers Weekly* and other Periodicals," *Bulletin of the New York Public Library* (October 1936 and July 1940) was an important early example. Peter Morse's masterful *John Sloan's Prints* (New Haven: Yale University Press, 1969) exemplifies the degree of sophistication which this approach developed within three decades.

The interest in documenting specific subjects precisely and objectively has brought forth a very large number of specialized studies of printers, publishers, subjects, genres, regions, iconography, and the technology of printmaking. Many of these studies are published in periodicals and conference reports. A few, such as Sinclair Hamilton's *Early American Book Illustrators and Wood Engravers, 1670–1870*, 2 vols. (Princeton: Princeton University Press, 1958 and 1968), successfully integrate the author's original research with the work of others to study a subject of large scale. The kind of scholarly research in American prints that began in the 1930s and that has increased in scope and intensity every decade since has been the work of collectors, antiquarians, librarians, curators, and professional historians from many fields (including, but not limited to, art, medicine, music, transportation, women's rights, printing, and religion). It has enlarged the concept of a print to include theatrical posters, broadsides, music titles, photomechanical images, and ephemera of every sort.

Beginning in the 1960s, an increasingly important part of the literature of American prints has appeared in catalogs of exhibitions. The exhibitions themselves have been so numerous during the 1960s, 1970s, and 1980s, that no truly inclusive single record of them exists, though some of the more important have been noted in *The Print Collector's Newsletter*, *The Magazine Antiques*, *Imprint*, and other periodicals. Catalogs of collections

have been much rarer. Karen F. Beall, *American Prints in the Library of Congress* (Baltimore: Johns Hopkins University Press, 1970) is an invaluable reference source even though it includes only a small fraction of that institution's holdings. *Catalogues raisonnés* of the work of American artists who were only secondarily printmakers have contributed much to the growing body of documentation.

In the 1980s, several writers have attempted general histories of American prints of the present century, or some significant part of it. Among these are Una E. Johnson's *American Prints and Printmakers . . . from 1900 to the Present* (Garden City: Doubleday, 1980) and James Watrous's *A Century of American Printmaking 1880–1980* (Madison: University of Wisconsin Press).

The terminology (which is not complex) and the mechanics of printmaking processes (which are only slightly more so) have frequently been explained in print, but not always with sufficient clarity. An excellent brief introduction to this terminology can be found in Richard V. West's introductory essay for the exhibition catalog *Language of the Print* (Brunswick, Me.: Bowdoin College Museum of Art, 1968). Though his examples range widely and include only a few American examples, his discussion applies to all the prints illustrated in the present volume.

D. T.

INDEX

Flexner, Thomas, 175, 181
Flint, Janet, 39, 236
Fort Ontario, Oswego, N.Y., 117
Fort Plain, N.Y., 121
Fort Wellington, Ontario, 80
Forty Thieves of the Common Scoundrels of New York, 157
Foster, Allen Everts, 266
Foster, Birkit, 210
Fowler, Taddeus Mortimer, 121, 122, 131, 132
Franklin, Benjamin, 147
Franklin County, N.Y., 87
Frost, Arthur B., 164
Fulton, N.Y., 117, 121

Ganso, Emil, 254, 259
Genesee County, N.Y., 131
Geneva, N.Y., 121
Gifford, R. Swain, 184, 186, 188, 190–97, 209, 211, 212
Gilbert Stuart, 84
Gillray, James, 5, 92
Gingerbread Man, A New Comic Song, 48
Gladwin, George, 124
Glasgow, Daniel T., 49, 61
Glasgow, James Irvine, 49, 61, 63, 65
Gleaning from the Shipwreck, Montauk, 204
Glens Falls, N.Y., 172
Gloucester, Mass., 37, 205
Government, The, 149
Gowanus Bay, New York Harbor, 198
Graham, C. B., 27, 28
Grammercy Park, New York City, 223
Great Political Car and Last Load of Patriots, The, 150
Griffin, Davenport, 240
Groton, N.Y., 130
Growth of Gun and Boots, 167
Gun, Boots, Etc., 166

Haden, Seymour, 184, 187, 188, 189, 198
Hallock, Charles, 168
Hamerton, Philip G., 184, 188, 195, 210, 211
Hamilton, Sinclair, 181, 266
Harlem, N.Y., 205
Harper, Ida Husted, 244
Harrison, William Henry, 94, 99, 104, 108–109, 154
Harshe, Robert B., 232, 233, 240
Hart, Charles, 43–47, 49, 52, 55, 57, 60–64
Hazen, James C., 119, 132
Heights of Monterey, 59
Helms, Bill, 164, 181
Henry, George, 145. *See also* Maungwudaus
Hill, J. W., 116, 118, 129, 131
Hiroshige, 217
Hitchcock, Ripley, 205, 211, 212
Holman, Louis A., 209, 212
Homer, Winslow, 5, 43, 63, 266
Hone, Philip, 99, 101, 110
Hopper, Edward, 210
Hoppin, Augustus, 152, 158, 159, 172, 174
Hornell, N.Y., 121
H.R. Robinson Trade Card, 96
Hudson River, 114, 130, 195, 197, 201
Hudson River Tow, 197
Hullmandel, Charles, 19, 61
Hunt, William Morris, 66, 146
Huron, Lake, 135

Ilion, N.Y., 121
Imbert, Anthony (and Shop), 6, 8, 11–41, 92, 131
Indian River, N.Y., 73
Ingham, Charles C., 88
Inman, Henry, 29, 35
In the Harbor, 203
Ioway Indians, 140, 142, 146
Iroquois Indians, 135
Ithaca, 126
Ithaca, N.Y., 114, 125, 126, 132

Prints and Printmakers of New York State, 1825–1940

was composed in 10-point Mergenthaler Linotron 202 Baskerville
and leaded 2 points
by The Composing Room of Michigan, Inc.,
with initial capitals in Howland Open
by Rochester Mono/Headliners,
and ornaments provided by Jōb Litho Services;
printed sheet-fed offset on 80-pound Karma Natural
Smyth sewn and bound over 80-point binders boards in Joanna Arrestox B
by Maple-Vail Book Manufacturing Group, Inc.;
with dust jackets printed in 2 colors by Philips Offset Co., Inc.;
designed by Will Underwood;
and published by

SYRACUSE UNIVERSITY PRESS
SYRACUSE, NEW YORK 13244-5160